The Economics
of the Arts

The Economics of the Arts

edited by

MARK BLAUG

Professor of the Economics of Education, University
of London Institute of Education and London School
of Economics

Martin Robertson

First published in 1976 by Martin Robertson & Company,
17 Quick Street, London N1 8HL

ISBN 0 85520 122 3

Typeset by Preface Ltd, Salisbury
Reproduced and printed by photolithography
and bound at The Pitman Press, Bath.

Contents

Preface: Recent Developments in the Economics of the
Performing Arts *by W. J. Baumol* 1

Introduction: What is the Economics of the Arts About?
by M. Blaug 13

A The Rationale for Public Subsidies to the Arts

 1. Reasons for Subsidizing American Theater (1968)
 by T. Moore 25

 2. Arguments for Public Support of the Performing Arts
 (1966) *by W. J. Baumol and W. G. Bowen* 42

 3. What's Wrong with the Arts is What's Wrong with
 Society (1972) *by T. Scitovsky* 58

 4. Welfare Economics and Public Subsidies to the Arts
 (1969) *by A. T. Peacock* 70

B Evaluating Public Expenditure on the Arts

 5. Cultural Accounting (1973) *by A. T. Peacock and
 C. Godfrey* 87

 6. Does the Arts Council Know What It Is Doing? (1973)
 by K. King and M. Blaug 101

 7. The Arts Council and Its Critics (1973) *by R. Findlater*
 with A Reply (1973) *by K. King and M. Blaug* 126

 8. Rationalising Social Expenditure — The Arts (1976)
 by M. Blaug 132

 9. A Survey of American and British Audiences for the
 Performing Arts (1966) *by W. J. Baumol and
 W. G. Bowen* 148

C Special Problems

10. Unsettled Questions in the Political Economy of the
 Arts (1971) *by L. Robbins* 175

11. The Economics of Museums and Galleries (1974)
 by A. T. Peacock and C. Godfrey 189

12. Are Museums Betraying the Public's Trust? (1973)
 by J. M. Montias 205

13. On the Performing Arts: The Anatomy of their
 Economic Problems (1956) *by W. J. Baumol and
 W. G. Bowen* 218

14. The Demand for Broadway Theater Tickets (1966)
 by T. Moore 227

15. Risk, Uncertainty and the Performing Arts (1975)
 by F. P. Santos 243

16. The Supply of the Performing Arts (1974) *by R. Weiss* 260

Acknowledgements

We wish to thank the following publishers and authors for permission to reprint their works: *American Economic Review*, Cambridge University Press, Duke University Press, *Encounter, Lloyds Bank Review*, Manchester School of Economics and Social Studies, *Museum News, Review of Economics and Statistics, Social Trends, The Three Banks Review* and *Twentieth Century Fund*; W. J. Baumol, M. Blaug, W. G. Bowen, R. Findlater, C. Godfrey, K. King, J. M. Montias, T. Moore, A. T. Peacock, L. Robbins, T. Scitovsky and R. Weiss.

Preface: Recent Developments in the Economics of the Performing Arts

by W. J. BAUMOL

Professor of Economics, New York University

In the past few years the economic pressures besetting live performance have grown dramatically in large part for reasons discussed in various papers in this collection, in part for reasons that were not anticipated. In this preface I will attempt to review some pertinent developments in recent years, and to discuss some of the reasons that led matters to develop as they did.

Some years ago William Bowen and I revalidated our credentials as dismal scientists by predicting that the live performing arts along with education and a variety of public services would experience a pattern of rising costs that would steadily and cumulatively outstrip the rate of inflation characterizing the remainder of the economy. That is, we argued that the costs of such activities would outstrip cumulatively the costs of other things to which the economy may choose to devote its resources. There is no point in recapitulating our reasons for this conclusion which are described in some detail in the excerpts from our writings in this volume.

We were at that time a bit (but only a bit) more optimistic about the other side of the matter — the prospective generosity of donors and their willingness to cover the gap between expenditures and earned incomes. Particularly in the United States, governments had at that time barely begun to contribute to the support of the arts, and while we offered no political forecasts, there seemed to be grounds for hope for some significant contributions from this quarter.

As it happens, both these views turned out to be more or less in

1

agreement with subsequent events — at least for a time. Costs did continue to rise, and if they rose even more quickly than some of our extrapolations had suggested this is I believe mostly a manifestation of our cowardice in not following the analysis all the way in the direction it pointed. We felt at the time that our projections had been biased to err on the conservative side, but doubts that even those figures would be considered credible held us in check.

The rise in funding by the public sector on the other hand, was far greater than anything we had anticipated. The budget of the New York State arts council expanded from $1,504,477 in 1966—67 to $35,702,900 in 1975—76, while the National Endowment on the Arts and Humanities, which had just been established as we were writing, grew from an initial expenditure on the arts of $2,534,308 in 1966 to an outlay of $74,750,000 in 1975. Meanwhile support by private individual donors did not slacken in response to these new sources of funds, and the private foundations also continued their support.

All this has changed dramatically in the last two or three years, for reasons which are worth examining before turning to a somewhat more systematic review of recent developments.

Uneven Progress of the Chronic Financial Crisis

Because of the unrelenting and cumulative rise in their *relative* costs, the live performing arts can be expected to find themselves in permanent crisis, no less a reality for the paradoxical juxtaposition of terms. If the cost of the arts grows say 5 percent more rapidly than the costs of other items supplied by the economy, and does so year-in year-out, then this sector is sure to find itself subjected to at least two chronic financial difficulties. First there will be pressures which make live performance every year more expensive relative to ther items that compete for the consumer's expenditure. And second they force upon the organizations that supply live performance fund-raising goals that must rise constantly perhaps at an accelerating absolute rate. Each passing year will render its predecessor's funding target obsolete and inadequate to prevent a reduction in quantity and quality of its offerings. It is certainly not enough for these targets to keep pace with the general rate of inflation, for whatever the rate of increase of prices in the economy, the costs of the arts rise even faster. Even if revenues and gifts rise precisely in proportion with costs, any shortfall must

represent a growing problem. If costs, revenues and gifts each rise six percent per year, then any remaining gap must also rise at a (compounded) rate of six percent, and that cannot continue indefinitely.

Yet, while the resulting crisis is chronic it does not follow that its severity must remain unchanged from year to year. On the contrary, since such vital influences as the amount provided by philanthropy can vary unexpectedly and substantially in response to other economic events or more or less autonomously, live performance may find itself in financial circumstances that differ very sharply from one year to another.

There is some pattern to these differences. Characteristically the non-profit arts organizations run into difficulties in years when business conditions are bad because donors cannot afford to be generous. The financial problems of the arts also seem to be aggravated by inflation which presumably induces retrenchment in purchases of items that are not absolutely indispensable.[1]

It should consequently not be very surprising that the last few years with their unhappy and unprecedented combination of recession and inflation, have not been a happy period for performing organizations. Their costs have soared, along with those in the remainder of the economy and probably more. Musicians and other performers have continued to press for increased compensation, a demand that is easy to justify, but to which the performing organization can ill afford to accede.

But the more immediate source of difficulty, whose consequences have perhaps not even yet fully manifested themselves, is the effect of the conjunction of economic events upon two of the main financial supports of the arts — the private foundations and state and local governments.

The foundations have found themselves squeezed by a combination of rising costs and a sharp decline in the market value of their stock portfolio. When these values were at their nadir some of the leading foundations were forced to undergo sharp reductions in their programs, some planning to reduce the amounts they give out annually by a third or even a half, even as unprecedented inflation rates were cutting the purchasing power of each dollar they provided. The recent recovery in the stock market does not appear to have produced any substantial reliberalization of foundation spending, their continued conservatism being quite understandable under the circumstances.

Simultaneously, financial pressures upon the government of New York State, prime source of support for the arts, have produced a protracted emergency as the depressed economy contributed to a reduction in revenues at the same moment that inflation and the rising relative cost of public services was taking its toll in terms of demands for funds. With other states and local governments undergoing similar difficulties, it is clear that the arts will be doing well if they are able to avoid a substantial reduction in the number of dollars received from this source.

The main point in all this is the vulnerability of live performance to economic events beyond its control, and the sporadic character of the pressures to which it is likely to be subjected.

Rising Costs and the Mass Media

While the discussion of rising costs has been framed in terms of live performance, related problems also arise in the mass media. It has been suggested that the electronic mass media provide the key to the solution of the technological problems of the performing arts and their resistance to increases in productivity. There is no doubt that the advent of films, radio and television did permit a once-and-for-all increase in productivity which is probably unparalleled in any other economic activity in this century. For example, by going from live to televised performance an orchestra may increase its audience from 3000 to as many as 30 million persons, with virtually no change in total man hours expended, yielding a 10 thousand-fold rise in number of persons served per man hour.

Yet this has so far proved to be no more than a temporary victory. The very effectiveness of this electronic revolution provided several noteworthy countereffects. First, it limited the market for performers by permitting a few groups to reach audiences which formerly could be served only by a large number of performers. More important for our purposes, it reduced severely the scope for further productivity gains. In television today it is estimated that less than 20 percent of the budget is devoted to transmission, the portion of the activity in which further innovation is readily to be expected. Some 60 percent of the budget is now devoted to the performance itself where, as we have seen, the scope for productivity increases seems minimal. Even if

productivity in transmission technology were to grow by an (implausible) 10 percent per year this would translate into a rise in productivity in television of little more than 20 percent of that amount — some 2 percent per year overall. It is no wonder that costs of television in recent years are reported to have been growing at rates comparable to those of the live performing arts.

Recent Data on Costs of Performance

In order to determine whether costs of the performing arts have indeed been rising in recent years in accord with the predictions of our analysis, i.e., to see whether they have continued to rise with considerably greater rapidity than the general price level, I have assembled the most recent data available upon the two central pieces of evidence in our study. Specifically, I have used data supplied by the Ford Foundation indicating the behavior of cost *per performance* for eleven of the best-known orchestras in the United States[2] and for the Metropolitan Opera, because these organizations offer detailed financial records expressed in comparable terms over a continuous period. Few other performing organizations have equally satisfactory data.

Figure 1 and Table 1 show, for 1937 to 1971, the average expense *per performance* incurred by our eleven 'basic' orchestras. Particularly during the latter part of this period the number of performances given by these organizations has been rising, increasing from an average of 140 per orchestra in 1966 to 160 performances in 1971. Consequently, total expenditures per orchestra have been increasing even faster than cost per performance. Yet it is the latter figure that is the pertinent datum for our purposes because it, and not total expense, indicates the trend in the costliness of the 'product' of orchestral activity, i.e., of the performance.

The graph confirms that this cost has been rising quite steadily, and that in the most recent years reported it has been accelerating.

More important is the comparison with the behavior of prices in the economy generally, which for our purposes we represent by the consumer price index. The graph shows that the Vietnam War was indeed beginning to impose its cost in terms of inflation, but that the rise in price level was nowhere near that of cost per performance. With the passage of time these pulled further and further apart.

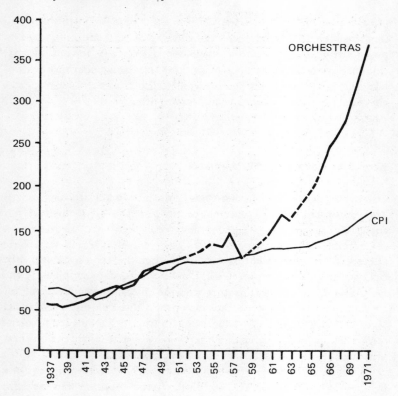

Figure 1. Index of Expense per Performance for Eleven Basic Orch-
estras Compared to Consumer Price Index, 1937–1971 (1948 = 100)
Source: See Table 1

Figure 2 and Table 2 provide the same sort of information for the
Metropolitan Opera, this time for the period 1950–1971. Again they
show precisely the same pattern as that exhibited by the orchestras.

It may be noted incidentally that the increasing distance in more
recent years between the graph of cost per performance and that of the
consumer price index need not be interpreted as a change in the
underlying pattern of affairs. It is a prime characteristic of any
relationship that grows at a steady but compounded rate, that its
absolute rate of increase will grow constantly larger and larger, seeming
to explode with the passage of time. This is simply the nature of the
compounding process in which each step feeds on its predecessor and

Table 1. Index of Average Expense per Performance, 1937–1971, for Eleven Basic Orchestras (1948 = 100)

Year	Average Expense Per Perf.	Index	Year	Average Expense Per Perf.	Index
1937	$3,678	77.12	1954	Na	—
1938	3,715	77.89	1955	$6,310	132.31
1939	3,588	75.23	1956	6,250	131.05
1940	3,333	69.88	1957	6,917	145.04
1941	3,306	69.32	1958	5,716	119.85
1942	2,993	62.75	1959	Na	Na
1943	3,081	64.60	1960	Na	Na
1944	3,446	72.25	1961	6,955	145.83
1945	3,795	79.57	1962	8,027	168.31
1946	4,090	85.76	1963	7,664	160.70
1947	4,327	90.73	1964	Na	Na
1948	4,769	100.00	1965	Na	Na
1949	5,086	106.64	1966	10,129	212.39
1950	5,252	110.12	1967	11,542	242.02
1951	5,321	111.57	1968	12,584	263.87
1952	5,557	116.52	1969	13,825	289.89
1953	Na	Na	1970	15,589	326.88
			1971	17,591	368.86

Source: Orchestral records and data supplied by The Ford Foundation from its survey of non-profit performing organizations. For further details see Baumol and Bowen, *Performing Arts: The Economic Dilemma* (New York: *The Twentieth Century Fund,* 1966) Chapter VIII, pp. 181–207. Na = no data available.

snowballs in an accelerating growth path. If productivity in the economy does indeed grow by a more or less constant percentage in excess of that in the arts, we would expect from our analysis precisely the sort of patterns exhibited by the two figures.

With this sort of cost increase and recession in the economy we should expect no erosion of the financial gap — the difference between expenditures and earned income — which the non-profit institutions must cover out of philanthropy.

Figure 3 indicates that in fact the gap has continued to grow at a roughly constant percentage rate, at least for the eleven basic orchestras. It should be noted that the vertical scale of the graph is logarithmic so that the roughly constant distance between the expenditure and earned income curves indicates that the *proportion* of the gap in the orchestral budgets has remained more or less steady.[3]

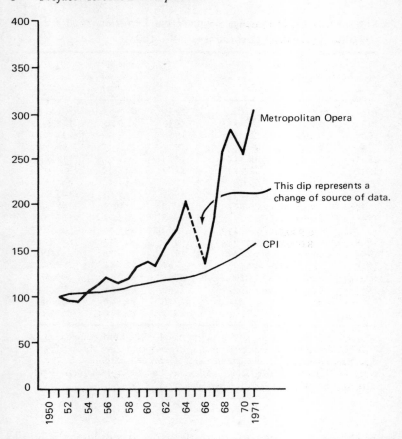

Figure 2. Index of Expense per Performance for Metropolitan Opera Compared to Consumer Price Index, 1951–1971 (1951 = 100)
Source: See Table 2

Performances and Audiences in the Commercial Theater

While the commercial theater does not suffer directly when there is a contraction in philanthropy, as a profit-seeking institution it does reflect economic pressures very directly. Not only is it subject to the effects of rising costs, but it may also encounter more difficulty in raising funds from investors — a matter not dissimilar to the reduction in donations to non-profit institutions.

Table 2. Index of Expense per Performance, 1950—1971, for
Metropolitan Opera (1951 = 100)

Year	Total Expenditure	Number of Performances	Expense per Performance	Index
1950	$4,000,000	Na	Na	Na
51	4,500,000	205	$21,951	100.00
52	4,600,000	213	21,596	98.38
53	4,600,000	212	21,698	98.84
54	4,900,000	207	23,671	107.83
55	5,300,000	217	24,423	111.26
56	5,600,000	214	26,168	119.21
57	5,900,000	233	25,321	115.35
58	6,100,000	233	26,180	119.26
59	6,700,000	234	28,632	130.43
60	6,900,000	236	29,237	133.19
61	6,900,000	239	28,870	131.52
62	8,000,000	235	34,042	155.08
63	8,800,000	237	37,130	169.14
64	11,000,000	244	45,081	205.37
65	Na	Na	Na	Na
66	15,806,104	538	29,379	133.83
67	21,346,432	549	38,882	177.13
68	16,930,640	301	56,247	256.23
69	17,424,528	285	61,138	278.52
70	15,997,690	201	56,132	255.71
1971	19,612,560	292	67,166	305.98

Source: 1951—1964, Baumol and Bowen, *op. cit.*, p. 296; 1965—1971,
R. Sheldon of The Ford Foundation.

Table 3 indicates what has occurred in terms of total number of new
productions, total number of productions running per season (including
holdovers from previous seasons) and total number of performances. Its
figures begin just before World War II, the pre-war data being reported
for ease of comparison. It will be noted that in the period 1950—1970
it is difficult to discern any trend; the new productions ranged in
number from 48 to 75 per season, and the number of playing weeks
from about 1000 to 1300. The figures fluctuated between these limits
but showed no steady movement in any particular direction.

Since then, however, matters seem to have deteriorated somewhat.
The number of playing weeks has twice dropped below the previous
minimum, though it did rise again to 1100 in 1974/75. There has also
been a decline in new productions which twice in a four year period
have been at or below the previous post-war minimum of 48.

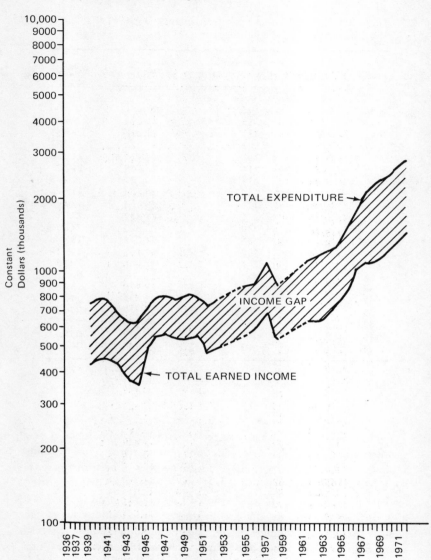

Figure 3. Average Total Expenditure and Total Earned Income of Eleven Basic Major Orchestras, 1939–71
Source: Baumol and Bowen and The Ford Foundation. See Tables 1 and 2.

Table 3. Broadway Activity, 1939—70

Season	New Productions (including revivals)	Total Playing Weeks	Total Gross Income
1939/40	91	991	$12,665,800
1940/41	69		
1941/42	83		
1942/43	80	Figures not available for	
1943/44	97	the seasons 1940/41	
1944/45	92	through 1946/47.	
1945/46	76		
1946/47	79		
1947/48	76	1,325	28,826,500
1948/49	70	1,231	28,840,700
1949/50	57	1,156	28,614,500
1950/51	81	1,139	27,886,000
1951/52	72	1,072	29,223,000
1952/53	54	1,012	26,126,400
1953/54	59	1,081	30,169,200
1954/55	58	1,120	30,819,000
1955/56	56	1,239	35,353,100
1956/67	62	1,182	37,154,500
1957/58	56	1,081	37,515,300
1958/59	56	1,157	40,151,300
1959/60	58	1,156	45,665,500
1960/61	48	1,210	43,829,500
1961/62	53	1,166	44,250,700
1962/63	54	1,134	43,829,500
1963/64	63	1,112	39,148,500
1964/65	67	1,250	50,462,765
1965/66	68	1,295	53,862,187
1966/67	69	1,269	55,056,030
1967/68	74	1,259	58,941,809
1968/69	67	1,209	57,743,416
1969/70	62	1,047	53,324,199

Source: T. G. Moore, *The Economics of the American Theater.* Durham : Duke University Press, 1968; and *Variety,* June 4, 1975.

Somewhat surprisingly, the economically difficult period, 1974–76, seems to have been relatively helpful to the theater, bringing with it a sharp increase in gross theatrical revenues, much of it of course representing only inflation. An explanation widely offered is that the precipitous rise in travel costs and stock market losses kept potential attendees at home. In any event, producers and theater owners to whom I have spoken are skeptical about the duration of this improvement.

Concluding Comment

This concludes my few observations on recent developments in the economic state of the arts in the U.S. It is, of course, highly incomplete, and makes no attempt to hint at the very great problems that seem to have been encountered in other countries. Yet it may offer the reader some feeling about what has been transpiring.

Let me close by offering a brief comment about this volume, which Professor Blaug has put together with his usual skill and insight. It is hard for me to be detached in my evaluation of the items included since my own work is so heavily over-represented. Yet I can say that the writings of others that have been selected include most of the finest work that has been done by economists on the subject. The discussions lay out very clearly the great range of economic problems of the arts and offer us some insights into their sources. Altogether, the book seems to me to offer a first-rate introduction to the reader who is concerned about the economic circumstances of the arts. And they show, unfortunately, that such a reader may have a good deal to be concerned about.

1. For evidence on these matters see W. J. Baumol and W. G. Bowen, *Performing Arts: The Economic Dilemma*, New York: The Twentieth Century Fund, 1966. The evidence on inflationary periods must be treated with some caution since most such periods in previous U.S. history were times of war which may also have involved difficulties of different sorts for the arts.
2. These include Chicago, Cincinnati, Cleveland, Indianapolis, Kansas City, Minneapolis, National (Washington), Philadelphia, Pittsburgh, St. Louis, and San Francisco.
3. For a fuller discussion of the meaning of a logarithmic scale on a graph, see Baumol and Bowen, *op. cit.*

Introduction: What is the Economics of the Arts About?

by M. BLAUG

The economics of the arts is a relatively new subject, with a small but steadily growing literature. It has emerged in recent years out of the eagerness of economists to apply their tools to hitherto untried areas and the recognition by arts administrators of the increasing economic pressures on the arts. The time is hardly ripe for a textbook in the economics of the arts but this collection of articles will, it is hoped, demonstrate that there really is such a subject and that its achievements to date have already done much to illuminate the economic problems of the arts.

The intellectual imperialism of economists is one of the phenomena of our time: recent years have seen economists analyzing problems of national defense, health, education, sports, crime, and even marriage — 'economics in unwonted places' is how one writer described it.[1] Economics is indeed more than a collection of techniques for investigating the workings of an economic system. It is a way of looking at the world, being a special case of a much more general 'logic of rational action'. For that reason, economists experience little difficulty in appraising activities which appear, at first glance, to have nothing to do with economic ends; their apparatus will not always be equally illuminating but in a surprising number of instances it yields immediate, dramatic insights. So it is, I believe, in the case of the arts.

The application of economics to the arts, however, teaches us almost as much about economics as about the arts. The tools and concepts which prove to be most fruitful are those which are acquired in any first-year course in economic principles: the response of demand to variations in prices and incomes; the role of prices in rationing scarce supplies; the notion of substitution at the margin in both production and consumption; the distinction between fixed and variable costs, and

between average and marginal costs; the idea of a preference function underlying all private and public decisions; the strengths and the weaknesses of 'Pareto optimality' as the definition of 'efficiency'; the problems created for applied welfare economics by such phenomena as externalities and public goods; and so on. The economics of the arts may, therefore, constitute something of a testing ground for the practical relevance of fundamental economic concepts: apparently abstract, such concepts may nevertheless be shown to have direct relevance to practical problems in such a field as the arts.

Be that as it may, the economics of the arts has, so far at any rate, involved the application of only the most elementary economic concepts. This book of readings should, therefore, be accessible, not only to intelligent laymen, but even to sixth formers and high school students in civics and economics and certainly to college freshmen and university undergraduates taking their first year of economics. It should also prove useful as ancillary reading in courses on arts administration, social policy and public finance.

The 16 articles that follow touch on almost all the outstanding problems of the performing and visual arts: opera, ballet, modern dance, orchestral concerts, theater, museums, and galleries, but unfortunately not television, radio and films, and not jazz or pop music. A great deal has been published in recent years on the economics of the mass media, particularly on such questions as alternative ways of paying for commercialized radio and television.[2] But not all of radio and television involves the 'arts', properly so-called. Much of it is 'entertainment', and as such lies outside our scope. The distinction between arts and entertainment may well be artificial and conventional but once we drop the distinction, there is little excuse for not also including sports, the mass entertainment of our day and age. And so to avoid covering the waterfront, I have deliberately excluded articles and books on radio and television. No such excuse can justify exclusion of films. I have simply failed to discover anything short that would exemplify economic analysis of the cinema. But there are excellent book-length studies of the film industry which will serve to demonstrate the power of the economist's approach.[3] Likewise, the decision to exclude jazz and pop music has nothing whatever to do with any specious distinction between fine and commercial art. It is simply that jazz and pop music have not so far attracted the attention of professional economists, which in the case of pop music, is no less surprising than it is deplorable.

We begin our collection of readings with a set of papers on the economic rationale for public subsidies to the arts. As we look at the arts around the world, we are struck by three facts: one is that the arts are everywhere subsidized, two is that the level of subsidies varies enormously between countries and between different types of artistic activities within countries, and three is that the ratio of private charity to public subsidy likewise varies enormously from country to country — at one extreme is the United States, where government gives little but private individuals and foundations give much, and at the other extreme is Britain, where government gives much but the private sector gives almost nothing (we ignore the socialist countries, where of course all subsidies are public). It is conceivable that neither the subsidies themselves nor their variations between countries can be explained on economic grounds: they may simply reflect custom and historical tradition. On the other hand, persistent patterns in public support for a particular set of human activities may be the result of certain economic characteristics of those activities, no less real for being dimly perceived rather than explicitly recognized. In any case, these are just the sort of phenomena which are grist to the economist's mill and few economists writing on the arts have been able to resist speculation on the economic case for subsidizing the arts.

Our first selection reproduces some relevant pages from Moore's full-length study of *The Economics of the American Theater*. Moore discusses seven 'reasons for subsidization': (1) the divergence between social and private benefits, that is, externalities; (2) national prestige; (3) attraction of business and tourism; (4) equity considerations; (5) price discrimination as a method of maximizing revenue, being relevant to private charity rather than public subsidy; (6) the infant industry argument; and (7) the need to stimulate artistic innovation. He goes on to discuss the question of who should subsidize, that is, central government, local government, or some buffer group like the British Arts Council, and concludes by asking whether the subsidy should take the form of tax exemptions rather than grant-in-aid.

Our second selection is an excerpt from Baumol and Bowen's book, *Performing Arts: The Economic Dilemma*, a pioneering analysis by two professional economists of the financial plight of the performing arts in America and Britain. Baumol and Bowen begin by considering the effects of government support for the arts on the level of private donations, contrasting the situation that obtains in the two countries. Having posed the question — why exempt the arts from the market

test? — they proceed to discuss the arguments for public intervention. They single out three arguments: (1) the issue of income distribution; (2) the education of minors, assuming that a taste for the arts is instilled by early experience; and (3) the fact that the arts partake of some of the characteristics of 'public goods'.

The concept of 'public goods' arises so frequently in many of the other readings that we do well to spend a moment establishing its meaning. The central difficulty in grasping the concept is its two-dimensional character. Public goods, unlike private goods, cannot be provided to one consumer without providing them to all consumers — think of national defense or a malaria eradication campaign. This is the so-called 'non-excludability' definition of public goods. Furthermore, public goods, unlike private goods, may be consumed by one individual without in any way reducing the amounts available to other consumers — think again of national defense, or even better, the dissemination of knowledge. This is the so-called 'non-rivalry' definition of public goods. When a good possesses both of these characteristics, we have a 'pure public good', and a moment's reflection will show that it is impossible to devise a set of prices which will express people's preferences for pure public goods: pure public goods can only be provided by a ballot box decision.

However, examples of pure public goods are hard to come by. At first glance, a public park would appear to qualify on grounds of non-excludability and non-rivalry. But the moment the park is congested by people, non-rivalry ceases to obtain and the scarce space can now be rationed to eager entrants by a toll charge. Contrariwise, seats in a half-empty theater are private goods on grounds of excludability but public goods on grounds of non-rivalry. Some goods, in other words, are neither pure private nor pure public goods: they are 'mixed commodities', in which case a perfectly competitive market mechanism may well fail to provide them in optimal amounts.

Baumol and Bowen argue that the performing arts are such a case of 'mixed commodities' and they strengthen the argument by considering the intergenerational benefits of maintaining a vital tradition of live performances. It is a curious paradox that the inclusion of inter-generational considerations converts every private good whose provision entails an accumulated heritage of knowledge and skills into a pure public good: such goods cannot be provided to consumers in the present without providing them to all consumers in the future, and consumption today in no way reduces consumption tomorrow. But the

question of future generations is a two-edged sword, as Peacock argues in our fourth selection: future generations will be richer than we are and better able to satisfy their needs for the performing arts, the more so if we today husband our resources and devote them to productive investments rather than to unproductive 'luxuries', such as the arts. Besides, the argument involves a disputable question of fact, namely, whether a lack of public support for the arts would sap the tradition of live performances beyond the capacity of any future generation to revive it.

The emphasis in Baumol and Bowen, as well as in Peacock, on schooling as a way of cultivating a taste for the arts illustrates another difficulty in the standard arguments of economists for public subsidies to the arts. Both positive and normative economic theory is predicated on the assumption that consumers' tastes are given and we have no theory of how tastes are formed even as they are satisfied. Confronted with such phenomena as education, advertising, and the arts, where consumption invariably means both getting what you like and learning what it is you like, the rigor of applied welfare economics, even when accepted on its own grounds, fails to get to the heart of the matter. There is certainly nothing in economic theory that tells us that a competitive market will bring about an optimal level of investment in the formation of tastes. The decision to encourage the formation of certain tastes and to discourage others must be a collective decision and if this is 'cultural paternalism', so be it. In a nutshell, although perhaps expressed too crudely, this is the argument of Scitovsky, the author of our third selection. The same argument crops up again in King and Blaug (Reading 6) and in Robbins (Reading 10).

Peacock's paper, which follows Scitovsky's, introduces us to 'Baumol's Disease', whose applicability to the performing arts is explained by Baumol and Bowen themselves in Reading 13. Baumol's Disease refers to the inevitable increases in costs of production occurring in certain labor-intensive service industries, in which technical progress is incapable of raising the productivity of labor for the simple reason that in these industries labor is both an input and an output. In the rest of the economy, wages are continually rising and these wage increases are not necessarily inflationary because they are accompanied by equally continuous increases in the productivity of labor. These non-inflationary wage increases spill over into such fields as the arts (and restaurants, hotels, barber shops, etcetera) in the form of rising prices for materials and ancillary services, as well as rising salaries for

artists. But these latter salary increases are wholly cost inflationary because they are not offset by productivity gains within the arts. The net result of these forces is either price inflation in the arts, or, if prices are held down by custom and tradition, cost inflation or a growing gap between receipts and expenditures in arts organizations.

Some of the gloom of this 'dismal' analysis is offset, as Peacock points out, by substitution on the part of consumers of hi-fi equipment, television, and video cassettes for live performances: substitution in consumption thus makes up for lack of substitution in production. Furthermore, if the income elasticity of demand for the arts is positive, the effects of the rising relative costs of the arts over time on the receipts of arts organizations will be offset by the tendency of people to spend more on the arts as their own incomes rise. After all, if Baumol's Disease applied to the arts without qualifications, it would be difficult to explain how unsubsidized and commercially viable theaters and orchestras have survived so long in so many countries. Nevertheless, even Peacock accepts the fact that the performing arts suffer from Baumol's Disease, requiring sources of finance other than box office sales if they are to continue to survive in the modern world.

Peacock concludes his analysis by examining a wholly new principle of subsidizing the arts: instead of assisting arts organizations by grants or tax relief, the State would assist individuals by furnishing them with arts vouchers, cashable for seats at appropriate times and places. Something similar to this already exists in certain socialist countries in Eastern Europe, where students, pensioners, and trade union members are provided with free or discounted tickets. Peacock, as well as Blaug (Reading 8), discusses some of the problems that would be raised by a system of arts vouchers. Whether these problems are resolvable in present circumstances is a matter of controversy but I can think of few better examples of the ingenuity of economists in conceiving of new remedies to old ills than the idea of vouchers for the arts.

All the arguments so far have been confined to the general case for public subsidies to the arts. Assuming, for the sake of argument, that the case is made, the question remains: how much public subsidy and in what amounts to which types of artistic institutions? This brings us to a group of readings attempting to grapple with questions of criteria for allocating public expenditures on the arts.

We begin with a paper by Peacock and Godfrey on 'Cultural Accounting' in Britain. Cultural accounting is an example of flow-of-funds analysis, confined in this case to the flow of funds made

available to the arts from both private and public sources, and to the uses made of these funds by different types of artistic organizations. So diverse and complex is the flow of funds to the arts in any modern economy that evaluation of public expenditure on the arts is hardly possible without a preliminary attempt to draw up a set of cultural accounts. As expected, Peacock and Godfrey produce several startling conclusions, not only about the distribution of public expenditure between the performing arts on the one hand and the visual arts on the other, but between different types of performing arts, such as opera and ballet versus orchestras and theaters. Work of this kind is now going on in several European countries, under the auspices of the Council of Europe, and we may confidently expect that in years to come, cultural acounting will become as familiar an idea to students of economics as national income accounting and flow-of-funds analysis.

The next selection by King and Blaug examines the objectives of the British Arts Council as revealed by Arts Council publications on the grounds that the achievements of a public authority can only be fairly assessed in terms of its own stated aims. It is interesting to compare the Council's case for subsidies to the arts with the views of economists delineated earlier. It is also interesting to discover that the Council does have a definite set of objectives but that most of these are too vaguely specified to permit evaluation of effective achievement.

As we know, economists frequently rush in where angels fear to tread. King and Blaug were widely criticized for their attack on the Arts Council, an organization that is understandably loved by many and hated by some. To convey something of the flavor of the debate, I have included a riposte to King and Blaug by Findlater, together with a reply by King and Blaug. A further selection by Blaug continues the debate, somewhat more constructively than before. American readers who pine for an American counterpart to the British Arts Council need to be reminded that buffer committees for distributing funds to the arts are no less subject to a continuous intellectual cross-fire than a Ministry or Department of the Arts.

Just as the attempt to evaluate public expenditure on the arts requires cultural accounting, so it requires periodic surveying of audiences. We have heard repeatedly of the equity argument for public subsidies to the arts as if it were an established fact that the beneficiaries of subsidized seats are largely those too poor to pay cost-covering prices. I have included another selection from Baumol and Bowen's book to illustrate both the methodology of audience surveys and the kind of

results that such surveys typically produce.[4] What Baumol and Bowen demonstrate for both America and Britain is that audiences for opera, ballet, orchestral concerts, chamber music, and drama comprise an extremely small proportion of the adult population. Moreover, these audiences are largely young, well-to-do, exceedingly well educated, and engaged in professional occupations. Lastly, and more surprisingly, they are very similar in background and personal characteristics from art form to art form. In other words, the arts appeal to a small and remarkably homogeneous group of people who are both affluent and highly educated. This puts a new gloss on some of the arguments for public subventions to the arts and raises profound questions about the avowed objectives that are said to underlie public support for the arts.

We turn now to a group of six readings which treat particular problems in the economics of the arts. The first two by Robbins and Peacock and Godfrey discuss Britain's short-lived experiment with entrance fees for museums and galleries (introduced by the Conservative government in January, 1974 and abolished by the Labour government in March, 1974). Robbins lines up against museum and gallery charges on the grounds that it is senseless to price facilities that are underutilized even when they are free. But Peacock and Godfrey are sympathetic to the general idea of entrance charges to museums and galleries, although it is worth noting that the particular system of charges which they recommend in the closing pages of their paper is not the one that was actually adopted by the British government (for example, museums and galleries were not allowed to retain any portion of the revenue taken in).

The latter part of Robbins' paper takes up the British policy of export licensing for works of art certified to be of 'national importance' and moves on to discuss the incentive effects of death duties on private donors to national collections of paintings and drawings. The latter is an issue that also arises in Peacock and Godfrey's analysis, leading naturally to the question of whether such national collections should be preserved intact for all future generations, or whether they should be periodically adjusted to cater to present tastes. This question came to be furiously debated in America in 1972 when the Metropolitan Museum disposed of its several Van Goghs and Henri Rousseaus in order to acquire its first Annibale Carracci. Montias' paper, Reading 12, provides a fascinating discussion of the issues, culminating in the suggestion of an art auction scheme to value donated works of art for purposes of income tax exemption.

This brings us to Baumol and Bowen's exposition of Baumol's Disease in the performing arts, of which enough has already been said. There follow two essays which are somewhat more technical than any that have gone before. In Reading 14, Moore measures both the income and price elasticity of demand for Broadway theater tickets, and shows, surprisingly enough, that the demand is fairly price-inelastic and that even the income-elasticity is much less than unity. His paper illustrates, not only the complexity of such estimates for an industry like commercial theater, but also the potentialities of audience surveys as a source of the requisite data.

Reading 15, a paper by Santos published here for the first time, calculates the private rate of return to training in the performing arts, considered as a personal investment by dancers and singers. The author shows that it is negative on average, at least in the United States, and subject to extremely high variance. The willingness of individuals to take up the performing arts as a career, therefore, must be due either to the phenomenon of psychic income or to the presence of an atypical preference for risk. For those who never have believed that people take up occupations for purely financial reasons, here is the first well-attested case in point.

The volume closes with an instructive piece by Weiss on the lower costs of orchestral concerts in America as compared to Britain, owing to the tendency of American orchestras to spread the fixed costs of rehearsals over several live performances. In pointing to this and other potential cost savings in the field of orchestral music, Weiss contributes yet another qualification to Baumol's Disease in the performing arts.[5]

The internal coherence and systematic development of the economics of the arts as a subject in its own right should be apparent even from this slender collection of readings. But the problems awaiting the attention of future economists of the arts are nevertheless legion: the optimal structure of seat prices in a theater for purposes of maximizing box office receipts; the trade-off in opera houses to cheap opera in the native language as compared with expensive opera in the original language;[6] the wage elasticity of supply of actors, dancers, singers and musicians; the enforcement of copyright in music as related to the income elasticity of supply of composers;[7] the performance elasticity of demand for orchestral concerts, that is, the response of the public, not to variations in seat prices, but to the items to be performed in a particular concert; the failure of arts ticket prices around the world to rise as fast as retail prices, despite Baumol's Disease; the response of

private benefactors to reforms of the tax system; the spillover effects of artistic activities on transport facilities, restaurants, hotels, etcetera, and indeed the uncovenanted gains to all 'third parties'; the foreign exchange costs and the foreign exchange earnings of the arts; the impact of private music teaching on the creation of an audience for the arts and, in particular, the impact of music education in the schools on the next generation of adult audiences; the calibration of the achievements of governments in pursuing certain avowed policies in the arts; and so on; and so on. We have only begun to scratch the surface of what may one day prove to be one of the most rewarding branches of applied economics.

1. B. R. Williams, 'Economics in Unwonted Places', *Economic Journal*, March 1965.
2. See e.g. P. Wiles, 'Pilkington and the Theory of Value', *Economic Journal*, June, 1964; and R. H. Coase, 'The Economics of Broadcasting and Advertising — The Economics of Broadcasting and Government Policy', *American Economic Review*, May, 1966; and, *Educational TV: Who Should Pay?* Washington: American Enterprise Institute, 1968; and S. Caine, *Paying for TV?* London: Institute of Economic Affairs, 1968.
3. See e.g. J. Sproas, *The Decline of the Cinema. An Economist's Report.* London: Allen & Unwin, 1962, which attacked the myth that television is destroying the cinema and correctly predicted current developments in films and cinema housing; also T. C. Kelly, G. Norton and G. Perry, *A Competitive Cinema.* London: Institute of Economic Affairs, 1966.
4. See also a more recent survey in Canada: S. Globerman, S. H. Book, *The Audience to the Performing Arts.* Toronto: Ontario Arts Council, 1975.
5. See also the evidence of significant economies of scale in certain Canadian performing arts groups: S. Globerman, S. H. Book, 'Statistical Cost Functions for Performing Arts Organizations', *Southern Economic Journal*, April, 1974. *einer Theorie der sozialpolitik*, eds. B. Külp, W. Stützel. Dunker & Humblot, 1973; and A. T. Peacock and R. Weier, *The Composer in the Market Place.* London: Faber Music, 1975.
6. But see M. Blaug, *Why Are Covent Garden Seat Prices So High?* London: The Royal Opera House, Covent Garden, 1976.
7. But see A. T. Peacock, 'The Economic Value of Composition', *Beiträge zu*

A. The Rationale for Public Subsidies to the Arts

1. Reasons for Subsidizing American Theater

by T. MOORE

reprinted from The Economics of the American Theater *Duke University Press (1968) pp. 116–30*

In our economy, under a free market system, we normally assume that the best allocation of resources is determined by the free market. The price of goods and services reflects the cost to society of these services, and the consumer purchases them on the basis of what they are worth to him.

Every dollar spent on the arts represents a dollar of resources which has been transferred from some other use. Normally, therefore, we would believe that a dollar's worth of arts should be equal in subjective value to a dollar's worth of other goods and services. If we lower the price of theater tickets or opera tickets through a subsidy, consumers will normally buy more. The value to a consumer of the marginal purchase of tickets will be equal to the price of the tickets, which in fact is lower than the cost of producing that additional service. Hence, one would normally argue that it would be a waste of resources to subsidize the arts or any other such field.

Social Benefits Exceed Private Benefits

Thus, to maximize economic welfare, the price of any good or service should be equal to the marginal social cost of supplying the good or service. However, economic welfare is only a part of total welfare. As A. C. Pigou noted,

> On the one hand, a man who is attuned to the beautiful in nature or in art, whose character is simple and sincere, whose passions are controlled and sympathies developed, is in himself an important element in the ethical value of the world; the way in

25

which he feels and thinks actually constitutes a part of welfare. On the other hand, a man who can perform complicated industrial operations, sift difficult evidence, or advance some branch of practical activity, is an instrument well fitted to produce things whose use yields welfare. The welfare to which the former of these men contributes directly is non-economic; that to which the latter contributes indirectly is economic. The fact we have to face is that, in some measure, it is open to the community to choose between these two sorts of men, and that by concentrating its efforts upon the economic welfare embodied in the second, it may unconsciously sacrifice the non-economic welfare embodied in the first.[1]

Two points are involved in Pigou's statement. One is that there may be social benefits or social costs, which in theory are subject to monetary measurement but which are not equal to the private benefits or private costs. That this leads to a misallocation of resources has long been recognized by economists. Pigou, however, is saying something else. He is suggesting that a certain type of society or of man or of consumption may be *ethically* better than another. Pigou brings this out clearly when he writes,

Of different acts of consumption that yield equal satisfaction, one may exercise a debasing, and another an elevating influence. The reflex effect upon the quality of people produced by public museums, or even by municipal baths, is very different from the reflex effect of equal satisfactions in a public bar. The coarsening and brutalizing influence of bad housing accommodations is an incident not less important than the direct dissatisfaction involved in it.[2]

Essentially he is claiming that there is a hierarchy of values; some things are better in some non-economic sense than others. To the extent that people agree that values can be ranked and to the extent that they agree on the ranking, citizens may desire to subsidize and promote those values which generally have been agreed upon as the most desirable.

A closely parallel argument rests on the proposition that the social benefits from the arts are greater than the private benefits. Attending an opera, the theater, or going to a museum, it is alleged, leads a consumer to be a better citizen. This rationale appears to be based on the proposition that the arts are educational, that they improve the quality of citizenship, that they make the citizen more thoughtful, and that they teach him about the world. It is undoubtedly true that there

is something to this position – that attending a good play or a good opera may in fact improve the quality of citizens. For example, the arts undoubtedly improve conversation. By attending a play or an opera, going to a concert, or visiting an art gallery, an individual learns more, becomes exposed to more ideas, and as a result can talk more fluently about more subjects. To the extent that other individuals' pleasure is increased because there are more people they can converse with, the arts benefit people other than those who pay for tickets.

While it is true that some theater is educational, it is less obvious that the best way to achieve these benefits is to establish resident companies in major cities. Such companies will benefit only a minority of the population, a group which by most standards least needs its education and recreation subsidized. A more practical approach would be to finance a traveling company to tour the public schools. Such a company could tour all the high schools in a state, thus bringing live drama to those who most need it.

Prestige

Another reason advanced for aiding cultural activity is that it raises the prestige of an area. Again, social benefits are greater than private benefits. The more arts, the more vigorous the arts, the better developed the arts, the more prestige any one country has with the citizens of other countries. This has been generally recognized, both in the United States and elsewhere. France, by subsidizing any company that wants to present French plays or music outside the boundaries of the country, admits its force. The American Department of State, when it subsidizes the export of American cultural attractions, is acknowledging its effect. Russia also subsidizes the export of some of its cultural attractions. At heart, this argument is based on national defense: subsidizing the arts is an attempt to attract the minds and allegiance of people beyond the borders of a country by exhibiting a vigorous cultural life.

Attraction of Business and Tourism

In any city, a thriving cultural life may be a great attraction. On balance, it may make the difference in determining whether some

company establishes a new plant or research office in that city. It can lead to the attraction of better men for universities located in the area. It is clear that a thriving cultural life makes it easier for colleges and universities to attract faculty members and graduate students. It therefore becomes very much in the interest of large companies and institutions of higher learning to support the arts in their communities. Furthermore, it is in the interest of the whole city to aid the arts, at least in some small way. A few thousand dollars a year spent to maintain a fine symphony orchestra may lead to the influx of thousands of dollars in business. The same argument, of course, can be applied to the maintenance of a major league baseball or football team. In fact, many cities have subsidized major league sports by building stadiums and renting them to the team at low rates. The justification of this procedure is normally that it will attract more business to the city.

Certainly part of the attraction of New York City is its thriving theater district, its great museums, its opera houses, its ballets, and its symphony orchestra. Many tourists come to New York City just for the theater. Some businesses locate there because it is an area with a large supply of highly trained labor, labor which has migrated to New York at least in part because of its cultural advantages.

Income Redistribution

Another argument takes two forms: first, since the arts are too expensive for the poor to afford, admission prices should be lowered through government aid; second, since the performers in the arts are inadequately paid, we should subsidize the performers. If it is the patrons who are to be subsidized, then it would appear that, rather than cut the price of all theater, opera, and concert tickets, it would be preferable to issue discount tickets to those in reduced circumstances, such as students and the poor. In fact, we do find such discounts being offered. In many cities, provision is made for free concerts for children, and in New York, cut-rate tickets are sold, in effect, to students and employees of large institutions to attend the Broadway theater. The justification for subsidizing the performers appears somewhat tenuous, to say the least. It is on a par with subsidizing farmers and merchant seamen. If it is rational to subsidize performers because they are poor, then by implication it must be more rational to subsidize all people who are poor, regardless of their occupations.

The 'income redistribution' argument for subsidy to the arts, then, indicates a policy of selected aid, with the government supplying the difference between the list price and a low price for the poor. It does not justify a blanket outlay for the performance of art works. Subsidies for opera and for the theater can be intended to stimulate the creation of new operas and new plays. In fact, in Canada and France, as we have seen, such subsidies are given directly to playwrights and composers. The National Endowment for the Arts allocated $150,000 in its first year to commission new works and to defray the cost of copying scores and parts. If the intent is to encourage the writing of new plays, operas, or musical compositions, such direct aid is more efficacious than subsidizing the performance of established works.

Income Distribution

Another criticism of the market mechanism is based on income distribution. The market reflects the desires of individuals as weighted by their purchases. Since their purchases depend on their income, the rich have more to say about the allocation of resources than the poor. This, of course, is true and applies to all products, not only the arts. However, it is probably true that if the allocation were determined by equally weighting all individuals, less rather than more art would be produced, since people with low educational attainments usually do not appreciate or desire the arts and since these people are normally also the ones with small incomes. Hence, the current allocation of resources, as determined by the current income distribution, leads to more art than would exist with a more equal distribution of income.

Price Discrimination

There is a further rationale for aiding the performing arts. It is clear that if the public is willing to pay the cost for opera, ballet, or any other art form (or for that matter any product or service), the value of the art form must be greater than what the public is forgoing, so that consumers will be better off with the opera than without. For some consumers the value of the opera is very great and they might be willing

to pay $100 to see a performance; for others the value is lower and they would be willing to pay no more than $5. If the opera house charges a single price it might not be able to pay for the cost of the opera. At $100 only a few buy tickets; at $5 the house is sold out, but $95 in potential revenue is lost from the would-be $100 buyers. If the management could charge $100 to the real lover of opera and $5 to the less enthusiastic devotee, it could collect more revenue per performance and, by assumption, pay the cost of the opera. However, if it must charge the same price per seat to all patrons irrespective of the intensity of their love for opera, costs will not be covered. This may easily be the situation of many of our opera houses today. A more desirable allocation of resources — that is, a longer season — could be achieved if all the intensely interested people could be made to pay higher prices.

In other words, the opera house must practice price discrimination; it must charge those with an intense liking for opera more for a seat than those who are less enthusiastic. To discriminate successfully is not easy. In order to do so, one must be able to differentiate the market and keep the people with strong demand for opera from purchasing tickets at the lower price which is being charged others.

Consider the Metropolitan Opera in New York, which practices price discrimination. Those who purchase season tickets are asked to contribute to the opera. In fact, in some cases the Metropolitan Opera Society 'suggests' how much should be contributed for each price range of tickets. Thus, those who have season tickets pay a considerably higher price per seat than those who buy individual tickets. But part of the cost of the price discrimination is borne by the non-theatergoing taxpayers, since such contributions are tax-deductible.

Purchasers of season tickets cannot, though, be made to contribute. Pressure can be applied by withholding better seats for successive seasons, but this is the only pressure available to the Opera Society. In principle, if the benefit from a longer opera season that goes to each individual were taxed and given to the opera company to extend the season, society would be better off. This is not practical. But, on the basis of the compensation principle,[3] a subsidy from general tax revenue might be justified.

It should be borne in mind, though, that since gifts to non-profit organizations such as opera are tax deductible, more funds are forthcoming than would be in a completely free market with no government. Hence, even though some individuals do not give, in the aggregate enough resources may be devoted.

Infant Industry

It has been claimed that with more information and more exposure to the arts, people would participate in them more frequently, and that what is needed is to bring the arts to the people to develop the demand. For the theater this argument is weak. At one time the legitimate stage was widespread; since then it has been replaced by other forms of amusement. The Federal Theatre Project, while bringing drama to millions, had no measurable long-run effect on playgoing.[4] Many people have experience with the theater at some point in life, and yet they reject it. The only new art forms are motion pictures and television, and neither is an infant industry. Like the argument for tariffs, the argument for stimulating an infant industry appears at best to be a temporary expedient. Thus, it would seem that the infant industry argument does not have a great deal of validity, either empirically or theoretically.

Innovation and the Arts

By one definition, great art must be innovative. New ways of saying old things must be developed, or new ideas must be expressed in new ways. A new painting resembling technically the style of Rembrandt is worth little and would usually not be considered great art. A well-composed play that dealt with a hackneyed theme and treated it in a commonplace fashion would be unlikely to win for its author the Nobel Prize for Literature. To survive the test of time, to win the plaudits of the public, and to add luster to contemporary art, a work must be novel.

The importance of new processes and products is not confined to the world of art. If an electronics manufacturer or a drug company tries to survive merely by imitating what others have developed, it is unlikely to be successful. But one important difference exists: in manufacturing, if a new product is developed or a new process invented, it can be patented and the developer can reap the benefits.[5] In the world of arts no such protection exists. When the Theatre Guild launched *Oklahoma!*, a musical which integrated story, song, and dance, there was no way to prevent imitation. And in fact all successful musicals since have been built on the innovations of *Oklahoma!*

Thus the returns from new approaches in art may be great but do not accrue entirely to the innovator. In technical economic terms, the social gains exceed the private gains. Whenever the entrepreneur cannot capture the entire benefit from his action, he will devote few resources to it. As a consequence entrepreneurs will do less innovating than is desirable, since there will be some experimentation in which the gain to society is greater than its cost but the gain to the producer is less than its cost. In such a situation a subsidy would produce a more efficient use of resources.

Summary of Reasons for Subsidization

The most common arguments for subsidization are based on educational advantages: social benefits exceed private benefits. The benefits are hard to measure and depend largely on subjective views of welfare — a more cultivated society benefits all members. A second argument is based on the proposition that there is an economic benefit to be derived from more art; for example, additional business will be attracted to the area. The income redistribution contentions do not stand up under careful consideration, but the price discrimination argument, while rather technical and of dubious practical significance, has theoretical justification. The final argument deals with the benefits from innovation. Since great art, by some people's definition, must be innovative art and since the benefits (from innovating) to society exceed those to the innovator, subsidies are called for.

Who Should Subsidize?

In the section above we have considered the reasons for aiding art forms. We have ignored in general the question of who should do the aiding, whether it should be done by the city government, the state government, or the federal government. Who should do it depends in part on why it is being done. In general, the arguments about attracting more business to a community would seem to lead to the city government's being the source of revenue, since a federal government

subsidy for all cities would defeat the objective of attracting more business to any one of them.

In general, subsidization by the local government may be preferred, since the city is interested in making the area a better place to live. At the city level there is more local control.[6] Each area provides the amount of culture its citizens desire. In the United States, as we have seen, it is the city governments which have been the primary sources of government aid.

The best argument for state help would seem to be that states have better tax sources and, consequently, can more easily allocate funds to the arts. People who live outside the city limits benefit from the arts; yet, if the city government does the subsidizing, they do not bear the cost. City councils, being generally interested only in the benefits received by city voters, will ignore the improvement in the well-being of suburbanites when appropriating funds for the arts. Hence, they will tend to under-invest in culture. The same argument applies, but to a weaker extent, to state subsidies: individuals residing outside the state may benefit without paying any of the taxes used to support the arts. However, since almost all beneficiaries are state residents, the problem is probably negligible at the state level.

The same reasoning applicable to state governments would apply to the federal government. The federal government has the largest tax resources. People cannot avoid federal taxes easily by moving out of the area. In addition, a federal subsidy for the arts would allow an orchestra to travel widely, not just through one state but throughout the country. Because everybody would be paying, such art groups would be expected to travel widely, even to some of the sparsely populated areas of the United States.[7] Much of the recent controversy over subsidizing the arts has been concerned with obtaining federal funds. State and local tax revenues are allegedly being strained already. Consequently, it is felt that the federal government, with its greater tax resources, can more easily aid the arts.

The prime argument against the federal government as a source for subsidies is based on an objection to federal control. The arts would undoubtedly be hampered by more control. It seems likely that the federal government would want a voice in determining the allocation of its resources. For example, during the thirties, under the auspices of the Works Progress Administration, the federal government undertook to sponsor various arts. Even though Harry Hopkins, head of the WPA, believed in a 'free, uncensored, adult theatre,'[8] the problem of political

control grew with the project. Practically at the very start in 1936, Elmer Rice resigned because of an administration ruling that no ruler or cabinet officer of any foreign nation could be portrayed on a Federal Theatre stage. One production, *The Cradle Will Rock*, was prevented from opening by federal government authorities. In Chicago, the play *Model Tenement*, which dealt with a rent strike, was banned, reportedly on order of the mayor.[9] The state WPA leaders in Illinois also prevented the local opening of *Hymn to the Rising Sun* because it 'was of such a moral character that I can't even discuss it with a member of the press.'[10] (The play later opened in New York where the critics praised it.) In Massachusetts there was opposition to the production of *Valley Forge* by Maxwell Anderson; and in Connecticut, citizens of New Britain protested that Shakespeare's *Merchant of Venice* was anti-Semitic.

The WPA officials in California canceled *Judgment Day* by Elmer Rice. David Niles, who was head of the WPA information service, said that the cancellation of *Judgment Day* was not censorship, which as a known liberal he opposed, but merely 'selection.'[11] But, of course, 'selection' is the nub of the problem; someone has to do the selecting. A subsidized theater is left with the choice of a safe program which no one will criticize or a program that may win critical acclaim but will also produce opposition. As Hallie Flanagan puts it, 'If you are playing safe you depend upon old plays which have had safe receptions or you imitate the formulas as closely as you dare. Every time you open a new play, or an old play in a new way, you run the risk of failure — and at the same time, the only chance of a creative success.'[12] Inasmuch as almost no one desires to subsidize a theater of pap, the issue becomes a matter of deciding 'whether it [the body subsidizing] wants plays chosen by non-political people, in which case some will probably be politically unwise; or by political people, in which case either caution or party politics will rule.'[13]

The Federal Theatre Project attempted valiantly to steer clear of partisan politics and yet put on stimulating drama concerned with current problems. Such an attempt was, as would be any such effort, doomed to failure. In the case of this project, the program itself was supported and owed its very existence to one party, for the Republicans opposed subsidized drama. No matter how good the intentions of the administrators, they were more likely to reflect the opinions of the New Deal than of Herbert Hoover. The very people attracted to the project would, of course, favor the programs of the

administration, and what to them was an unbiased presentation of the facts would appear to the opposition as wilful omission or misrepresentation of the vital arguments against Roosevelt's programs. For example, the Living Newspaper productions, such as *Power* (an inquiry into the use of power), *One-Third of a Nation* (a history of slum housing), and *Triple-A Plowed Under* (the farming problem in America) dealt with governmental solutions to social issues that the Republicans felt were better left in the hands of private enterprise. Undoubtedly, had conservatives been running the program, the Living Newspaper productions would have been concerned with the growth of government in Washington and the 'destruction' of free enterprise.

While there is general agreement that there was considerable governmental pressure involved in the Federal Theatre Project, it is argued that a national arts foundation could avoid the problem of governmental control. The Rockefeller Panel Report on the performing arts, after admitting 'the problem of protecting artistic freedom,'[14] suggests that the European experience and the National Science Foundation show that the arts can be aided without impairing artistic freedom. While the National Science Foundation certainly does not censor research, it is all too apparent from public complaints that the direction of research is being influenced. Those fields and those types of projects that are believed by NSF to be productive are favored. Hence, the direction of research is diverted from what it might have been. This is inescapable when large funds must be allocated among competing ends.

Frederick Dorian, in his book *Commitment to Culture*, attempts to document the freedom from control of the arts under subsidy in Europe. Yet he writes that 'censorship in Austria applies to the entire scope of the performing arts,'[15] and 'in the patterns of art support [in Italy] there is a constant give and take. . . . The overall result has in recent years inclined to the liberal side.'[16] 'In the fall of 1960 this play [*Arialda* by Giovanni Testori] was removed from a Milan theater because it "offended the public morale".'[17] Also in 1960, the Archbishop of Naples objected to and succeeded in halting the performance (in opera form) of *Le Martyre de St. Sébastien* by Debussy at a state-supported opera.[18] In France, 'art patronage has been an exponent of the power in charge.'[19] 'The Fifth Republic has, if anything, reinforced the role of government art support and, there can be no mistake about it, imposed a more rigid supervision of the national art institutes.'[20]

The British Arts Council seems, however, to have escaped the problems of most of its Continental neighbors, since there have been few complaints about governmental control. Yet it should be noted that the stage is censored in England by the Lord Chamberlain, and in 1962 'a Parliamentary committee decided that while ideas on the printed page provided "little mischief," the same ideas on the stage were a "stimulation" to vice.'[21]

The relative rareness of examples of censorship in Europe are not proof of the freedom of the arts. Examples of censorship in Russia are even rarer. Few would argue, however, that the arts are free behind the Iron Curtain. Artists know what will be supported and what will not and tend to produce that which is approved. In Europe writers and performers know what will be aided and what will be censored, and in Great Britain few scriptwriters satirize the Queen since they know it will not be permitted.

After reading Dorian's book, this author was struck by the relative freedom of the arts in the United States. Censorship is rarer and tends to happen at the local level. What is banned in Boston may flourish in Connecticut. No monolithic organization directs the arts into approved channels. The very diversity of sources of revenue for the arts guarantees that variety will exist. If an artist cannot receive support for his work from one source, countless others exist, and if his work has any merit he is almost sure to find a patron or an audience.

The new federal program does not seem to present much danger to the arts yet. The small size of the appropriations means that the National Endowment for the Arts cannot affect the direction of the arts. Only if the funds grow to such a size that they begin to dominate a substantial portion of the activity would there be much danger. Moreover, part of the funds must be turned over to the states for administration, a limitation which reduces the power of the federal government to channel the arts.

Two avenues are available to aid the arts without central control. The government can grant tax concessions to theater projects without regard for their content — in which case no politician or government official can be involved in the selection of plays — or the subsidy programs can be administered by the states.

The route that would lead to the most vigorous and enterprising theater would be the route of tax exemption. If the federal government eliminated all taxes — admission and income — on playhouses and legitimate stage productions and if states and cities eliminated all real

estate and admission taxes, the free drama would be greatly stimulated without the problem of 'selection.'[22] Any state or federal program of cash aid to the theater would tend to degenerate into support for companies which concentrated on the classics — the safe ones — and light comedies and musicals.

If the states or cities did the subsidizing, the problem of political control would be less. Since party control is divided among the states, there would be more diversity in the type of programs presented. Yet even state-administered programs would be likely to lapse into dullness since the subsidies would probably be controlled by civil service personnel anxious to maintain their jobs in spite of changes in administration. Therefore, they would opt for the safe but mundane and revive already-established pieces.

The arguments presented above for subsidizing the stage do not give an unambiguous answer to the question of how much aid there should be. The answer clearly depends on how much theater is desired. Nationwide, however, an increase in funds devoted to drama may lead to no increase in the production of good plays if all the available talents are already involved in the theater. Certainly any large federal program would encounter this problem. True, playwrights could be lured from motion pictures, directors from television, and actors from both. But such a shift would be to the detriment of films and broadcasting. In the long run more skilled people might be drawn into the performing arts, but as was suggested in Chapter II, it appears that the talents necessary to write a good play are scarce, and it might take huge sums to increase the number of good playwrights even modestly.

On the other hand, as Chapter II also showed, plays of limited appeal have been squeezed out of the commercial market. A national program of aid to the theater would probably result in a larger market for such works and hence entice some writers back to the stage from other media. An increase in the number of plays of limited appeal could only benefit the stage in the long run. While few might be masterpieces, more experimentation would be encouraged and this might lead to new approaches in drama. Even if these innovations benefited the entire theater, the producer or author who experimented might reap few of the gains. As was argued above, there may be too little investment in this area, and a national subsidy might stimulate the theater and have total benefits greater than total costs. Yet a policy of cash grants could have the wrong effect; rather than stimulating innovation, it might discourage it. Groups producing safe and non-controversial theater

would in all likelihood get the funds and be better able to compete with the innovators. Tax exemption, however, would benefit the theater as a whole and would lead to more innovation.

How Much Aid?

To achieve the desired results both of freedom for the theater and more theatrical activity, tax relief appears to be the appropriate means. The removal of the admission tax is a step in the right direction, for there are good reasons why drama ought to be helped and no reasons why it should be harmed. The excise tax on tickets seems both inexplicable and undesirable, and its repeal at the federal level is to be commended. Yet many states and municipalities still tax tickets. The abolition of the federal tax on tickets, as Chapter VI showed, will probably expand theatrical activity on Broadway by approximately 10 per cent. The effect outside New York cannot be predicted from the data at hand, but the removal of the tax will certainly lead to more summer stock, more touring, and maybe more resident companies.

The federal government could go further; federal income taxes on the profits of theatrical enterprises could be removed. While this action would have no effect on non-profit repertory companies, it would stimulate summer stock, touring companies, and Broadway productions. Non-profit organizations, such as repertory companies, opera houses, and ballet groups, would be unaffected by such tax exemption. But an income tax exemption for earnings from the performing arts would invigorate all branches of the arts.

A city or state wishing to stimulate drama could waive real estate taxes and remove any taxes on admission, but these items would have only a small effect. Cash grants are required if it is desired to give more substantial help to the performing arts. The amount of aid would depend on the size of the city and the amount of theater, opera, and ballet the community wanted. Let us imagine, for example, a city of moderate size with no professional repertory company, which wishes to establish one that will operate from thirty to thirty-six weeks a year in a five-hundred-seat house. Such a theater could be supported at the box office if the population over fourteen years old in the area were greater than 750,000.[23] If the area has less than that, the city could expect the box office to contribute toward costs the ratio of the total population

in the area (over fourteen) to 750,000. That is, a metropolitan area with a population of 500,000 (over fourteen) could expect two-thirds (500,000/750,000) of total costs to be covered by the box office. Hence, if a resident company in a five-hundred-seat theater with total costs of $300,000 per year is to exist, a subsidy of $100,000 a year must be forthcoming.

Unfortunately, even if a city is willing to spend the money, it may still be unable to establish a viable repertory company. As noted in the previous chapter, the presence and success of a resident theater has usually depended on the efforts of one or more dedicated and talented individuals. A city may be anxious to establish such a theater, yet have difficulty in attracting the talent. Assuming that a talented director can be found, the desirability of a subsidy will depend on the value of the stage to the community. The city should ask: 'Will the theater attract enough new business to the area to compensate for the subsidy, or would business prefer the cash?' If businessmen would prefer lower taxes to a subsidized theater (i.e., new business will not compensate for higher taxes), then is the value to the community in terms of an improved cultural climate great enough to make it worthwhile? It should be borne in mind that the chief beneficiaries of the theater (besides those who work there) will be the better-educated, wealthier portion of the population.

To Subsidize or Not to Subsidize?

A partial list of areas subsidized by the federal government would include agriculture, education, research, mining, shipbuilding, the merchant marine, aviation, and motor transportation. Most economists will agree that certain of these subsidies are unjustified and distort the allocation of resources in our society. In other cases, such as education and research, advocates point to the social benefits from these activities and claim that if unsubsidized the market would produce too little research and too little investment in education. The argument for subsidizing the theater is akin to the one for subsidizing education; if higher education should be subsidized, then by the same token the performing arts (which are educational) should be aided. Note, however, that aid to higher education and aid to the arts are subsidies

which benefit chiefly the well-to-do. Thus they can be considered to be regressive in their effect on income.

Unfortunately, there has been little rational discussion of the issue. Most arguments for aiding the performing arts have amounted to asserting either that the arts cannot survive without help — which is clearly untrue for the theater — or that 'I like the arts, I think there should be more of them, and therefore everyone should be taxed to help them.' On economic grounds, neither of these arguments justifies governmental aid.

The chief argument against subsidy is that such aid distorts the allocation of resources. With aid, box office earnings will not cover total costs, and the value consumers put on the company will be less than the total cost to society of having it. It follows therefore that the total welfare of society will be less than if there had been no subsidy. In addition, an unsubsidized theater will be freer than a subsidized one.

In the end, whether one believes in subsidies for the theater or not depends on one's taste for the theater and one's beliefs concerning the external social benefits of having a large and active theater. In any case, the best method of furnishing such aid for the sake of a free, unfettered theater would be tax exemption.

1. A. C. Pigou, *The Economics of Welfare* (4th ed.; London: Macmillan, 1938), pp. 12–13.
2. *Ibid.*, p. 17.
3. The compensation principle states that if in theory, the people who benefit could be taxed to compensate those that lose and still be better off, then the change should take place.
4. The companies organized under the Federal Theatre Project disappeared without a trace as soon as federal funds were withdrawn. In 1940 and 1941, after the project was abandoned, there were fewer resident companies in existence than in 1935 when it started.
5. In some areas, e.g., basic research, developments are not patentable; hence the same problem arises.
6. There also may be more corruption and fewer able administrators. Hence, many might prefer that most functions be handled by the national government. The problem here is outside the scope of this book and deals with the whole issue of a federal system.
7. The Arts Council of Great Britain has practically abandoned any effort to bring the arts to the people in sparsely populated areas. See W. E. Williams, 'The Arts and Public Patronage'.
8. Hallie Flanagan, *Arena* (New York: Duell, Sloan and Pearce, 1940), p. 67.
9. *Ibid.*, pp. 135–136. The mayor later denied all knowledge of the production.

10. *Ibid.*, p. 136.
11. *Ibid.*, p. 287.
12. *Ibid.*, p. 226.
13. *Ibid.*, p. 288.
14. *The Performing Arts: Problems and Prospects* (New York: McGraw-Hill, 1965), p. 145.
15. *Commitment to Culture*, p. 45.
16. *Ibid.*, p. 67.
17. *Ibid.*, p. 106.
18. *Ibid.*
19. *Ibid.*, p. 191.
20. *Ibid.*, p. 205.
21. New York *Times*, December 6, 1962, p. 53.
22. Exempting income earned in backing a theatrical production from federal income taxes would amount to a huge subsidy.
23. Cities below 750,000 generally do not have such an establishment, while those with larger populations usually do.

2. Arguments for Public Support of the Performing Arts

by W. J. BAUMOL and W. G. BOWEN

reprinted from Performing Arts: The Economic Dilemma
Twentieth Century Fund (1966) pp. 370–86

Some Arguments for Government Support

'We are the only major nation on earth whose government still does so little about the nation's cultural treasure in the performing and visual arts, and it is high time that we caught up.'[1] With these words a noted Senator stated clearly one of the most common arguments for government support – the argument by example. It is done elsewhere, why not here? The argument by precedent also takes another form: 'Our government came to this conclusion [that federal assistance is warranted] about United States shipping in 1950, about agriculture in 1862, about education even before this.'[2]

Though these analogies may be effective in forcing us to think about the issue, they suffer from two serious shortcomings. It does not necessarily follow that because support is appropriate for some social and economic activities it is equally desirable for others. Even more important, the argument by analogy provides no evidence that government assistance to the other activities cited was justified in the first place. To remedy this deficiency a variety of beneficial side effects reputed to flow from the arts are frequently brought to our attention, consequences ranging from those which serve the noblest purposes to those which cater to the most material ends, from the enrichment of the nation's expanding leisure time to the provision of employment opportunities.

Most often, however, the advocacy of public support is made to rest ultimately on what might be considered higher grounds, the 'intrinsic value' of artistic activity. Lord Bridges put the matter most forcefully

42

in his Romanes Lecture in 1958 when he stated 'The heart of this matter is surely that the arts can give to all of us, including those who lack expert knowledge of any of them, much of what is best in human life and enjoyment; and that a nation which does not put this at the disposal of those who have the liking and the capacity for it, is failing in a most important duty.'[3]

Arguments Against Government Support

The one argument which most of us today would regard as an antediluvian manifestation is that poverty is good for the arts and stimulates creativity. 'We want to develop a hungry theater,' said one witness at the House Hearings on economic conditions in the performing arts, who went on to assert that only a hungry man feels compelled to say 'what's in him.'[4]

A more thoughtful objection to the use of government funds for the arts asserts that there are higher priorities, that poverty, disease, crime and ignorance have a stronger claim on government funds. Thus, Lord Bridges notes in his address a case where an expenditure related to the arts was attacked in the press on the basis that the money could have been used 'to build six bungalows for old people' in the area. While this alternative use of funds may be appealing, it must be recognized that, as a practical matter, the money in question, if not used for the arts, may well not be employed to construct 'six bungalows' or for any other similar purpose. In any event, even if one believes that more money should be spent on the poor, it does not follow that less should be spent on the arts. Perhaps economies should be effected instead in some other part of the government budget, or perhaps total outlays by the public sector should simply be increased. It is capricious and arbitrary to attack expenditures on the arts just because one believes some other projects have a higher priority. Such an argument is valid only if one can think of *no* better source of the requisite funds and if one can be reasonably sure that the monies denied the arts would, in fact, be devoted to the six bungalows, or to whatever else is deemed worthier.

An argument of a very different sort is that government support of the arts would serve mainly to displace private funds, which in turn implies that a great deal of government money would have to be spent

to bring about a small increase in the total resources available to performing arts organizations.

Unfortunately, there is little evidence on the basic factual issue — the effect of government grants on private contributions.[5] We do know, at least on an impressionistic basis, that in Western European countries there is little private giving to the arts; and, as was noted in the last chapter, governments do provide considerable direct support in these countries. One possible inference is that government grants have discouraged private giving, but it is at least equally plausible that causation has flowed in the opposite direction — that it is because of a lack of private support that continental governments have felt obliged to spend considerable sums on the arts. To the best of our knowledge no strong tradition of private giving to the arts exists in any European country, and it may well be that private contributions would be small even in the absence of government grants.

Our audience survey shed some interesting sidelights on this question. If we compare by income class the proportion of persons who contribute to the performing arts regularly in Great Britain and the United States, we find that in the lower income brackets the proportion giving regularly is about the same in the two countries, but in the upper brackets there is a much lower rate of contribution in the United Kingdom. This distinction may be one result of the greater tax incentives provided in the United States, or it may mean that the wealthy are the first to reduce their contributions when the government begins to finance artistic activity. Of course, other explanations are also possible — for example, the effect of the higher overall level of per capita income in the United States has to be considered — and it would be fatuous to pretend that the implications of these results are unambiguous.

On the whole, we were somewhat surprised at the high proportion of contributions reported in our English audience surveys, as our examination of the financial records of leading performing organizations indicated that they obtained relatively little money from private contributions. We, therefore, studied the organizations to which English respondents said they contributed. Comparing a London orchestral audience with an orchestral audience in the United States, we found that in the American case two thirds of the organizations to which respondents reported donating were major professional groups, whereas in the London sample semi-professional or amateur groups made up

nearly half of the total. This finding suggests that where the state takes a major share of responsibility for the support of professional organizations, a higher proportion of private contributions will go to amateur activity.

An historical study of English philanthropy has emphasized that time and again private donors have directed attention to a need, and then, when society at large assumed responsibility for ministering to that need, moved on to new fields.[6] This does not mean that government grants to the performing arts would necessarily drive away private donors in the United States. Developments in the field of education provide evidence to the contrary. Here the government has been doing more and more, and yet private contributions have also been rising at a very substantial rate indeed.[7] It is also reassuring that the institution of private philanthropy seems so well established in the United States. For this reason, and perhaps because of our greater wealth, total charitable contributions are higher in this country than abroad. Moreover, no one has proposed government grants of a magnitude which would make private support redundant.

Another argument against public support is the danger of public control. Senator Barry Goldwater voiced the fears of many people when he said that 'the Federal Government eventually will do more harm in this field than good by overregulating it, by over-controlling it.'[8] Americans are still haunted by the memory of the atmosphere of thought control which surrounded the demise of the Federal Theatre Project, and it is not easy to forget the moment when counsel for the House Unamerican Activities Committee asked Hallie Flannigan: 'You are quoting from this Marlowe. Is he a Communist?'

This objection, that public support implies public control, though one of the most persuasive, has turned out to be one of the least valid in practice. There is ample evidence that government support in Western Europe has not meant public control. John E. Booth, reporting on the European experience, writes:

The performing arts, under government support, are manifestly free from political pressure or interference. Broadly speaking, and exceptions exist, goverment does not impose its view . . . Within the bounds of public acceptance, all are free to be exposed, experimentation is encouraged.

The extent of the freedom is evidenced in the testimony of all

concerned — government officials, producers, playwrights, and critics . . . the freedom is implicit in the range of works produced year in and year out.[9]

And in our own country a review of experience suggests strongly that we must regard as unfortunate aberrations the WPA history and the more recent outburst of two Congressmen of considerable repute against 'eroticism' in the dances of Martha Graham. In our researches we encountered no case of interference by state or local governments, even where the amount of assistance provided has been relatively large.[10] An official concerned with the Library of Congress concert series, one of the oldest government supervised arts programs in the country, told us that he could recall no instance where his decisions had been questioned or where any attempt was made to influence his program, aside perhaps from an occasional call by a Congressman suggesting hesitantly that he would appreciate a hearing for a performer from his constituency.

Indeed, one can make a strong case to the effect that interference by private patrons is far more frequent and poses a far more imminent threat than does government control. It has been charged more than once that some performing organizations share the tribulations of the group 'controlled by a handful of people who consider the operation as their own private domain. They dictate not only administrative policy, labor policy, fund raising policy, but public standards of taste . . '[11] We know of at least one case where a leading patron of an orchestral group has virtually banned contemporary music; and where, in addition, the occasional performance of a pre-nineteenth century piece is suffered only as an obvious exercise in forbearance. Even the foundations have not escaped charges of undue influence — the Harkness Foundation's rift with the Joffrey Ballet is a notable case in point.[12] In such circumstances government support, instead of reducing the freedom of the arts, can serve to increase it. We conclude, then, that there is little factual basis for the fear that control would be an inevitable concomitant of government assistance.

There is, however, an associated danger which has much more substance. While government assistance may not circumscribe the freedom of the arts in any direct sense, it can effectively dampen their vitality. If support is channeled exclusively to old, established organizations, it can discourage experimentation and make for general stagnation. We have seen in the preceding chapter that this charge has

been leveled against the Arts Council of Great Britain. However, the indictment is more telling in connection with arts programs in several other countries, where some of the famous old theaters and opera companies, recipients of heavy government support, are apparently suffering from an advanced case of ossification. If, on the other hand, government support is spread thinly over a variety of enterprises of widely varying quality, in order to avoid the charge of 'favoritism,' the inevitable result is a diffusion of mediocrity. This is not an imagined danger. The state of stagnation of several European systems of higher education can be attributed at least in part to a misplaced egalitarianism in the distribution of government funds. When fifth-rate institutions and research projects are supported on a scale not far below the support given those of the highest quality, insufficient financing at the top level can lead to a 'brains drain' if there is somewhere else to go.

But these perils, while potentially very serious, seem unlikely to apply in the case of the United States, at least in the imminent future. No one is suggesting support on a scale which would make government the exclusive source of funds for any activity, and a pluralistic arrangement in which private and public support both play a role automatically acquires checks and balances. Such a mixed system has been highly successful in maintaining the vitality of our system of higher education, and there is no obvious reason why it should not work just as well in the arts.[13]

The Market Test

There remains the fundamental objection to public support which arises out of the application of the market test to the performing arts. The Philistine is surely entitled to ask: If the arts do provide so much to their audiences, why are the audiences not willing to bear their cost? The most basic objection to government support of the performing arts is simply that those who want to see them ought to pay the price. 'The small percentage of people who enjoy opera does not qualify it for public financial support,' wrote one commentator, who went on to say: 'If opera cannot pay for itself, the fault is with opera, . . . It has never been a principle of our society that the people as a whole should be forced to pay for the entertainment of a few — and it must not be so now.'[14]

Though some may find it distasteful, this objection is not without merit. Insolvency *per se* does not constitute adequate grounds for public assistance. No doubt when the automobile first came into general use financial catastrophe threatened manufacturers of buggies, yet we hardly feel that public funds should have been poured into that industry. The reason is clear: if consumers did not value buggies sufficiently to purchase them in quantities and at prices high enough to permit their continued production, the manufacturers no longer had any reason for survival. They had failed the stern test of the market which says that goods and services should be produced only if they are worth their keep to the consumer. But then, one may ask, does not the same test apply just as harshly to the performing arts? If audiences do not want them sufficiently to cover their costs through admission charges, why should this fact be construed as a *prima facie* case for public support? Might it not argue the contrary — that live performance is an obsolete vestige of a handicraft economy which deserves no public assistance precisely because effective demand for it is inadequate?

This is a particularly telling argument in a discussion of government assistance, for government funds, unlike private gifts and contributions, are supplied *involuntarily* by many individual members of the public. If the arts are to receive help from government sources, it becomes important to explain why the performing arts should be among those privileged activities which are granted exemption from the market test.

The proper response, it may be felt, cannot be given on a materialistic level. Rather, it must be phrased in terms of finer and less tangible concepts: the inherent value of beauty and the ineffable contribution of aesthetic activity. To the man in the street, however, this may not be an acceptable answer. Indeed, it is likely to smack of things he rightly considers dangerous: paternalism, dictation of tastes and violation of consumer sovereignty. He may well ask whether we are to base the allocation of the nation's resources on the aesthetic standards of some group of individuals who consider the true standards of beauty to have been revealed only to them. If public funds are to be spent to provide 'good performance' which the public does not seem to want, then might not the next step be the proscription of other types of performance which the public does desire — perhaps the prohibition of immoral drama, or the discouragement of jazz, or of modern art or of anything else which does not appeal to those who dictate the aesthetic standards. If we accept the sovereignty of the public — the fundamental principle that in a democracy choices are to be made by the citizens of the

community — an appeal for the sanctity of the arts simply will not suffice.

But if, as we have shown, audiences are drawn from so limited a segment of the community, can one ever expect to demonstrate that government support of the arts accords with the desires of the public? The answer is to be sought in the nature of activities which, by general consent, are exempted from the market test. One does not expect the defense establishment to show a profit, the courts to pay for themselves or the elementary schools to cover their costs out of their revenues. There are good grounds for these exemptions — grounds fixed firmly in economic analysis and involving no departure from democratic ideals. Much of the remainder of this chapter will be devoted to a discussion of these grounds and an examination of their applicability to the performing arts. It should be emphasized that our analysis is not intended to pre-judge the amount of government support that is desirable, or even, for that matter, to argue that government funds should necessarily be devoted to such purposes. Rather, it is our intention to describe the logic on which such decision, one way or the other, should be based if it is to satisfy the criterion of rationality.

The Egalitarian Grounds

The economist recognizes three basic grounds which can legitimately be used to defend government subsidy of unprofitable activities. The first ground for government intervention in the economy is inequality of opportunity. We generally take it as an article of faith that it is undesirable for anyone to be kept from achieving as much as he can through the abilities with which he is endowed. It is, therefore, widely agreed that no market test need support the flow of public funds devoted to the opening of opportunities to the impecunious. This exemption is neither capricious nor merely a matter of tradition. The market test has been described as an election in which the consumer decides what commodities shall be produced and in what quantities. He decides this, not by casting votes, but by the way in which he spends his dollars. But it is very important to remember that under this system not all men have the same number of votes. The affluent consumer has a far greater influence on the course of events than does a purchaser whose finances are quite limited. Therefore, government funds intended

to promote equality of opportunity directly or indirectly may be viewed as a means for improving the way in which the market election is conducted.

Now, one may well argue that the extremely narrow audience for the arts is a consequence, not of limited interest, but of the fact that a very large segment of the community has been denied the opportunity to learn to appreciate them. In part this may be so because many persons cannot easily afford the admission charges. However, the lack of facilities in many of the nation's communities also constitutes a denial of opportunity. How can people learn to enjoy the living arts if no plays, no concert performers and no dancers are available to them? People can be deprived of opportunities by phenomena other than poverty and ignorance, and if the government wishes to improve the situation as far as the arts are concerned, it may have to help in the provision of opportunities for attendance in many parts of the country where professional performance is now totally unavailable.

The Education of Minors

A second legitimate reason for government support can be dealt with briefly. It is maintained that while in a democracy most individuals can be left to decide for themselves how their incomes should be spent, some classes of people are not competent to make their own decisions. In particular this argument is applied to minors, with the result that the latter are not permitted to purchase alcoholic beverages, drive automobiles, or decide for themselves whether funds shall be devoted to their schooling. The application to the arts is immediate, and is not unrelated to our accepted policies on education. It is felt that if children and adolescents are not exposed to artistic performance during their minority, by the time they become adults it will be too late. The arts must be made available early, while tastes are still being formed and behavior patterns developed.

It should be made clear that while the logic of this argument is acceptable enough, it rests also on an allegation of fact which has yet to be tested: the hypothesis that taste for the arts is instilled by early experiences. No one seems to have any overpowering evidence that this is so. No one has tracked down the children who attended the New York Philharmonic's young people's concerts which were given

continuously from 1898 (by the New York Symphony Society before it merged with the New York Philharmonic) until 1939, or the WPA performances, to see whether they subsequently showed greater interest in the arts than persons coming from otherwise similar backgrounds.

Public Goods and the Market Test

The third ground which can be used to justify government expenditures involves the class of commodities and services which the economist calls 'public goods.' Public goods are items which, when provided to one person, automatically and unavoidably become available to other members of the community as well. For example, if current efforts succeed in reducing air pollution in Los Angeles, pure air will have been supplied not just to one Angeleno and his family but to all the inhabitants of the city.

The provision of public goods cannot be entrusted to market forces alone. The profit motive and free enterprise, which work so effectively in bringing private goods to consumers when and as they want them, are subject to a fatal limitation as regulators of the supply of public goods. The reason is that commodities of the latter type lack the basic requisite of the market — saleability. This is seen most easily in the case of an item such as national defense. To pose the relevant question — can the operation of our military forces be left in the hands of private enterprise? — is to answer it. The proposition is ridiculous on its face. Defense benefits everyone, but if an individual were sold 'a piece' of it, just what would he have purchased? National security, which is vital to all citizens, cannot be sold to any one of them. When someone desires a good such as a shirt or a pound of potatoes he must pay its price or the seller will refuse to hand the item over to him. But if an individual cannot be excluded from the enjoyment of the benefits of a good, there is no way a private seller can enforce the payment of a fee which would cover his costs. One cannot hope to sell rights to unpolluted air in the city streets, and for this reason the idea of an air cleaning firm has never attracted private investors.

While public goods cannot pass the market test, it does not follow that such items are unwanted by the general public. Even though consumers cannot be made to pay for them, they may regard them as well worth their cost. In such a case it is the normal commercial

mechanism and not consumer demand which has failed to function. A government's decision to supply a public good is, therefore, not necessarily a decision to flaunt the wishes of the consumer. On the contrary, government financing may be the only way in which the wishes of the body of consumers can be put into effect.

The Case of 'Mixed Commodities'

The situation is slightly more complicated in the case of mixed commodities — goods and services whose characteristics are partly private, partly public. Education is a prime example. When a student attends a school or a university his own welfare (including his future earning ability) is thereby increased. In this sense education is a *private* good — it can be sold to an individual purchaser because it yields benefits specifically to him. But at the same time education is also a *public* service because it enriches society as a whole — it not only increases the productivity of the individual, it makes for a better life for everyone in the community. Without general education the democratic process as we know it could not function effectively.

Unlike pure public goods, mixed commodities can be expected to cover part of their cost by sale to the public. One can charge a price for the direct benefits which flow from the provision of facilities for higher education, for inoculations against contagious diseases, slum clearance projects, etc. This is possible because the consumer can be excluded from the enjoyment of direct benefits if he does not pay the fee. A student who refuses to pay tuition may not be permitted to attend the university, and a tenant who chooses not to pay his rent can be evicted.

The consumer cannot, however, be excluded from the indirect benefits associated with mixed commodities, since these are unavoidably made available to all members of the community. Therefore, the price tag which can be put on quasi-public goods may be insufficient to cover their cost of production. But, in this case, failure to pass the market test does not necessarily mean that the goods in question are unwanted; it merely reflects the fact that they are not amenable to ordinary commercial standards of valuation. In these conditions public support may be entirely justified as the only available means to make demand effective.

The Performing Arts as 'Mixed' Services

The reader can readily see where all of this is leading. If the performing arts are mixed commodities which confer direct benefits to the community as a whole, government support of the arts might well be completely consistent with the desires of the entire community. To determine whether the arts do or do not fall into this category it is necessary to look closely at the advantages they offer to the public at large.

There are at least four types of general benefit which may flow from the arts. The first of these may perhaps be considered unworthy, but it is, nevertheless, very real — it is the prestige conferred on a nation by its performing arts. Many persons who themselves have no desire to attend an opera or a program of contemporary dance take pride in the international recognition conferred on our singers and the creativity of our choreographers. To them the availability of a number of fine orchestras is a measure of the achievement of America, and is therefore a prime source of satisfaction. They would be most unhappy if the United States became known abroad as a cultural wasteland, a nation in which mammon had put beauty and art to rout.

Lest this phenomenon — the prestige conferred by cultural activity — be considered insufficient justification for any substantial support, it need only be recalled that concern with our image is the prime justification behind many of the billions currently being expended on the space race. If the national feeling of achievement which would attend getting to the moon at an early date is worth the outlay of tens of billions on the propulsion of astronauts into space, then the expenditure of a small fraction of this amount to obtain the prestige offered by a viable performing arts establishment may also be justified. It is in this connection that the potential role of the arts in U.S. foreign policy has been stressed. George London testified before a House committee that 'the arts were being used as a potent propaganda weapon of the cold war.' He suggested that in many parts of the world the United States is considered 'a purely materialistic country devoted to profits and consumers' goods, and bereft of spiritual or cultural values. This is a theme which particularly the Soviets pound upon and make political capital of.'[15] The use of State Department funds to finance international tours of American companies can be regarded as a small first countermove.

A second equally materialistic set of indirect benefits which flows

from the arts is the advantage that the availability of cultural activity confers on business in its vicinity – the fact that it brings customers to shops, hotels, restaurants and bars. On a national level, distinguished performing arts organizations may serve, analogously, as a significant tourist attraction.[16] A particularly good illustration was provided in an editorial in the *New York Times* which commented on competition among 117 communities in 46 states, each seeking to become the site of a $280 million facility for experimentation in nuclear physics. The editor reported:

> In setting up its criteria for a choice, the [Atomic Energy Commission] noted that the location should have adequate cultural and educational facilities for those who will work at the facility. The result has been much soul-searching in communities that would like to have the accelerator and realize that past neglect of local educational and cultural institutions casts a blight over their chances.
> Many local readers over the country are now becoming aware that a strong research-oriented university, a thriving symphony orchestra and a lively theater no longer can be ranked as frills. They are essentials for a community's economic expansion in an age when science and scientists play an unprecedentedly important role.[17]

A third and far more appealing type of social contribution credited to the performing arts involves future generations. One may well feel that ability to appreciate the arts cannot always be achieved without a suitable period of training and acquaintance.[18] We have all met people who admit they have never themselves learned to enjoy a particular art form, but feel it important that such an opportunity be available to other members of their families. This same phenomenon has a significant extension to the posterity of the community as a whole. We support programs for the conservation of natural resources and for improvement of architecture in part because few of us are willing to take the responsibility of passing on to future generations a country whose beauty has been destroyed.

But provision for the future requires support for the arts in the present. Though it is demonstrably false that the arts 'when once destroyed can never be supplied,' it is true that their rehabilitation is not likely to be quick or easy. There is the old saw about the man who asked the secret of the lush lawns at Versailles and was told that the answer was simple: they need only be watered daily for three hundred years. The development of mature cultural activities, of exacting

standards of performance, and of an understanding audience cannot be achieved overnight. Funds must be provided today if the arts are to be kept alive for tomorrow. A program to preserve the arts for the nation's posterity is a case of indiscriminate benefits *par excellence*. No one can say whose descendants will profit one hundred years hence from resources now devoted to that purpose. Neither can these benefits be priced and their cost covered by an admission charge. Though most Americans may be happy that future generations will have the arts available to them and are content to have funds spent for the purpose, there is no way in which the free market, unaided by public funds, can enable these desires to be realized.

Still another type of indirect benefit provided by the arts is their educational contribution.[19] If, as is generally conceded, a liberal education confers indirect and non-priceable benefits upon the community, the same must be true of the arts. If the teaching of the humanities makes for a finer civilization, for a richer community, for a better life for everyone, this is necessarily so with the arts as well; for without the arts a vital element is taken from the humanities. How can drama be taught if there is no drama available for the student to experience? What can the teaching of music mean if no one can hear performances of professional quality? If the arts are reduced to an atrophied relic of ancient history, a critical component of our educational system must concurrently be lost.

One main conclusion can be drawn from the analysis central to this chapter. If one agrees that the performing arts confer general benefits on the community as a whole, in the manner described above or in other ways, he must conclude that in part, and perhaps in large part, the arts are public goods whose benefits demonstrably exceed the receipts one can hope to collect at the box office. It is a long-standing tenet of economics that if the wishes and interests of the public are to be followed in the allocation of the nation's resources, this is the ultimate ground on which governmental expenditures must find their justification. Government must provide funds only where the market has no way to charge for all the benefits offered by an activity. When such a case arises, failure of the government to provide funds may constitute a very false economy — a misallocation of the community's resources, and a failure to implement the desires of the public. In such circumstances, government outlays are no manifestation of boondoggling bureaucracy, no evidence of creeping socialism, but a response to one of the needs of the society at large.

1. Senator Jacob K. Javits, quoted in Stoddard.
2. Stoddard, p. 3.
3. 1958 Romanes Lecture, pp. 12–13.
4. House Hearings, II, testimony of John D. Wentworth, managing director of the Washington Theater Club, Washington, D.C., p. 533.
5. Great Britain would seem to be an excellent locale for such a study, since a comparison of current patterns of giving with patterns before World War II and the inauguration of the Arts Council might be very enlightening, but no such investigation seems to have been conducted.
6. See David Owen, *English Philanthropy, 1660–1960*, Belknap Press, Cambridge, Mass., 1964. Welfare activities and hospitals are obvious examples.
7. See Council for Financial Aid to Education, *Guide Lines to Voluntary Support of America's Colleges and Universities*, Report on surveys conducted in 1954–55, 1956–57, 1958–59 and 1960–61, which shows that 728 institutions reported receiving somewhat less than $290 million in private support in 1954–55, while only eight years later, in 1962–63, 1,036 institutions reported receiving $911 million from private sources.
8. Senate Hearings, p. 180.
9. Booth, p. vi.
10. In an article in the *Newsletter* of the American Symphony Orchestra League (November–December 1963, pp. 13–14), the manager of the Milwaukee Symphony reported that his organization had been receiving funds from the city for four years and that not one city official had tried to interfere in any way. He suggested that his experience was applicable elsewhere.
11. House Hearings, II, statement of Mrs. Diane Fivey, San Francisco Executive Secretary of the American Guild of Musical Artists, p. 350. See also the letter by a member of the San Francisco Arts Commission, *New York Times*, Nov. 29, 1964, p. 49.
12. *New York Times*, March 18, 1964, p. 48.
13. There is, however, some danger that individual giving will follow patterns set by government grants. The psychological 'seal of approval' conferred by government aid may supplement the effects of matching-funds requirements in diverting the flow of private funds toward the pattern adopted by public agencies. Apparently this has been the experience in Canada. (See Hendry, p. 64).
14. Letter from Mr. William Eugene Hudson of New York City, printed in the *New York Times Magazine*, November 12, 1961, and quoted in House Hearings, II, p. 236.
15. House Hearings, II, p. 21.
16. Booth (p. iii) points out that the encouragement of tourism is an important motivation behind some of the support provided in Western Europe.
 Support whose form seems to recognize the relationship between performance and some types of business activity has been provided in San Francisco, where a tax is levied on hotel rooms and the proceeds are divided between convention bureaus and the arts.
17. *New York Times*, Aug. 15, 1965, p. 85. Note that all of the indirect benefits in such a case are usually derived locally, and so this is an argument which can serve as justification primarily for local support.
18. We have already had occasion to note another type of indiscriminate benefit associated with training children to appreciate the arts. This is the fact that because of the great mobility of the American population, an organization providing children's concerts in one city is likely to be building future

audiences for other cities. This clearly argues for federal rather than local support.

19. The items mentioned are not the only indirect and indiscriminate benefits provided to the community by the performing arts. There are others; for example, the fact that the live performing arts serve as training grounds for the mass media.

3. What's Wrong with the Arts Is What's Wrong with Society[1]

by T. SCITOVSKY

reprinted from American Economic Review *May 1972 pp. 1–19*

You will have guessed from my title that what I have to say will be neither reassuring nor very constructive. I do believe the arts are in a bad way in this country. Measured by admissions to live performances of legitimate theatre and music, our art consumption per head is less than a half of West Germany's, and Austria's, little better than a half of Norway's and Switzerland's, and less than a third of such East European countries' like Hungary, Czechoslovakia and East Germany. In a cultural center like San Francisco, the past season's more than 1.8 million admissions are very impressive when related to her 700,000 population – they probably exceed those in any city of comparable size anywhere in the world. But when one remembers our suburban way of life and the fact that San Francisco is the dov⋯⋯ ⋯ ¹½ million Bay Area residents, then this turns out to be not ⋯ figure, more in keeping with our low national average. ⋯ national average used in these comparisons is very app⋯ subject to a wide margin of error; but other indices sh⋯ same disparity. For example, the sale in this country ⋯ serious music, at 4 per cent of total record sales, is about a ⋯ corresponding European ratios: 12 per cent in England and ⋯ in France and West Germany.[2]

This is the record, what is the explanation? One can seek ⋯ demand or on the supply side. Economists, by hallowed tradi⋯ always concentrated on the latter, which throws some light ⋯ subject but not very much. I propose to depart from tradition a⋯ enlightenment on the demand side. We have many serious eco⋯ problems in this country; but failure of the pattern of consumpti⋯ conform to consumers' preferences is not among them. If the art⋯

insufficient attention and insufficient funds, consumers' preferences are mainly to blame and changing them the best remedy.

It is true that our mass-production society is biased against minority needs and tastes; and that the enjoyment of the arts has usually been the privilege of a small elite. But rather than ask if this small minority gets its due or how it could be made to get it, I propose to raise the larger question why this minority has remained quite so small in our affluent society; indeed, why it has remained a minority at all.

After all, our standard of living has been rising pretty fast. We have long ago caught up with and left behind Western Europe in affluence, why aren't we, all of us, members of the elite? The real income of the average American equals the average real income of the richest two fifths of Frenchmen, the wealthiest one fifth of Italians and of the top 3 or 4 per cent of Japanese.[3] If statistics of income distribution were available for the world's 3½ billion population, I dare say that the top decile would contain the vast majority of Americans, perhaps all but the 25 million who are on welfare or below the poverty line.

Money alone does not, of course, make an elite, it also takes education. But in years of schooling received we are again on top of the world – perhaps by an even wider margin.[4] We are, the great majority of us, the world's elite in terms of both income and education; why then don't we have the tastes of an elite? The answer to this question is all the more important, because our tastes, as reflected in our consumption and production patterns, are being followed the world over. The fear of Americanization, voiced by so many other countries' elites, is well founded. What then shapes the American taste, how and why is it different from that of other elites?

Our modest interest in the arts can hardly be blamed on a sparing distribution of aesthetic sensibility by providence. It probably has to do instead with the nature of our education and the direction it has taken. From classical Greece to 18th century Europe, work and leisure were specialized functions, specialized along class lines. Education was largely the privilege of the leisure class; and this was logical enough, considering that the successful pursuit of leisure and pleasure requires far more learning and a far greater variety of skills than does work. The development of the arts and their appreciation was one result of education mainly aimed at developing the skills and providing the background necessary for the enjoyment of life.

Beginning with the 18th century, progress has greatly accelerated and taken a new turn; and in this we had a great share – so much so

that America has for long symbolized progress and been called the land of progress. Work and leisure have come to be distributed more equally among men; and we in America laid the economic basis for the better distribution of leisure by developing most of the products and appliances that provide domestic service without domestic servants. Education, too, has ceased to be a privilege and become available to all; but its nature and aims have changed and are still changing; it is increasingly aimed at providing professional training in production skills rather than the general liberal-arts education, which provides training in the consumption skills necessary for getting the most out of life. The changing aims of education are responsible for our increased productivity; they also explain the paradox that as progress frees more and more of our time and energies from work, we are less and less well prepared to employ this free time and energy in the pursuit of an interesting and enjoyable life. Our social engineers are much concerned, and rightly so, that America is acquiring leisure faster than the preparation for using it;[5] what is even more distressing is that we should need to be trained and told what to do with our leisure, because our many years of schooling have failed to develop our taste and awaken our interest in the many pleasures that life can offer.

The schools of education are not so much to blame as society at large and its puritan attitude. Our founding fathers did not want to abolish the leisure class, to which most of them belonged; but they did change its attitudes and aspirations. They wanted man to get his main earthly satisfaction from work, with consumption providing merely the necessities and comforts of life. This may have been a workable proposition in the craft society of the 18th century; since then, technical and economic progress have rendered most work far too mechanical and fragmented to be enjoyable.[6] Today, only the manual and intellectual arts and crafts and the businessman's profession, his profit-maximizing activity, remain challenging and rewarding. For the majority of us, work has ceased to give pleasure and meaning to life; and our puritan tradition and education also prevent our seeking them in consumption. We smile condescendingly over the prejudices of 18th century America, which morally disapproved of the theatre and frowned on wasting time and money on sports and the arts; but this is no smiling matter, because our behavior is still governed by those prejudices. The average American devotes to active sports and exercise one third of the time the average European does;[7] his visits to theatre and concert hall stand in about the same ratio. Even our relative money

expenditure on recreation and amusements is one third lower than Western Europe's.[8] The arts have become respectable in the United States; but the enjoyment of life has not. We are for Culture, because it is spelled with a capital C, not because we derive, or know how to derive pleasure from it. The resulting ambivalence is what's wrong with the arts.

We have inherited a deep-seated conviction that the serious business of life is production and the making of money. Consumption, and especially the spending of money, time and effort on the enjoyment of life, we regard as a frivolous and not quite respectable occupation. This is why we eat, not what is good, but what is good for us; go on holidays, not for enjoyment, but to keep the kids busy or give the wife a rest, and buy extra chrome and accessories with our cars, not for the fun of it but for better resale value. Keynes rescued the respectability of spending money, if not as a source of enjoyment, at least as a means of stimulating production, employment and profit; but we have never overcome our moral embarrassment over spending time and effort on enjoyment or acquiring the skills of enjoyment. The American consumer has relinquished to the producer all initiative, expertise, even discernment, concerning the taste and quality of most consumers' goods, from the food he eats and clothes he wears to the furnishings around him. He takes a passive attitude to consumption, relying on the seller to supply the know-how and relieve him of the bother; he even takes pride in being an unskilled consumer, above the trifling cares of consumption and able to pay others to supply the skills and do the caring.

The result has been, not a mere transference of tasks from one side of the market to the other, but a complete change in the very nature and content of consumption. For one thing, when the consumer is unskilled and unwilling to exert himself to enjoy and enrich his life, the satisfactions accessible to him become pretty restricted. For another, the producer's initiative has inevitably led to the stressing of satisfactions whose production yields the greatest economies of scale and to the extension of producer technology into the consumption sphere. Hence the largely defensive nature of our consumption, its focusing on the avoidance of pain, effort, discomfort, boredom, the unknown and the uncertain. Such seeking of comfort and safety is very different from the active pursuit of pleasure the leisure classes of the past engaged in. Nor is the choice between comfort and pleasure a simple matter of economics, imposed by budgetary constraints, except to a limited

extent. We shall never be affluent enough to afford both pleasure and comfort, because pleasure depends on the assimilation of novelty, the relief of strain, the resolution of conflict, the understanding of complexity; and one cannot have the pleasure without accepting into the bargain the facing up first to the initial shock. A predictable happy ending or too simple a piece of music is that much the less enjoyable; too great ease or explicitness turns much potential pleasure into mere defense against boredom. The old leisure classes fully understood this and were adventurous enough to take the risks and make that investment of time and effort in the development of mind and body, senses and spirit, so essential for the enjoyment of the good things of life. By contrast, our increasing reluctance to accept discomfort and face the uncertain and the unexpected is increasingly in the way of our obtaining pleasure; and technical progress has completely failed so far to resolve the dilemma. It seems a strange irony of fate that our puritanical rejection of pleasure as the ultimate aim of life should have led to a preference system in which the making of money is the main challenge and effortless, pleasureless comfort the main reward. Adopting such a preference system on the selfish plane can also bedevil one's unselfish actions: our efforts to help the poor among us and in the third world are bound to be marked by the way in which we help ourselves.

This bias in our preferences is best illustrated by a comparison of our living patterns with Western Europe's; but I can only quote a tiny sample from the wealth of available data. Time budgets, consumer spending surveys, a miscellany of statistics and other information all show that we typically spend less on pleasure and more on safety and comfort than they do, that we usually trade quality of life to save effort or obtain extra safety, and that often we are forced into such tradeoffs by restrictions our authorities impose, supposedly to protect people from their own folly, and with never a thought of the pleasure they force people to sacrifice for what often are insignificant increments of safety.

We save half an hour a day on cooking, housecleaning and errands; it is they who spend half an hour more over their meals, presumably because they enjoy them that much the more, while our skimping on the time, effort and skill needed for good cooking is the secret of the dullness of our food.[9] We have twice as many operations and hold twice the number of life insurance policies than inhabitants of the more affluent countries of Europe;[10] but we go on vacations not even half as often as they do.[11] – This latter is especially significant, because

vacationing depends very much on income. U.S. data show a high income elasticity of demand for vacations; European data show a high rank correlation between countries' standards of living and percentages of adults vacationing; yet, when the United States is compared to Europe, we rank among the poorest European countries, with Portugal and Italy. As though our high standard of comfort and safety were an irreducible minimum, absorbing so much of our income that, measured by what's left over for the enjoyment of life, we seem worse off than many others poorer than we.

Other reasons for our fewer vacationers are our lesser tolerance for the hazards of life away from home, and our less good vacation amenities, partly explained in turn by our authorities' lesser tolerance for citizens' taking risks for pleasure. For example, one of the more unreasonable reasons why swimming is so seldom accessible in this country is the extremely high bacterial standards of water purity most States require before they authorize swimming. This is approximately as high as the standard the Public Health Service sets for the milk we drink; a few States set much higher standards than this for swimming and bathing.[12]

I mention these matters seemingly unrelated to our subject, because the hazards of vacationing and tourism are not so different from the hazards of art and art appreciation, and because government's cheerful sacrifice of the citizen's access to nature for the sake of illusory or insignificant increments of safety is part of the same philosophy that lies behind its neglect of the arts. The same Government whose $30 million subsidy to the performing arts is a tiny fraction of West-European public subsidies, spends on medical research almost $1.7 billion, which is twice the proportion of the GNP that Britain, France, and West Germany spend on it.

I was trying, with these few examples, to establish that the economic difficulties of the arts have more to do with our preferences than with our economy, that our very modest appreciation of the arts is part and parcel of our very modest enjoyment of life, and that our Government's miserly attitude towards the arts is again an integral part of a larger collective preference system, which is fully in keeping with consumers' individual preferences as revealed in the market place.

I presented a diagnosis which, if correct, calls for action. If you deplore the neglect of the arts in our midst, you can help matters by whatever means will influence the public's taste. Those of us who would like to see Governments more generous toward the arts would do

well to consider on what basis this can be justified. None of the standard arguments in favor of Government financing is really applicable to the arts.[13] They are not a collective good, which could be more cheaply or efficiently provided by Government; their subsidizing is not a suitable means for mitigating income inequalities, nor can it be justified on grounds of protecting the interests of future generations. A subsidy to the arts favors the art-loving minority of the present generation; and while something can be said for offsetting the tendency of our economy to discriminate against minority tastes, the argument loses much of its force when one remembers how well-heeled most members of this minority are.

The only valid argument for Government aid to the arts is that it is a means of educating the public's taste, and that the public would benefit from a more educated taste. It is fashionable to deprecate this argument on the ground that it has often been tried and never with success.[14] Such reasoning, however, is dimensionally false and unduly pessimistic. One cannot expect society to share mortal man's ability to learn once and be the wiser for life. Society, being immortal, must acquire every bit of wisdom at the cost of continuing education. But once one gets the dimensions right and realizes that art education is not a matter of pump priming but a continuous process, then there is plenty of cause for optimism. The arts may be badly off today; but they used to be much worse off in the past. Progress has been enormous and there is no reason why it should not continue. Today's youth is highly critical of its parents' values, probably including those I talked about. They may well be against our putting comfort and safety ahead of pleasure, and not only when this takes the form of young musicians being hauled off the streets for obstructing the sidewalk with baroque music. On the other hand, whether subsidies to the arts will influence their or anybody's tastes depends on how and on what they are spent. The Arts Council of Great Britain has justly been criticized for spending too much on Covent Garden, thus subsidizing the cost of living of high society but gaining few recruits to music. We too tend to favor the safe and comfortable arts and neglect both the experimental and the middle-brow, although all these need equal treatment if we aim not at national prestige but at helping the public to learn to enjoy the arts.

Spreading subsidies broadly is desirable also as a means of maintaining competition and consumers' market pressure to keep prices and costs from skyrocketing. The financing of the arts bears many similarities to the financing of medical care; we must be careful lest the cost of the

arts follows the course that the cost of medical care has taken. This, however, having to do with the spending of money not yet available, is one of the problems of the future. For the present, I have made my point. If anything is wrong with the arts, we should seek the cause in ourselves, not in our economy. I am asking you to think about it, and to think about it as consumers rather than as economists.

Table 1. Annual Admissions to Theatres and Concerts per 100 of Population

	Theatres	Concerts	Total
Austria (1967/8)	66	(22)[a]	(88)
Czechoslovakia (1967)	70	17	87
East Germany (1967/8)	72[b]	12	84
Hungary (1968)	57	15	72
West Germany (1967/8)	44	14	58
Norway (1968)	30		
Switzerland (1968)	28	(13)[a]	(41)
Netherlands (1965)	17[c]	14[c]	31
United States (1970/1)	(16)	(6)[d]	(22)

[a]Concert admissions estimated on the assumption that the ratio of concert to theatre admissions is the same for the country as it is for its largest city, for which complete data are available. Probably an underestimate.

[b]Admissions to workers' theatres, not included here, would add another 5 points.

[c]Admissions only to subsidized events and those subject to entertainment tax. Probably an underestimate.

[d]Excludes chamber-music groups and solo performers.

Sources: The Statistical Yearbooks of Austria, Czechoslovakia, East Germany, Hungary, Switzerland, the Netherlands; also those of Vienna and Zurich. For West Germany, B. Mewes, 'Theater und Orchester 1967/68,' in *Statistisches Jahrbuch Deutscher Gemeinden 1969* and F. Harlan, 'Konzertstatistik 1968,' to be published. For Norway, 'Innstilling Nr. 40 1970 til Stortinget om Teatervirksomheten i Norge.'

The U.S. ratios are based on data for non-profit performing arts, Broadway, Off-Broadway, 'the Road', and summer stock, contained in *Economic Aspects of the Performing Arts* (National Endowment of the Arts), *Variety*, June 9, 1971, and T. G. Moore, *The Economics of the American Theater*.

66 *The Rationale for Public Subsidies to the Arts*

Table 2. Total Annual Admissions to Theaters and Concerts in San Francisco and the Average of Total Annual Admissions in Munich and Hamburg

	San Francisco pop. 716,000 Bay Area pop. 4,628,000	Munich — Hamburg av. pop. 1,538,000
Opera	203,500	514,000
Light Opera, Operetta	332,400	226,509
Concerts	457,800[a]	399,000
Theatre, nonprofit	308,000	743,000
Theatre, commercial	298,700	810,900
Other[b]	224,700	54,100
	1,825,100	2,747,600

[a]Excludes solo performers and visiting chamber-music groups.

[b]The S. F. figure is more inclusive and comprises ballet, folk-dance groups, rock concerts, the British Grenadier Band, etc. The M.—H. figure refers exclusively to dance.

Sources: The San Francisco estimates are my own. I am grateful to the business managers of the Opera, the Symphony, the Northern California Ticketron agency, the several theatres and dance and music groups of San Francisco and to Mr. John Kornfeld for supplying the data; and to Mr. Martin Snipper for advice. For the Munich — Hamburg data, see the German sources cited in Table 1. These cities' similar populations and almost identical per capita art admissions render the use of averages meaningful. Unlike San Francisco, neither is surrounded by separately incorporated bedroom communities.

Table 3. Public Subsidies to the Performing Arts and to Medical Research (Current Operating Expenditures only) in National Currencies and as Percentages of the GNP

	Performing Arts in millions	%	Medical Research in millions	%
United States (1969/70)	$30[a]	.003	$1,695	.17
United States (public subsidies plus private contributions from Foundations, Business and Individuals) (1969/70)	$80[b]	.008	$1,890[d]	.19
United Kingdom (1970)	£6.6[c]	.015	£41	.09
West Germany (1968)	DM 505.5	.09	DM 490	.09
France (1968)	Fr 83.5	.013	Fr 457.3	.07
Sweden (1969/70 & 1965/66)	Kr 222.6	.15	Kr 91	.09
Norway (1968 & 1970)	Kr 29.2[e]	.04	Kr 53.2	.08

[a]Federal subsidies of $5.5 mn were brought to $10.3 mn by assuming that the performing arts received half of the $9.6 mn grants the States' Arts Councils dispensed out of State and Federal funds. No data exist on grants from the cities, I assumed these to be twice the combined Federal and States' grants.
[b]The income of the 187 major non-profit companies from sources other than ticket sales was $58.7 mn. My rounding to $80 mn to account for the minor ones may be overgenerous.
[c]Does not include Local Government support to music.
[d]Does not include drug research by pharmaceutical firms.
[e]Does not include the substantial support from municipalities.

Sources: For medical research expenditures: U.S., D. P. Rice and B. S. Cooper, 'National Health Expenditures, 1929–70,' Social Security Bulletin, Jan. 1971, Table 2, p. 6; U.K., private communication from Prof. B. Abel-Smith, School of Economics, London; West Germany and France, 'Le Financement Public de la Recherche et du Développement dans les Pays de la Communauté,' in Office Statistique des Communautés Européennes, Études et Enquêtes Statistiques, No. 2, 1970; Sweden, T.C.O., Forskning o Framsteg (1970), Table 4, p. 38; Norway, English Summary of the 1968 report (published in 1970) of the Norwegian Technical Scientific Research Foundation, table on p. 53.

For subsidies to theatre and music: U.S., National Endowment for the Arts, Economic Aspects of the Performing Arts; U.K., The Arts Council of Great Britain, 25th Annual Report, 1969–70; France, 'Le Budget des Affaires Culturelles depuis 1960,' in Ministère des Affaires Culturelles, Notes d'Information, Avril 1967, p. 5; West Germany, B. Mewes, 'Theater und Orchester 1967/68,' in Statistisches Jahrbuch Deutscher Gemeinden 1969, D. Linkmann, 'Gemeindliche Kulturausgaben 1968,' in the 1970 volume of the same volume of the same series and personal correspondence with Dr. Mewes; Sweden, Swedish National Council of Cultural Affairs, Some Preliminary Facts About the Cultural Expenditures in Sweden, (mimeo'd. May 3, 1971) Table 1, p. 3 and Table 4, p. 22; Norway, see source given in Table 1.

1. U.S. data on the arts are shockingly inadequate. Most of those given here had to be assembled from scratch or estimated; and I owe many thanks to my research assistant, Mr. G. Wilkinson, for his careful work. I am also deeply indebted to Mr. Martin Snipper, executive director of the San Francisco Art Commission, without whose help and advice the survey of concert and theatre admissions in San Francisco could never have been undertaken.

2. The U.S. percentage is based on 1970 totals of the dollar value of factory shipments of phonograph records as collected and released by the Recording Industry Association of America in New York. The European percentages were obtained by private communication from the Musical Heritage Society. Cf. 'The Crisis of Classical Records in America,' *Stereo Review*, February 1971, pp. 57—84 for a good discussion.

3. I am grateful to Mr. S. Kohlhagen for these estimates, which he based on W. Beckerman & R. Bacon, 'International Comparisons of Income Levels: A Suggested New Measure,' *Economic Journal*, Vol. 76, pp. 519—36 and national estimates of personal income distribution by size.

4. The ratio of students enrolled in institutions of higher education to total population was, in 1967, 4 times as high in the United States as in Western Europe. Cf. *UNESCO Statistical Yearbook 1969*, Table 2.12, pp. 257—73.

5. Cf. J. C. Charlesworth (ed.) *Leisure in America: Blessing or Curse?* (The American Academy of Political and Social Science, 1964, Philadelphia).

6. Cf. for the best, and best-known discussion of this subject Georges Friedmann, *Le Travail en Miettes*, (1964, Paris).

7. Çf. 'Recherche Comparative Internationale sur les Budgets Temp,' INSEE's *Etudes et Conjoncture*, Sept. 1966, Table III.1, p. 155.

8. In 1968, U.S. expenditures on 'Recreation and entertainment' were 5.6 per cent of total private consumers' expenditures; the corresponding percentage for the EEC countries, the U.K., Norway and Sweden, combined was 8.0 per cent. Cf. *United Nations Yearbook of National Accounts Statistics, 1969* Table 7 of each country's tables.

9. Cf. the items 'Ménage' and 'Repas' in the table cited in footnote 6 above. The comparison is between the U.S. and the average of the 3 Western European countries cited.

10. Cf. J. P. Bunker, 'Surgical Manpower — A Comparison of Operations and Surgeons in the United States and in England and Wales,' *The New England Journal of Medicine*, Vol. 282 (1970) pp. 135—44; Institute of Life Insurance, *Life Insurance Fact Book 1970* and *A Survey of Europe Today* (London, 1970) Table 12, pp. 70—1.

11. In Western Europe, the proportion of the adult population taking holidays of 6 days or more in 1967 was 66 per cent in Sweden, 64 per cent in G. B., 62 per cent in Switzerland, 49 per cent in France, 28 per cent in Italy; 44 per cent in Western Europe as a whole. In the United States, the proportion of the total population taking trips of 6 nights or more for reasons other than business, family affairs and attending conventions was, in 1967, 28 per cent. By assuming that half of those giving business, etc., as the main purpose of their trip combined this with a holiday, one raises the proportion of holiday takers to almost 32 per cent. The fact that the European data refer to adults only renders the disparity even greater, since a higher proportion of children than of adults can be assumed to take vacations. Cf. *A Survey of Europe Today*, Table 42, pp. 138—9 and U.S. Bureau of the Census, *1967 Census of Transportation*, Vol. 1, *National Travel Survey*, Table 8, p. 24.

12. The U.S. Public Health Service sets the greatest permissible number of coliform organisms in pasteurized milk at 1,000 per 100 milliliters. Most

States set the same standard, as a monthly average, for water declared suitable for swimming and bathing, although some require much higher standards of water purity. In Utah and Washington 50, in Maine 100, in Montana and New Hampshire 240 coliforms per 100 milliliters on a monthly average are the permissible maxima for water to swim and bathe in. Cf. Resources Agency of California State Water Quality Control Board, *Water Quality Criteria, California State Report,* 2nd ed., 1970.

13. Cf. Alan Peacock, in 'Welfare Economics and Public Subsidies to the Arts,' *The Manchester School,* Vol. 37, 1969, pp. 323–35, where the conflict between the music lover and the good economist strikingly illustrates the truth of my statement [reprinted below as Reading 4].

14. Cf. A. Hilton, 'The Economics of the Theatre,' *Lloyds Bank Review,* July 1971, p. 26.

4. Welfare Economics and Public Subsidies to the Arts[1]

by A. T. PEACOCK

reprinted from Manchester School of Economics and Social Studies *December 1969 pp. 323–35*

I. Introduction

Subsidizing the Arts involves the same kind of issues as subsidizing particular industries or services in the economy, however distasteful this may seem to those who are conditioned to think in terms of a moral hierarchy in the ordering of consumption expenditure. In this analysis, attention is confined to two arguments for subsidization which are derived from the existence of 'market failure', i.e. the recognition that the strict Paretian assumptions of divisibility of goods and absence of externalities of production and consumption are not met with in practical life. A particular aspect of the problem of indivisibility which is relevant to the subsidization of the Arts is the taking account of the welfare of future generations, that is to say the welfare of those whose interests cannot be directly expressed at present through the exercise of their own preferences in the market.

It is assumed that we are not interested in the contribution of Arts to stabilization or growth. Full employment of resources is given and we ignore the possibility that subsidizing the Arts might be a possible way of inducing people to work harder and more efficiently than if cultural activities were left solely to the judgement of the market. Cultural paternalism which might be justified on the grounds that the community does not know what is good for it, is ruled out. Apart from any predisposition of the author to oppose paternalism, the assertion of imposed value judgements is too easy a way of deriving support for public intervention designed to give the public not what it wants but what it ought to have!

Before we can proceed to answer the question, should we subsidize the Arts, and how it might be done, we need information on two matters. The first is the scope of the 'industry'. Here I shall consider only the performing arts, although much of the argument could be applied to the visual arts. I shall also assume that we are interested not only in the playing and performing of 'classics', but also the problems associated with ensuring continuous 'creation'. The second matter is that we should have some idea of the present nature of the industry, and will want to know in particular why so many artists and critics talk about 'Art in the Red' or 'Art in Jeopardy'. As their worries are shared by no less an authority than William Baumol, a useful point of departure is Baumol's analysis of the arts as the victims of the unbalanced growth problem.

II. 'Baumol's Disease'[2]

Let us assume that the economy is divided into two sectors. In sector 1, productivity of labour is constant, and in the other it grows at a constant rate of increase, r. Writing outputs as Y_{1t} and Y_{2t}, and quantities employed in the two sectors as L_{1t} and L_{2t}, then their value in time t will be:

$$Y_1 t = aL_{1t} \tag{1}$$

$$Y_{2t} = bL_{2t}.(1 + r)^t \tag{2}$$

For simplicity, let us call $(1 + r)^t$, K.

Let it be further assumed that wages per unit of labour are the same in each sector, fixed at W_t shillings, and that W_t grows at the same rate as output in the 'progressive' sector, so that:

$$W_t = W.K \text{ (W being some constant)} \tag{3}$$

From these two assumptions we find that labour costs per unit of output (C_1, C_2) will grow without limit in sector 1 and remain constant in sector 2. This follows because:

$$C_1 = \frac{W_t.L_{1t}}{Y_{1t}} = \frac{W.K.L_{1t}}{aL_{1t}} = \frac{WK}{a} \tag{4}$$

$$C_2 = \frac{W_t.L_{2t}}{Y_{2t}} = \frac{W.K.L_{2t}}{b.L_{2t}.K} = \frac{W}{b} \tag{5}$$

A corollary to this proposition is that we would expect that market demand for the output of sector 1 would decline relative to that of sector 2. A simple example is given by the assumption that relative outlays on the two commodities remain constant and that prices (P_1, P_2) are proportional to labour costs.

$$\text{i.e. } \frac{P_1 Y_1}{P_2 Y_2} = \frac{C_1 Y_1}{C_2 Y_2}$$

Thus:

$$\frac{P_1 Y_1}{P_2 Y_2} = \frac{C_1 Y_1}{C_2 Y_2} = \frac{W.K.L._{1t}}{W.K.L._{2t}} = \frac{L_{1t}}{L_{2t}} = A \text{ (constant)}$$

from which it follows that the output ratio of the two sectors[3] would be:

$$\frac{Y_1}{Y_2} = \frac{aL_{1t}}{bL_{2t}K} = a.A/b.(1 + r)^t \tag{6}$$

$$Y_1/Y_2 \to 0 \quad \text{as} \quad t \to \infty$$

Now suppose the above demand conditions obtain in the market, meaning that the constant productivity sector would suffer a relative decline, and that government policy requires that the relative outputs are to be maintained. (This is an extreme, but useful simplifying assumption.) Then the condition must hold that:

$$\frac{Y_1}{Y_2} = aL_{1t}/bL_{2t}.K$$

or

$$(b/a).Y_1/Y_2 = \frac{L_{1t}}{L_{2t}.K} = B \text{ (constant)}$$

Now let $L = L_1 + L_2$ be the total labour supply, Then

$$L_1 = (L - L_2)B.K \text{ or } L_1 = \frac{L.B.(1 + r)^t}{[1 + b.(1 + r)^t]}$$

and

$$L_2 = L - L_1 = \frac{L}{[1 + B(1 + r)^t]}$$

Thus if the ratio of the outputs of the two sectors is to remain constant

$$L_1 \to 1, \quad L_2 \to 0, \quad \text{as } t \to \infty$$

The corollary of this proposition must be that the percentage rate of growth of the economy will approach zero, as t increases.

Removing Judge Brack from the cast of *Hedda Gabler* would certainly reduce labour input to Ibsen's masterpiece, but it would also destroy the product. Nor could one increase the productivity of the cast by performing the play at twice the speed. Anyone who doubts this proposition should try playing modern long-playing discs at 78 revolutions per minute. But are these sorts of examples persuasive?

III. Has Contagion Set In?

The description of the disease has been described by Baumol in rather dramatic terms, possibly deliberately, which is readily explicable in terms of his concern for the Arts.[4] However, we must consider a number of points before we can accept the diagnosis and estimate the degree of contagion.

(a) The first assumption of importance is that of the relative productivity of the Performing Arts and other services. Within broad limits, even casual empiricism would suggest that Baumol is right, which means that the substitution of capital for labour is strictly limited in the Performing Arts. We might question whether this will remain so in the foreseeable future. One has at least the impression that, albeit unconsciously, modern composers, for example write more and more for small ensembles, and employ all kinds of devices which vary capital intensity. Peter Maxwell Davies, for example, uses an ancient gramophone and pre-recorded tapes in his new composition *L'Homme Armé*. The casts of many modern plays, notably in Pinter, Becket and Wesker, are small in number, but it is a moot point how far the wage bill is a linear function of the number of the cast! It could also be argued that value as well as physical productivity depends on the number of players and labour intensity. In other words, fewer players and more machines on the stage may not be a complete substitute for a large orchestra in tuxedos. Performance is a visual as well as an aural entertainment.

However, even if Baumol is right, we must be careful how we define 'performance', and, as we shall see, definition is a vital matter when it

comes to the issue of subsidies. Audience access to the product is no longer limited to the concert hall and theatre, with the development of the new media of radio, television and gramophone. There is an interesting parallel here with other activities in which the degree of consumer participation in production has altered in response to technical innovation. Whether or not the changing relative cost of services has 'caused' technical innovations is a matter for discussion, but there are many cases in which production of services has moved into the household in recent years. The decline in the availability of domestic servants and wages which households are willing to pay has been matched by extensive use of durable household equipment. An even better example, perhaps, is shaving.[5] The invention of the safety razor turned the barber's shop into a hairdresser. In order to listen to music, it is now only necessary to switch on the radio or the phonograph. Even if it is claimed that 'there is no real substitute for live performance', the relevant comparison for the individual is between the costs of a theatre or concert ticket, plus other on-costs, such as transport and meals out, as against investing in more capital intensity in the form of stereo equipment and TV, coupled with a much lower variable cost of input. Whether the 'packaged evening' out or in will offer the same enjoyment is a matter of judgement.

(b) The strong assumption that wage rates are the same in the progressive and unprogressive sector obviously requires further investigation. One's instinct as an economist is to explore in detail the supply elasticities of labour in the performing arts and with little or no empirical data, one might postulate that it is likely to be inelastic in the short-run and elastic in the long. This is the economic counterpart to the dedication of the artist coupled with the strong personal satisfaction associated with performance. Baumol and Bowen[6] argue that even if money wages of artists rise at a slower rate than the general rise in wages, this is sufficient to price the Arts out of the market, because every wage increase increases variable costs, i.e. there are no offsetting productivity gains. As argued above, this may be implausible when one broadens the definition of performance to include the new media.

(c) It will be recalled from equation (6) above that the conclusion Y_1/Y_2 would diminish through time rests on the assumption that $P_1 Y_1 / P_2 Y_2 = A$, i.e. relative outlays in the two sectors would remain constant. However, we can infer nothing about the value productivity of the unprogressive sector from the physical productivity assumptions. Productivity gains may be zero in that sector and labour costs may rise

in line with those in the progressive sector, but producers of services may still be able to increase relative prices. Negative substitution effects resulting from growing costs to the consumer of services could be offset by positive income effects, for growing real incomes in the economy as a whole may encourage a shift of demand from the products of the progressive to those of the unprogressive (services) sector. In broad terms this is what appears to have happened in the last three decades, judging from the increase in the net output share of GNP of services.

The difficulty is that we do not have sufficient data to establish trends in the performing arts of a form which would make it reasonable to offer predictions. The prevailing view is that 'Baumol's Disease' is spreading in the performing arts to the extent that their survival depends in part on finance other than from the direct sales of services,[7] and in the absence of evidence to the contrary, we assume this in the rest of the paper.

In addition, it is assumed that the community interest lies in the preservation of live performance, not only of established works but of new musical works and plays and other 'happenings'. Associated with this is the assumption that these activities also determine the stock of domestic creative and artistic talent.

IV. The Welfare Economics of Subsidization[8]

As stated earlier, the argument for subsidization must be based on some form of 'spillover' from cultural activities, granted that we have ruled out objectives other than pursuit of consumer sovereignty. What I propose to do in this section is to consider common arguments used for subsidization and to reduce them to familiar categories in welfare economics discussion.

The first set of arguments relates to the spillovers received by other producers from the existence of performing arts. Thus, leaving aside other reasons for running Arts Festivals, which are considered later, it is claimed that we can use performing arts as a kind of loss-leader in this kind of situation. An extension of this argument is found in the view that one can increase the range of choice of factors of production in the form of professional skills by creating the right kind of cultural ambience, particularly in areas at present regarded as cultural deserts.

Assuming a closed economy, it is plausible to argue that the spillover

is purely a pecuniary one. Expansion in demand, if it occurs, in Festival towns is at the cost of reduction of demand elsewhere, assuming no area differences in the marginal propensity to consume. However, clearly the distinction between technological spillovers and pecuniary spillovers is difficult to make, even in this case. Movements must take place along the production functions of industries as a result of demand re-allocation, and it is difficult to determine how far the degree of market imperfection is altered as a result of successful 'festival' advertising.

If benefits can be regarded as mainly pecuniary, there is no case for national public action, unless we introduce inter-personal or possibly inter-regional comparisons of utility. If we confine our universe of decision-makers to a particular region, then the benefits may not be solely pecuniary, although here again if the initial regional position is one of full employment of resources, the effect of an increase in 'foreign' demand may be to raise prices, at least temporarily, as well as real incomes within the region. Even then, one has to prove that cultural inputs, however provided, are more 'productive' than any alternative way of attracting visitors using the same amount of resources. It is only when we assume that given inputs to culture *are* the most efficient method that we arrive at a possible reason for regional government subsidization. This is because the benefits provided by the loss leader are not easy to assign to, for example, individual shopkeepers and hoteliers so that they may not have an incentive to promote the cultural activity, or at least find it difficult to negotiate voluntarily on the division of its costs. A case is then made for a public subsidy, financed by some local form of taxation.[9]

The regional case can be applied to the international situation. If culture attracts foreign tourists, then, given full employment of resources, prices rise, and so do foreign exchange receipts (*less*, of course, any increase in imports, e.g. payments to foreign artists). One must trade off the changes in present real income against the changes in foreign earnings, which may increase future real income. Even then, assuming that we wish to maximize foreign exchange earnings, subject to some constraint on the adverse reactions on domestic real income, it has to be proved that at the margin 'culture' is the best method of achieving this result.

The second set of arguments concentrates on the alleged external economies of consumption derived from the Arts. Writing of the Arts, Lionel Robbins argues that 'the benefit is *not* merely dis-

criminate ... the positive effects of the fostering of art and learning and the preservation of culture are not restricted to those immediately prepared to pay cash but diffuse themselves to the benefit of much wider sections of the community in much the same way as the benefits of the apparatus of public hygiene or of a well-planned urban landscape'.[10] While being sympathetic with his general point of view, the author finds it difficult to trace the way in which spillovers from the 'culture vultures' attending live performances to others is supposed to take place. It would be interesting to poll the public at large in order to confirm whether they derived an uncovenanted benefit from the attendance at publicly-subsidized symphony concerts or modern plays by those whose median income is almost twice that of the employed population. There is possibly something to be said for the more limited argument used by the Arts Council[11] that the community derives a satisfaction which they cannot be excluded from enjoying as a result of the international prestige of the Royal Opera and Ballet and the National Theatre Company. Reports of rave reviews in *Pravda, Le Monde, Die Welt* and the *New York Times* may be very welcome, but at the same time, one has to face the difficulty that if the resources used to support Performing Arts have alternative uses which produce the same result, what then? How do we compare, say, subsidizing the Arts with the subsidizing of Concorde, or, say, the fares of Leeds United to play Milan? One cannot make a case on grounds of externality in absolute terms alone, however much one shares the value judgements of its proponents.[12]

The final argument is that of the satisfaction derived by the present community of economic decision-makers from conferring benefits on future generations. Even those who do not understand and appreciate music and drama may be glad to contribute towards making available their fruits to those who do, and particularly to those whose tastes are not yet formed. Present generations may derive positive satisfaction from preserving live performance safe in the knowledge that they do not risk being accused of narrowing the range of choice of cultural activities for future generations through allowing the Arts to die.

The argument suggests an analogy with the conservation of natural resources. It is true that if we destroy areas of natural beauty today, there is no resource-using activity which can bring about their future restoration. Is the same true of the Performing Arts? I agree with Baumol and Bowen that it is not necessarily true that if the Performing Arts languish, they need necessarily disappear for ever,

although it may take long enough for the re-creation of a cultural tradition. I would add the point that if the object is to preserve a *national* culture rather than a transplanted one, the analogy with natural resources conservation may be a closer one. One can always revive opera by importing Italian companies, but it may be a different matter agreeing a price at which they will be willing to revive Gilbert and Sullivan — and in English!

The crucial question is whether 'a program to preserve the arts for the nation's posterity is a case of indiscriminate benefit par excellence'.[13] This view may be persuasive and may partially account for the growth of support, in principle at least, for public subsidies to cultural efforts. At the same time, if consumption externality is to be derived from cultural investment, our attitude to its amount and form clearly depends on who is to benefit and who, in consequence, will make the sacrifices. This point has been made forcefully by Tullock in connection with the choice of a social rate of discount.[14] An increase in public investment which redistributes income to future generations from the present one, given present rates of economic growth, may represent a transfer of consumption benefits to those whose average *per capita* income will be higher than that of the present generation. As Tullock argues, are we willing to give a bounty to future generations rather than, say, to the underprivileged of the present generation? Put in such general terms, Tullock's point suggests that any government which took into account the wishes of a community which preferred to help today's poor rather than tomorrow's rich would not use a 'low' social time preference rate. The point therefore arises, is the 'future generations' argument in respect of the Arts less persuasive than it looks at first sight, because future generations are likely to be richer on average?

The answer is: not necessarily. The community in this instance is not being asked to approve generalised support for future generations through increased investment, but the selective support for one item to be made available for future consumption. Therefore, it is perfectly rational for a community to adopt a social discount rate which is 'high', so that there is no general encouragement to investment to benefit future generations but to offer a particular and continuing subsidy designed to support the performing arts.

Nevertheless, Tullock's argument suggests a restriction which might have to be placed on the *form* of subsidy, it the community is to be persuaded to give continuing support to the Arts. If the system of

upport, as at present, simply provides a subsidy to a cultural minority n the upper income groups, why should present generations be nterested in giving support to the *rich* of a future generation which nay be richer anyway? If resources are diverted from other uses, ncluding helping today's poor, in order to preserve our cultural eritage, the future generations argument will surely have more appeal f the benefits we hope they will derive from this diversion are much nore widely distributed than they are at present. How this might be lone is the main subject of the next section of this paper.

V. Policy Issues

n order to understand the policy issues and how they might be esolved with reference to our conclusions from welfare economics, one hould consider the present characteristics of government support for he Arts. I shall concentrate on central government support via the Arts Council for England and Wales.

There are three characteristics of this support of relevance to this nalysis. The first is that it is heavily concentrated on music, and articularly opera. Of the £5.75 mn. net expenditure by the Arts Council in fiscal year 1967/68, £3.3 mn. represented grants to music, ;1.3 mn alone supporting Covent Garden Opera. Drama received ;1.7 mn. and the remainder went to support Art, particularly Art xhibitions. The second is that expenditure is heavily concentrated in he London area, 80% of expenditure on music finds its way to opera, allet and orchestral societies, nearly 40% of expenditure on drama, all n London. The third characteristic is that financial support is almost ntirely given to the institution responsible for performance, as a device or lowering the price of admission.

Were this pattern of support to continue, it follows that, unless London-based orchestras, theatre companies, opera and ballet were villing to travel much more than they do at present,[15] the benefits will ccrue, via subsidized prices, largely to the upper income groups in the rea with the highest *per capita* regional income. Even then, the general olicy of subsidizing seats, even if companies travelled more, is not ikely to encourage a wide diffusion of benefits by income group. The resent policy, therefore, is not only 'unjust', but also sows the seeds of ts own demise, for it is difficult to imagine that a major expansion will

be sanctioned in expenditure in the Arts if the present policy continues
It is only fair to mention that the Arts Council is well aware of th
problem of regional concentration of the benefits of expenditure and i
doing what it can to change the existing pattern.

So far as the balance of expenditure is concerned between on
performing art and another, it is difficult to offer any specifi
observations as an economist. Aesthetic judgements are value judge
ments and cannot be proved right or wrong. In line with the doctrine o
consumer sovereignty, while one may be willing to be guided b
practitioners in the performing and creative arts about the direction o
public support, we must be protected from cultural monopoly. As
have suggested elsewhere (see n. 8), the same kind of problems arise i
the allocation of public funds for research in the social and natura
sciences. The best means of protection seems to be a rapid circulatio
in the membership of the grant-giving bodies so that all shades o
cultural opinion can be reflected in the allocation of funds throug
time.

The major question, however, is how the benefits of live per
formance can be diffused so that the poor of today and tomorrow ar
both able and willing to have access to them and are not to be asked t
support the rich today and the sons of the rich tomorrow, and in th
richest areas of the country. In principle, there are two solutions:
short-term and a long-term one. The short-term one requires tha
support is moved away from the subsidizing of producers of cultura
activities towards the subsidizing of individuals. The long-term one is t
devise a means of altering the preference functions of future gene
ations so that Baumol's disease may be counteracted through the marke
as well as through the political mechanism which offers state suppor

Those familiar with the author's writings will not be surprised to fin
that he would be in favour of a voucher system. In general terms, thi
would require that theatres and concert halls would charge commercia
prices and a certain proportion of seats would be available to som
defined group of persons, the vouchers then being exchangeable fo
cash disbursed by the grant-aiding body. Alternatively, the grant-aidin
body or bodies might agree to buy a certain proportion of seats and t
offer these free or at reduced prices to the relevant groups.

There are, however, a number of snags about this system whic
would have to be overcome. First, the attraction of such a scheme ir
say, educational provision is that the relevant group to be subsidize
selects itself, i.e. schoolchildren of a certain age group, and the fact tha

education is compulsory ensures that those whom the voucher is meant to benefit cannot be marketed. At the same time, the system assumes that the voucher is available for a range of alternative sources of supply of education, state or private.[16] 'Self-selection' by relevant groups is not nearly such an easy matter for one has to identify not only the relatively poor but those of their number who have an actual or potential interest in serious music or drama. It would also be difficult to guarantee that recipients of vouchers would not sell them to those better able to afford tickets at commercial prices,[17] which would be an interesting, if peculiar method of redistributing income. Even if these difficulties were overcome, it is inconceivable that there would be sufficient alternative and continuous sources of supply of serious music and drama to make it worth while to use the voucher scheme as an incentive device to increase the supply of live performance.

Perhaps the best that can be done is for the Regional Arts Associations to be more closely involved with the subsidization process. They would have more direct knowledge of the various drama and music organizations and schools whose members merit support. One might be able to circumvent the problem of voucher re-sale by a block-booking system for subsidized seats, so that no voucher was assignable to a particular individual.

Second, a formidable problem arises from the fact that it is claimed that opera companies and orchestras, like certain local wines, cannot travel and maintain their quality. We all know of cases where we have been led to believe that such organizations on tour will have certain artists appearing, but who somehow or other remember other more pressing (and possibly more lucrative) engagements. Again, some experimentation in pricing needs investigation. For example, Covent Garden could raise its prices somewhat and a proportion of the seats be filled with an eager 'provincial' audience whose vouchers covered their train fares, in whole or in part, as well as the price of seats. No doubt richer and better nurtured (in the cultural sense) Londoners would claim to suffer external diseconomies of consumption because such an audience might clap in the wrong place! At least, some experimentation is called for in the interim period so as to bring in being a cultural demonstration effect which might encourage other parts of the country to build their own opera houses and so be able to compete more effectively with London for public money.

In the longer run, the diffusion of benefits might best be brought about by directing a large part of any increase in funds for the Arts

through the education system. Apart from the possibility that such support may serve to alter the preference functions of future generations to create receptivity to the benefits of culture and so help to combat Baumol's disease, there is another important reason for the use of this channel. Developments in the creation of new music and theatre seem much more likely to appeal to those who have direct experience in composing and playing music and in performing and writing plays. If I am right in this, the earlier in life we start to encourage this form of creative activity the better for the survival of the performing arts.

1. This paper is a revised version of one delivered to the Staff Economics Seminar, University of York, and to the Conference of the Association of University Teachers of Economics held at the University of Essex, April 1969. I am grateful to both audiences for their comments and criticisms. In particular, I must thank Alan Prest for editorial comments and Gordon Mills, the discussant of the paper at the AUTE meeting. The article was completed before the author became Chairman of the Arts Council National Enquiry into Orchestral Resources.
2. This section summarizes the argument presented in W. J. Baumol, 'The Macroeconomics of Unbalanced Growth', *American Economic Review*, June 1967. For the application of the analysis to the performing arts, see William J. Baumol and William G. Bowen, *Performing Arts: The Economic Dilemma* Part II, Twentieth Century Fund, 1966.
3. Later in his article (see note 2) on p. 421, Baumol suggests that his mathematical analysis points towards the demise of sector 1 activities, including the theatre. It will be noted that all (6) can demonstrate is that output in sector 2 will expand relative to sector 1. Stronger assumptions are needed in order to produce a demise of the unprogressive sector, viz. a relative fall in outlays or a faster rate of growth in labour costs in sector 1. For example, using the same assumptions as embodied in (6), with the exception that:

$$C_1 Y_1 / C_2 Y_2 = \frac{(1 + r_1)^t . W . L_{.1t}}{(1 + r_2)^t . W . L_{.2t}} = A$$

it follows that if $r_1 > r_2$, then as $t \to \infty$, $L_{1t}/L_{2t} \to 0$. As before Y_1/Y_2 will also diminish, but at a faster rate than in (6).
4. See Baumol and Bowen, *loc. cit.*
5. This useful example is used by Carolyn Bell in her critique of the Baumol thesis. See C. S. Bell, 'The Macro-Economics of Unbalanced Growth: Comment', *American Economic Review*, September, 1968.
6. *Op. cit.*, Chapter VII.
7. For recent evidence, see *Grants for the Arts*, Eighth Report of the Estimates Committee, Session 1967/68, House of Commons Paper 443. It is also worth

noting that Professor Claus Moser, as one of the Covent Garden Governors giving evidence to the Committee, drew their attention to the Baumol/Bowen thesis. See page 122 of the Report.

8. A preliminary canter through these arguments is to be found in my article 'Public Patronage and Music, an Economist's View', *Three Banks Review*, March 1968.

9. It is beyond the scope of the present analysis to investigate the appropriate form of tax. Assuming that the object was to find an ear-marked tax which reflected, as far as possible, benefits accruing to producers of tourists' services, some form of selective sales tax would have to be found. At the same time, such a tax might result in a loss of economic efficiency. Awkward problems also arise in attempting to determine the incidence of such a tax.

10. See Lord Robbins, *Politics and Economics, Papers in Political Economy* 1963, p. 58.

11. See Arts Council, 22nd Annual Report and Accounts, Year Ended 31st March 1967.

12. This I believe to be the main weakness in the analyses of Lionel Robbins, *loc. cit.*, and Baumol and Bowen, *op. cit.*, Chapter XVI, 'On the Rationale of Public Support'.

13. Baumol and Bowen, *op. cit.*, p. 385.

14. See, Gordon Tullock, 'The Social Rate of Discount and the Optimal Rate of Investment', *Quarterly Journal of Economics*, May 1964.

15. It could be argued that TV and radio relays of performance reduce the weight of this proposition, but this is at least debatable, and, in any case, it is presumably the rich who largely own or rent the best forms of reproduction: for example, colour TV. Furthermore, these forms of relaying live performances are freely available to *all* regions and not simply to those deprived or subsidized ones. Finally, it is not without interest to note that historically the first areas to receive 'cultural' TV programmes through BBC Channel 2 were those with the greatest access to subsidized theatre and opera!

16. On this point — see A. T. Peacock and J. Wiseman, *Education for Democrats*, Institute of Economic Affairs, 1964.

17. Similar problems arose when pensioners were able to obtain vouchers for cheap tobacco. Non-smoking pensioners could then buy tobacco at lower prices than the rest of the smoking public but could not be prevented from re-selling it.

B. Evaluating Public Expenditure on the Arts

5. Cultural Accounting[1]

by A. T. PEACOCK and C. GODFREY

reprinted from Social Trends *November 1973 pp. 61–5*

Introduction

The authors are engaged with others on the application of cost-effectiveness analysis to public expenditure on the Arts. This requires them to consider the relation between government policies towards the performing and visual arts and the various methods of state support which both central and local government employ in pursuing these policies. A necessary adjunct to such a study is the preparation of a set of 'cultural accounts' which identifies the nature and magnitude of the flow of funds from the 'sources' of government finance for the Arts to the use made of these funds classified according to the type of artistic 'production', according to the type of decision-maker (central government, local government, private sector) and according to the factor inputs employed by the 'producers'. This appears to be the first attempt of its kind, though a Council of Europe study which is now in progress has somewhat similar objects in view.[2]

At this stage of the project it is not possible to 'fill in all the boxes', but the authors believe that the social accounting framework used[3] and their discussion of the main conceptual and statistical problems encountered may be of interest to economic and social statisticians.

The Framework of Accounts

In the case of the analysis of a product produced in the private sector and sold to domestic consumers, the framework of accounts would follow closely the sectoral classification found in the usual national income accounts, ignoring financial transactions. The 'industry' can be identified in the Standard Industrial Classification, its income receipts and payments presented in aggregate form and then, for example,

broken down according to an input-output classification which distinguishes final and intermediate outputs and inputs. For policy purposes, e.g. fiscal policy, subsidisation or taxation of particular sectors, this is the main information usually required and the transactors will be mainly in the private sector, either private consumers or producers.

In the case of the performing and visual arts, as in the case of education and health expenditure, the picture is much more complicated. The 'production' of the performing and visual arts, will be conducted both in the private sector (e.g. orchestras) and public sector (e.g. museums and galleries), and within the public sector by both central government (e.g. national museums) and local government (e.g.

Table I. Sources and Uses of Orchestral Finance

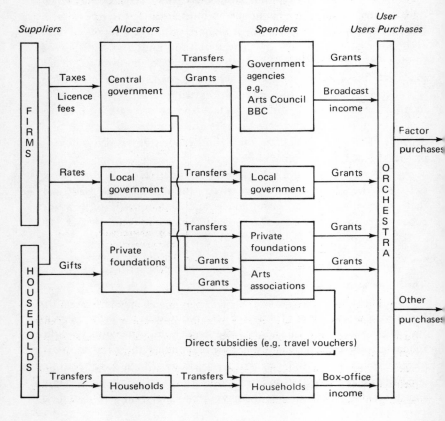

local art galleries). The private producers may be subsidised, although they operate on commercial lines, whereas the public producers, although not profit-making, may charge for services.

Both private and public producers may receive support from non-profit making private institutions, such as cultural foundations, gifts from individuals, and even subsidies from private firms in other lines of production. As examples, one might mention the gifts of pictures to state-owned national galleries, Gulbenkian foundation grants to composers and to private opera companies, and grants by tobacco firms to private orchestras. Private consumers of the Arts, too, may receive conditional subsidies, in the form, for example, of transport and ticket vouchers for theatre performances.

The complications in the scheme of payments and receipts require us to look beyond the direct payments by consumers to producers in order to trace the 'ultimate' sources of finance of the various kinds of Arts production. A suggested taxonomy requires us to identify the following 'stages' in the flow of funds from source to use:

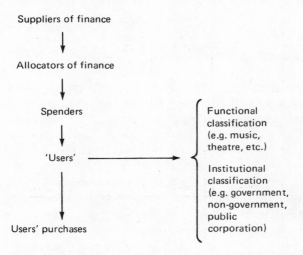

An illustration is given in Table I, where the example chosen is that of a British symphony orchestra. Its main sources of income are grants from the Arts Council, grants from local authorities and box-office income from concert promotions and engagements. In addition, it may receive some income from broadcast relays of concerts or studio performances, and occasional grants from foundations, e.g. the Stuyvesant and Sieff foundations. However, behind these direct sources

of income lies a complicated skein of transactions ranging from the tax receipts of government which eventually finance government agencies responsible for subsidies to the Arts and, through them, other private non-profit-making agencies, such as the regional arts associations and local music and orchestral societies, to gifts made by individuals and firms to charitable foundations for 'onward transmission' to producers of music. The picture would be even more complicated if we took into account that an orchestra may receive income from production of records and from concerts given abroad.

Clearly, if we wish to include all relevant forms of production of Arts, we increase the number of transactors and transactions. This suggests that for each 'stage' in the finance of the Arts a matrix should be constructed, showing the passage of funds from source to use. A set of matrices are presented in Tables III i-iv below. At this stage of our investigation we have concentrated on filling in the 'Use of finance' table.

Problems in Drawing up the Accounts

For the purposes of our investigation, we are primarily interested in performing and visual arts which receive regular support from central government alone or in association with local governments, and consequently the coverage of 'cultural production' in our accounts is narrow. (One might say that the definition of the arts adopted is implicitly 'bourgeois'!). Broadly speaking, we cover the main orchestras, opera and ballet companies and the subsidised drama among the performing arts, and national and provincial museums and galleries among the visual arts. Public libraries, historic homes in receipt of government support, professional training in the Arts, and the British Film Institute were all excluded, as well as the commercial theatre which sometimes receives indirect government support. A good case could be made for including all these items, but budget constraints alone were sufficient reason for exclusion. In any case, the main general problems of drawing up a 'Use of finance' table can be copiously illustrated by sticking to the narrow list.

Having, so to speak, delineated the 'column vectors' in Table II, which show the main lines of 'production' under consideration, the

Table II. Use of Finance, 1970/71

Great Britain

	Performing arts						Visual arts					
	Orchestras		Opera and ballet		Subsidised drama		National museums		National galleries		Local museums and galleries	
	000's	%	000's	%	000's	%	000's	%	000's	%	000's	%
Central government:												
DES	—	—	—	—	—	—	6,427	63.3	952	46.3	94	1.2
BBC	1,748	31.6	100	1.2	—	—	—	—	—	—	—	—
Arts Council	872	15.8	3,162	38.6	2,224	30.5	—	—	—	—	—	—
Other bodies	103	1.9	64	0.8	9	0.1	3,258	32.1	690	33.6	579	7.2
Local government	811	14.7	495	6.0	542	7.4	—	—	—	—	6,450	80.2
Regional arts associations	45	0.8	34	0.4	52	0.7	—	—	—	—	4	0.1
Households	757	13.7	3,188	38.9	4,321	59.3	454	4.5	406	19.8	822	12.2
Enterprises	605	11.0	35	0.4-	7	0.1	—	—	7	0.3	—	—
Other private institutions	459	8.3	486	5.9	52	0.7	16	0.2	—	—	98	1.2
Rest of World	132	2.4	637	7.8	80	1.1	—	—	—	—	—	—
Totals	5,531	100.0	8,200	100.0	7,286	100.0	10,155	100.0	2,055	100.0	8,047	100.0
	21,017						20,257					

next task is to identify their sources of income. In this case, our main interest lay in discovering the relative importance of public and private support for the different sorts of 'production'. So far as central government is concerned, a decision had to be made about the BBC. The BBC is an important 'producer' of music and drama in its own right, but it is also a major influence on the finances of other producers through its broadcasts of both live and recorded music. Although the BBC is not studied in our general investigation, we decided that it should be included in our accounting schema, both as a producer and source of finance for other production sectors.

Local government support illustrates another familiar difficulty in social accounting. An unknown but not insignificant part of local government support takes the form of 'hidden' subsidies, such as reduced rental of concert halls and other accommodation and other goods and services, e.g. free lighting and heating, box-office staffing and caretaking etc. No attempt has been made to impute a value to these goods and services.

Both local governments and regional arts associations support a wide range of artistic pursuits, but in confining our attention to those activities which receive regular support, we do less than justice to the role of these financing bodies. For example, by including only regional arts associations' support for professional companies, we record only half of their annual expenditure on the performing and visual arts. A large part of the remainder of their expenditure supports amateur production, often in the form of finance which enables amateur organisations to engage professional soloists.

In the private sector, we faced some difficult problems of allocation between the various 'purchasers' of services. The most interesting example is to be found in allocating box-office receipts between 'Households' and 'Rest of the World'. In our accounts the flow from the latter source represents only direct receipts by performing arts companies from foreign tours and a small amount of income from overseas royalties for recordings. However, the 'Rest of the World' flow should include box-office and other receipts from foreign tourists and overseas companies based in the UK, as well as purchases of books, postcards etc. and payments for admission to museums and galleries made by foreigners. We were unable to make an estimate of the amounts involved, which is all the more regrettable because of the frequent statement of the argument that our cultural institutions are a tourist 'draw'.

Finally, attention must be drawn to the fact that the form of accounts used leaves no place for the inclusion of transactions *between* producers of culture and for capital expenditure. The largest set of 'intra-sector' transactions takes place between opera and ballet companies and orchestras. The former, particularly when on tour, may engage the services of orchestras instead of employing their permanent orchestra (if they have one) which is based in London. Such transactions are excluded, as far as is possible, and this is not a difficult operation in the example just given. It is more difficult in the case of theatres where the only reliable source of data is the theatre company accounts. Thus theatres may obtain income from the accommodation of touring ballet and opera companies, but it is difficult to separate out the income received from this source from income attributable to subsidised drama. Although we have done what we can to identify the amounts involved, we believe that the subsidised drama receipts are still somewhat overestimated. On the whole the separation of current and capital receipts presents no major difficulties.

Comments on the Results

Table II presents our results for the latest year for which it was possible to obtain reasonable data. In offering comment on the pattern of sources of income, two things must be borne in mind. Firstly, there are bound to be variations in the structure of the flows represented in the table from year to year, even in the short as well as the long run. For example, in 1970—71 only one of the major drama companies undertook a foreign tour whereas both major companies (Royal Shakespeare and National Theatre) undertook foreign tours during the previous year. Secondly it bears repeating that Table II only records the direct support received by the 'cultural producers' from government. For example, the Arts Council gives grants to music societies and festival committees in order to help to promote concerts by the orchestras covered by our investigation. Such grants would appear in an 'Allocation of finance' table (See Table III.ii) as a flow from the central government (via the Arts Council) to 'Other private institutions'.

Looking at the overall picture first of all, the following features are

noteworthy:

i. The total flows to the performing and to the visual arts sectors were approximately equal.

ii. There were marked differences between sectors in the proportion of support received from taxpayers, including broadcasting licence holders, and ratepayers. At one end of the scale, the subsidised drama received 38.8 per cent of its income from government bodies, while at the other end national museums received 95.4 per cent. In general, the performing arts relied more heavily on box-office, and, if one excludes the operations of the BBC, orchestras derived 51.6 per cent of their income from non-governmental sources.

iii. There was a heavy concentration of central government support on London-based suppliers of culture. Ten out of the sixteen museums and galleries covered in our study are based in London and receive 88 per cent of central government support going to these institutions. 71 per cent of central government support to opera and ballet was received by the Royal Opera House and the Sadlers Wells Trust (Coliseum).

Some comments on the composition of income of sub-sectors may be useful:

Orchestras The largest single item was BBC expenditure on orchestral services, but by far the largest part of this item represented the expenditure by the BBC on its own house orchestras. One feature of this sub-sector is the considerable proportion of total income from the private sector — about 30 per cent — which comes from engagement fees as distinct from concert promotions by the orchestras themselves. Thus local authorities (for educational concerts), festival committees, and recording companies may hire orchestral services. In the first two cases, the hirers may recoup their hiring expenses from the household sector in the form of admission charges, but such transactions will be shown a stage further back in the social accounting schema. Engagements, therefore, account for the 'spread' of income sources. Conversely, the relative importance of 'enterprises' and 'other private institutions' as sources of income does not imply that 'households' are not financing these transactions to a considerable degree even though orchestras do not receive such income from households directly.

Opera and ballet Total expenditure on opera and ballet was nearly 50 per cent greater than on orchestras and well over double if BBC orchestral activity is excluded. A large part of the difference is accounted for by the size of the Arts Council direct subsidy to opera and ballet which is greater than the direct subsidy to orchestras and drama combined.

Subsidised drama There were approximately 100 subsidised drama companies in 1970–71 compared with about 30 opera and ballet companies. In contrast to the 'spread' of income received from the private sector by orchestras, practically all the income obtained by subsidised drama from this source came from the box-office. Direct receipts from households were not only the major source of income of this sub-sector, but these receipts were 10 per cent higher than the combined receipts from households of opera and ballet and orchestras.

National museums and galleries As previously stated, these institutions relied very largely on the central government for their income. In fact, they received 56 per cent of the total direct expenditure by the central government on support of performing and visual arts as defined. The national galleries, notably the Tate and the National Gallery, obtained a not inconsiderable income from publications which explains the bulk of the receipts from households by this sub-sector. However, receipts that are at present classified as Appropriations-in-Aid in the government accounts, are not under the control of the Trustees of the museums and galleries. This procedure is now under review by Lord Eccles and in future national museums and galleries may have more control over this revenue source.

Local museums and galleries Not surprisingly, as most of the institutions in this sub-sector are managed by local authorities, they received the bulk of their support from local finance. 78 per cent of local authority direct support for the performing and visual arts was applied to local museums and galleries. Total payments by households in this sector for admission and purchase of publications were almost as high as for the national museums and galleries combined. The remaining source of income of importance was in the form of Arts Council support for exhibitions.

Table III.i. Supply of Finance

		Payments to:				
	Central government	Local government	Households	Enterprises	Other private institutions	Rest of World
Received from:						
Households						
Enterprises						
Other private institutions						
Rest of World						

Table III.ii. Allocation of Finance

	Payments to:									
	Central government agencies			Local government	Regional arts associations	Households	Enterprises	Other private institutions	Rest of World	
	DES	BBC	Arts Council	Other bodies						
Received from:										
Central government										
Local government										
Households										
Enterprises										
Other private institutions										
Rest of World										

97

Table III.iii. Use of Finance

| | Performing arts | | | Visual arts | | |
| | Music | | | | | |
	Orchestral	Opera and ballet	Drama	National museums	National galleries	Local museums and galleries
Central government:						
DES						
BBC						
Arts Council						
Other bodies						
Local government						
Regional art associations						
Households						
Enterprises						
Other private institutions						
Rest of World						

Table III.iv. Purchases of Users

Users:	Payments as:					
	Wages and salaries		Other production expenditure	Promotion expenditure	V.A.T. and other tax payments	Other general administration expenditure
	Performers	Others				
Orchestras						
Opera and ballet						
Drama						
National museums						
National galleries						
Local museums and galleries						

1. The authors wish to express their appreciation for financial support from the SSRC for a project on cost-effectiveness of public expenditure on the Arts awarded jointly to Professors Mark Blaug (London) and Alan Peacock (York). They have also benefited greatly from information and comment received from the editors of *Social Trends* and from the Department of Education and Science.
2. See *National Cultural Accounts*, Council for Cultural Co-operation, Council of Europe, Strasbourg 1972. This study seeks to identify state expenditure only on cultural activities in a number of countries and adopts a much wider definition of 'culture'.
3. The framework is similar to that found in A. T. Peacock, H. Glennerster and R. Lavers, *Educational Finance: Its Sources and Uses in the United Kingdom,* Oliver and Boyd, 1968.

6. Does the Arts Council Know What It Is Doing?

by K. KING and M. BLAUG

reprinted from Encounter *September 1973 pp. 6–16*

The Arts are subsidised in Britain to the tune of about £35 million a year, the actual figure depending to some extent on how much of radio and television we include in our definition of the Arts. £35 million is a small sum compared to public subsidies of over £2,000 million to health and to education. But small as the sum is, it raises with a vengeance the problem of evaluating government expenditure. It may be difficult to say just why we spend money in the way we do on schools and hospitals, but it is even more difficult to say why we support the Arts in one way rather than another, and in particular why we support it as little as we do compared to other countries. It is clearly impossible to evaluate government expenditure in a particular direction without knowing the aims of government, particularly as there will usually be many different aims. Even if we succeeded in drawing up a list of aims — objectives, goals, ends, the reasons why — we still face the task of somehow measuring the effectiveness of various spending patterns in achieving these aims. Since the answers — one for each objective — are quite likely to go in opposite directions, we need a scale of priorities between objectives to arrive at a comprehensive evaluation. We label this evaluation technique 'cost-effectiveness analysis' and in principle it is as applicable to the Arts as it is to any other area of government activity, although in practice it may be particularly difficult to apply to the Arts.

Be this as it may, we must clearly begin with a statement of objectives. Unless we get this right, evaluation is impossible on anybody's theory of evaluation. In this article we examine the objectives of the Arts Council in subsidising the Arts and we will, therefore, confine ourselves to those aspects of the Arts supported by them. Although the Council is only responsible for about one-third of all public expenditure on the Arts (the remainder being largely devoted to museums and galleries), it exerts a more significant influence on the

101

Arts than other public bodies, such as local authorities. Its subsidies cover all major art forms including opera, ballet, orchestras, theatre, cinema and, to a lesser degree, art galleries and the experimental arts.

Our evidence derives mainly from the Annual Reports of the Arts Council. These reports concentrate on the financial aspects of the Council's activities but they always contain a brief section on policy issues. The space allocated to balance sheets reflects the Council's consistently maintained view of public accountability:

> Money, rough-hew it how we may, is the subject of all our Annual Reports. Indeed, the view gains currency in St. James's Square that everything in them outside the Accounts is properly called 'extraneous matter'[1]. (1965–66)

Nevertheless, the Council has always acknowledged the right of outsiders to ask the reasons why:

> There is a need to satisfy our readers who pay taxes but may not like reading balance-sheets, that we have not wasted their money and intend to spend it to even better advantage in the future. (1965–66)

The central problem to which we address ourselves is simply: What is a 'waste' of money in the field of the Arts, and how would one recognise waste if one saw it?

1. The Role of the Arts Council

In his introductory speech, heralding the creation of the Arts Council in 1946, Lord Keynes asserted that:

> The purpose of the Arts Council of Great Britain is to create an environment, to breed a spirit, to cultivate an opinion, to offer a stimulus to such purpose that the artist and the public can each sustain and live on the other in that union which has occasionally existed in the past at the great ages of a communal civilised life. (1945)

A more explicit statement did not appear until four years later, when Sir Ernest Pooley, acting as Chairman, referred to the Council as: 'a very important experiment – State support for the arts without State control. We prefer not to control, though sometimes we must; we want to support, encourage and advise' (1948–49).

Clearly, the Council saw itself playing a prominent and active role, a nucleus around which artistic activity would revolve. However, the nuclear concept was not expressed until many years later: 'the Arts Council's essential function was not to act as the universal provider but as the centre and focus of activities which might otherwise remain for ever unrealised hopes' (1967—68). The position of acting simply as a cashier dispensing funds was vigorously rejected from the beginning and the Council described its role as 'not merely the pay-master of the arts, but in some sense the national trustee for the arts' (1951—52). The term 'trustee' could imply a mere 'watchdog' role, or it might be stretched to include the idea of promoting new trends. Apparently it is the latter which the Council had in mind, since subsequent reports repeatedly stress the need for a forward-looking, active approach:

> There is another function which the Arts Council is seeking to develop: that of encouraging the production of new work in music, drama, poetry and painting. Just as scholarship depends upon experiment and research so do the arts need replenishment by contemporary innovation. (1955—56)

Despite the stress laid on innovation, however, the Council has never openly assumed the dynamic role of catalyst in the Arts. Repeated references in the Annual Reports suggest that the conflict between a hands-off policy and one of 'effective leadership' has never been decisively resolved. The problem is that of avoiding the Scylla of *laissez-faire* while likewise avoiding the Charybdis of artistic paternalism.

Unhappy with a near-monopoly position as public patron of the Arts, the Council soon advocated a diversification of sources of subsidy, in order to tap local initiative and enthusiasm. It is clear from the Council's detailed proposals for new Civic Arts Trusts that considerable thought has been given to the matter of how best to promote local efforts in the Arts:

> What might be the functions of a civic Arts Trust? The first might be to consider what annual provision in the various arts the city enjoys or lacks at present. Another might be to examine the reasons why some of that provision is deficient; is it, for instance, through the inadequacy of theatres and concert halls? Or through bad staff work among the managements of provincial towns? Or through the city's neglect to guarantee or underwrite the visit of some notable

company? There are, again, some puzzling equations to be solved. Why was such and such a visit to the town a roaring success when another, of equal merit, proved a dismal failure? What are the seasonal, the social, and the economic factors in these contradictions? Much of what we hear about these matters at present is gossip and speculation and one of the basic activities of a civic Arts Trust would be to discover the reasons why a city is so inadequately or sporadically provided with some or all of the arts. Map-making of this kind is one of the initial functions of such a trust. Another preliminary exercise is that of costing the arts: finding out what the city must provide in entrance money and subsidy to secure the various companies it wishes to see. (1953–54)

In the light of the evidently strong belief in local action, it is surprising that five years were to elapse before any initiative was taken, namely, the creation of the first Regional Arts Association (RAA) in 1958. Although 'more than two thirds of the Council's grant is spent outside London' (1970–71), the English RAAs together receive only about 5% of the Council's budget; the rest is provided directly to individual artistic organisations. A statement by Lord Eccles, in a House of Lords debate on the RAAs, referred to the need for more locally based and locally financed activities, since the regions still depended on 'direct subsidies from the Arts Council plus events produced, packaged and subsidised in or from London and then sent round the provinces' (*Hansard*, Vol. 329, No. 55, 22 March 1972). This observation is borne out in the latest report: 'The Council . . . is in the main regionally — not London — orientated, and this is insufficiently understood. Of the total number of grants made, 90% go outside London' (1971–72).

The Arts Council is, of course, well aware of the administrative problems created by the artistic dominance of London, combined with its own financial dominance over total public expenditure on the performing and creative Arts.

There would be little 'mutual benefit' if the Arts Council channelled all its assistance through the Regional Associations to named recipients without giving the association any say in the disposal of these funds. On the other hand, it is *intra vires* the Regional Association, and [it is] quite right and proper, for them to allocate funds in support of local enterprises which have little or no claim to

Arts Council support within the terms of our Charter ... It is perhaps easier to see than to define the principles to be followed in this case; the presence of an Arts Council representative as an assessor in the councils of the associations is the most effective safeguard. Another potential difficulty arises over the presence of a recognised client of the Arts Council (orchestra, repertory company, touring organization) within the boundaries of a Regional Association which we also support. Who is to provide the subsidy? The Arts Council alone? But then where is the 'mutual benefit'? The Association? But we have direct obligation to our client, of which we cannot divest ourselves. This is a fine field for the elaboration of case-law; the extremes to be avoided are, first, treating the Regional Associations as mere post-offices, and secondly, allowing them the sort of autonomy that constitutionally belongs to the Scottish and Welsh Committees of Council (this is something we are not entitled to devolve upon anyone in England). (1964—65)

In their statement welcoming the formation of the RAAs, the Council expressed the hope that 'such bodies will prove a rod for the Arts Council's back.' It would be interesting to know how much truth there is in this assertion. Unfortunately, the Annual Reports confine themselves to the purely positive aspects of the relationship between the Council and these local bodies. However, with the immediate prospect of a 40% increase in grants to the regional associations, it has become more important than ever for the Council to define clearly its role in the total system of public patronage to the Arts. We need merely note that this is *still* an unresolved aspect of the role of the Arts Council.

It is in the realm of advice that the Council has perhaps contributed most to the Arts. Certainly the Annual Reports have been more articulate on this aspect of their work than on any other:

The wording of the Charter is no doubt judicious: advice and cooperation come before holding and dealing with money. We can sometimes enjoy ourselves in the role of *sugar-daddy* to the arts, but we are at present more often, better and more characteristically employed as match-makers, midwives and nannies ... It is by the fruit of much patient and inconspicuous discussion and correspondence, field work, expert counsel and personal liaison that we must justify our existence. (1962—63)

Moreover, these functions were not limited merely to large and influential institutions but were extended to cover small and relatively unimportant concerns.

> While respecting the rights of self-government of all the bodies it supports, the Council devotes much time and attention to the policy of these bodies. It gives guidance at one end of the scale in advising an obscure *music society* on a programme of work suitable for its means and its membership. And at the other end of the scale, it conducts a patient and independent scrutiny of the artistic and economic conditions of Grand Opera. (1951–52)

Of all the original aims of the Arts Council — 'to encourage, support and advise' — the third is undoubtedly the most consistent of its functions. But it still remains to be seen in what sense 'encouragement' has been given; it still remains to analyse the value of the achievements of the Council and to ask how far this has been a fulfilment of Keynes' original ideal. The Arts Council itself has never pretended to pass ultimate judgment on its own contribution, or even to settle once and for all the proper scope of its activities:

> The major problem is to define our scope. We remain and always will remain an auxiliary body. Artistic activity would, happily, continue without us, and the contribution we can make to promoting artistic output will always be arguable. On this score we take a modest view. We have no evidence that poets, authors, painters or composers — or any creative workers — are the more fertile because we exist and give them our support. It would be complacent to entertain such belief. (1966–67)

But a year later they claimed a little more:

> That Britain is no longer 'the country without music' (or any of the other arts for that matter) is largely due to the patient work of the Arts Council over the past twenty years or so in supporting and encouraging performing, and to a lesser extent, creative artists. (1968–69)

A recent Annual Report sums up the contribution of the Council over 26 years of existence:

> Despite all the things we have not done and all the things we have done but ought not to have done, and all the things that still need to

be done, the Arts Council is a good and worthy institution in a wicked world. It has provided a stimulus and a sense of purpose to a great many people and a great many projects. Much that is good would have been lost without it. Much that is hopeful would never have seen the light of day and some things that are purposeless and pointless and positively nasty would have continued to maintain unproved pretensions. (1970—71)

It seems ironic that as far back as 1952—53, the Arts Council was asserting that: 'Public patronage, whatever form it takes, must select its roles and objectives with precision, and that is one of the lessons the Arts Council is beginning to learn.' It is difficult, however, to find any evidence in subsequent reports that the lesson has actually been learned. If it had, our critique would have been redundant.

2. The Case for Subsidies

The Annual Reports have devoted considerable space to the rationale for the existence of an organisation like the Arts Council. There is clearly no difficulty in finding economic arguments for subsidising the Arts. The standard reasons in economic theory for involving government intervention apply at least in part to the Arts and, in addition, there are special grounds for subsidising artistic activity.

The standard reasons have to do with causes of *'market failure'* (either economies of large scale production, or external costs and benefits, or consumer ignorance, or any combination of these, inhibit the operation of the market mechanism) and with the case of *'public goods'* (certain goods cannot be priced at all by a market because as soon as they are produced for one person, others cannot be excluded from consuming them). It is not clear whether these arguments actually apply to the Arts but, in any case, demand and supply of the Arts are highly interdependent. Tastes, and hence demand, tend to be stimulated by the mere provision of artistic facilities. For these reasons, the market mechanism may be an inefficient instrument for allocating resources to the Arts.

Moreover, there is the thesis (associated with the name of Baumol) which asserts that the real costs of producing artistic activity are bound to rise in the course of economic growth. There is little scope for cost-reducing technical progress in the Arts, but the wages and salaries

of artistic personnel tend to rise in step with wages and salaries in general. The result is a constant cost-push in the Arts, and hence public patronage is required to ensure a continual supply.[2]

Lastly, traditional welfare economics is silent about the question of income distribution. The market tends to equate effective demand with available supply, and effective demand clearly depends on the existing distribution of purchasing power among individuals. But many members of the electorate object fundamentally to the idea of distributing artistic goods and services on the basis of current purchasing power; in short, they have definite preferences about an equitable distribution of the Arts. This, too, might constitute a reason for government support of the Arts.[3]

None of these arguments appear in the Annual Reports. It is interesting, however, that the Arts Council, while dismissing almost all their critics as 'backwoodsmen', nevertheless expends much effort in defending itself against a vaguely specified attack on the very idea of public patronage of the Arts. Their defence rests essentially on what we might call 'the vacuum theory': the establishment of the Welfare State with its principle of redistributive taxation destroyed private patronage of the Arts and consequently created a vacuum which only government can fill. This theme is repeated time and again. The survival of the Arts now depends on government subsidies, and if these were withdrawn the end of artistic life would immediately follow.

> If the arts are to survive somebody must pay for them, and if the burden of subsidy, purchase or guarantee has become too heavy for the private patron it must be shouldered by the public ... The health, the education, the social welfare, the national defence of the people have all become the collective responsibility of the people, and no taxpayer or ratepayer can contract out of the obligation to contribute to the upkeep of the necessities and amenities of the Welfare State. The preservation of the fine arts is another of these collective responsibilities.[4] (1952–53)

The 22nd report returns to the 'vacuum theory', combining it with notions of a 'civilised' optimum amount of the Arts:

> There are few thinking people to whom the need for artistic subsidy would have to be justified today. It is not a matter of choice. In some ways it might be preferable to live in a society where the

measure of private support for our activities obviated the need for State assistance. But such a society has totally ceased to exist. The fiscal policies of every government in our memory have contributed to a situation where private bounty or investment is now totally inadequate to sustain a civilised ration of music and theatre, of poetry and picture. Nor need we be remotely apologetic in asking for the modest sums we need for our purposes from the public purse. The Government has garnered in much, if not most, of the wealth that cultured patricians and public-spirited industrialists could formerly bestow. It holds a portion of its treasury charged with a trust to use it for our purposes — and in fairness, the growth of the Arts Council in scope and importance demonstrates governmental recognition of this principle. (1966—67)

In short, the Arts Council exists to give back what the Inland Revenue has taken away! If so, might not a change in the tax laws be a better way of subsidising the Arts? Would it not, at any rate, be a good question to think about?

Another Council argument is based on the idea that education systematically fosters an appreciation of the Arts. Since education is largely financed from the Exchequer, it follows that the Arts have equal claim to be publicly supported: 'we should allocate more money than we do to ensure them [school children] an adequate provision in later life of those arts for which they are given some appetite in school' (1955—56). However, if the enjoyment of the Arts merely extends the educative process, the question of *who actually attends* subsidised performances becomes paramount. A study by Baumol and Bowen, based on both American and British audiences, found that the average theatre- and concert-goer was a university graduate, earning nearly twice the median income of the population.[5] In other words, if education fosters an appreciation of the Arts, it is not to school-leavers that we must look for evidence of the proposition. Moreover, believing as it does, the Council appears to have done very little to promote an interest in the Arts in schools; at least the Annual Reports make no mention of any co-operative ventures with the Department of Education and Science.

Besides, it is difficult to square this faith in schooling as a great promoter of life-long interest in the Arts with the Council's defensive attitude about the low popularity rating of so many of the activities

which it supports. These subsidies are, typically, defended by the argument that the tastes of the *discriminating few* are of *more* consequence because they are seeking 'enlightenment' and not just 'entertainment': 'there are abundant precedents to justify the public patronage of the arts for the benefit of the considerable minority who have cultivated a taste for serious pleasures' (1951–52).

This is precisely the supercilious attitude which Sir Ernest Pooley, one-time chairman of the Council, warned against:

> And do let us be gay; let us have entertainment. I never quite know what 'highbrow' exactly means, but in so far as it is a term of reproach, let us not be highbrow. You can have high standards of performance without being highbrow. The arts can provide for those who appreciate them a fuller life and greater happiness. But don't submit to that depressing sense of superiority and that 'precious-ness', too often affected by arts clubs and arts circles. Don't let us be afraid of being amused. (1948-49)

However, subsequent reports have ignored this entreaty and have proceeded to justify particular expenditures on grounds tantamount to 'preciousness.'[6]

Nearly all the Annual Reports have stressed the gross inadequacy of present grants to the Arts. The Arts, they say, find themselves permanently on the edge of insolvency, and this tends to affect their standard of performance.

> The need for public money arises not because our theatres and opera houses, our concerts and our art exhibitions are inefficiently run, or failing to draw a public. Rather the reverse. In part it arises because of their success. Subsidy is needed if the public appetite, which is now so clearly demonstrated, is to be satisfied by performances and works of the highest standard.[7] (1968–69)

This implies that a subsidy is needed merely to maintain standards of production, irrespective of the level of demand. Yet two years earlier they stated: 'If we could reach the point where public support was so effectively stimulated as to make subsidies unnecessary this would be a supreme justification of our work' (1966–67).

In view of the fact that Covent Garden played to 91% capacity in 1968–69, while Stratford reached 97% capacity in the 1970–71

season, and both receive support from the Arts Council, it is difficult to evaluate this contention. The statement clearly implies that increasing attendance would dispense with the need for subsidies — in which case what are we to make of the figures for attendance rates just cited?

That *some* subsidy is necessary may be readily agreed upon; but the amount required is still open to argument. This must obviously depend upon the potential revenue from the Arts. It would be interesting to discover on what grounds the Council bases its ticket pricing policy. Its approach to the question of ticket prices, however, has been ambiguous and contradictory. The 9th Annual Report states that: 'In many establishments there have, indeed, been marginal increases in theatre and concert prices, but it would be idle to pretend that there is any hope of coaxing the public to pay much more for its arts than it does at present' (1953—54). A year later, however, they altered their previous stand: 'A rapid jolt in prices no doubt would put audiences off; a steady acceleration of prices over the years would not' (1954—55). Two years later they stated:

> Whether admission charges are being raised enough to keep pace with rising costs is a matter for argument; yet where they are being increased consumer-resistance is not fulfilling the woeful predictions of the more timorous theatre and concert promoters. . . . Everything must continue to be done by the promoters of opera and music and drama to match admission prices as closely as possible to rising costs. (1956—57)

Ten years later the Director of the Royal Festival Hall pointed out to the Estimates Committee:[8]

> I would say in general that prices of seats are increasing all the time. All promoters are trying to get that extra bit out of the box office. They are increasing some of the prices. They could keep the price range exactly as it is by having the same number of seats at each price but by having more of the middle and higher priced seats they can get a higher capacity from the house.

If it is in fact possible to charge higher admission prices as time passes and costs rise, it is not clear why subsidies are necessary. *To maintain standards? to enlarge audiences? to cultivate new audiences?* The questions are obvious, but no answers are to be found in the Annual Reports.

3. Policy Dilemma: The Conflict of Goals

The most clearly defined statement of aims which the Arts Council has so far offered appeared in the 11th Annual Report. These were '(*a*) the improvement of professional standards of performance; (*b*) selective diffusion (of the Arts); (*c*) local responsibility (for the Arts); and (*d*) the provision of buildings (for the Arts)' (1955—56). A limited budget has given prominence to the first and second goals: artistic standards and selective diffusion have become the Council's over-riding pre occupation.

Even here, however, there has been constant soul-searching. Should expenditure be concentrated on maintaining a few selected strongholds of high artistic achievement? Or would it be preferable to disperse the available funds over a wider geographical area?

> The Charter of the Arts Council enunciates a double purpose – (a) that the Council should seek to elevate standards of performance and (b) that it should endeavour to spread the appreciation of the arts. The Council has sought to observe both these injunctions. But the size of the budget in a period of rising costs may require it to re-examine how far both these objectives may be simultaneously secured. Is it wiser in such times as these to consolidate standards rather than pursue a policy of wider dispersal? (1950—51)

They argue that since 'high standards can only be built on a limited scale', the emphasis must fall on standards:

> The primary responsibility imposed by its Royal Charter is to preserve and improve standards of performance in the various arts. The Arts Council interprets this injunction, in relation to its income as implying the support of a limited number of institutions where exemplary standards may be developed. (1955—56)

These statements clearly reveal the emphasis which the Council has always placed on 'excellence.' This emphasis is sometimes rationalised (as in the previous statement) by appealing to the constraints of a limited budget. At times, however, it is advocated on deeper grounds as the right policy in and of itself:

> But even if that income were double what it is, the duty of the Arts Council would still be to nourish good standards of production and performance, rather than attempt a premature and ambitious scale of

diffusion. Public patronage of the arts is a long term obligation: it must grow like the mustard-seed, not like the beanstalk. (1959—60)

The Arts Council has firmly held to this position, at least until recently. That they have been successful in achieving the goal of raising artistic standards is almost obvious from the esteem in which British drama, music, ballet and opera is held throughout the world.

However, the goal of selective 'diffusion' is more difficult to appraise. The term 'diffusion' as employed by the Arts Council has connotations over and above that of mere dispersal. Sometimes it refers to the conflict raised by concentrating on London rather than the regions; sometimes it refers to a contrast between regional concentration and widespread diffusion throughout Britain in small towns and rural areas; and on occasion it refers to diffusion to a larger, less homogeneous audience. As these are not consciously viewed as different aspects of the problem, the result has been to confuse the entire issue of wider dissemination of the Arts.

Let us take, first of all, the question of London versus the regional cities. The Council pleads that it is not responsible for amenities in London as opposed to the relative deprivation of provincial cities:

> The capital city is also the metropolis of the nation's art: the home, for example, of its National Gallery and its British Museum. It is both proper and inevitable that its National Opera House should be located there as well. Secondly, it was not the Arts Council which decided to establish these three institutions [i.e. Covent Garden, Sadler's Wells and the Old Vic]. The Arts Council did not decide to give half its money to London; it decided to act as patron to certain institutions aleady established, and of these the most meritorious and representative were situated in London. If any provincial city had assumed the responsibility for creating and maintaining, say, Sadler's Wells, the Arts Council would gladly have become its patron. It is highly improbable, in fact, that any large city in the Provinces could provide a continuous home for opera and ballet; they have insufficient catchment areas (or visitors) to supply the large audience and income an operation of such magnitude requires. (1955—56)

But, of course, this says nothing about the question of touring the provinces, which is sometimes employed as a reason for subsidising London-based companies.

One very large fraction of its [the Council's] revenue goes to subsidising such National Institutions as Covent Garden, Sadler's Wells and the Old Vic, which, although located in London, are as much a national inheritance as the British Museum, the National Gallery and the Victoria and Albert Museum. They even manage, in spite of innumerable difficulties, to tour many provincial centres; and the proportion of our budget which they absorb may reasonably be debited to the country as a whole, rather than to London. (1950–51)

Nonetheless, the Arts Council admits to weaknesses in its standards for distributing funds, on one occasion going so far as to say that 'The diffusion of the arts on their higher levels is at present sporadic, unplanned and unequal' (1953–54).

If a moratorium could be declared in the arts the present design of subsidy might indeed be radically altered. If it were possible – or ever had been possible at a given moment – to lay down a plan of subsidy based on ideal requirements in terms of music, drama, opera and ballet the structure of subsidy would doubtless be better balanced than it is. (1957–58)

This is the view that many critics of the Arts Council would no doubt endorse, although what form an 'ideal' subsidy pattern would take is unclear, especially as regional inhabitants would presumably hold different concepts of what constitutes a 'perfect' subsidy pattern. Indeed, they might dispute the following statement referring to 'arts trusts' as being little short of a gross misrepresentation of the facts: 'The Arts Council recognises its obligations to these bodies and by its continued and increasing support of them will ensure the Provinces an abundant share of the available arts.' (1955–56)

The second facet of diffusion is that of regionalism on the broadest possible scale to embrace the 'cultural deserts' outside the regional cities. The Annual Report of 1951 asked the question: 'Is it good policy to encourage small, ill-equipped expeditions to set out into the wilderness and present meagre productions in village fit-ups?' (1950–51). The intended answer is obviously *No*. But in trying to justify this attitude they rely exclusively on the costliness of living up to the doctrine of 'fair shares.'

How far, then, should diffusion go? This notion of diffusion is liable, in a democracy like ours, to get mixed up with the political axiom of

'fair shares'. When this happens it leads to the argument that, since the tax payers in Caithness or Cardigan contribute to the funds voted to the Arts Council, they should have their 'share' of the cornucopia of provision. But the economic consequences of this supposition are daunting and conclusive. (1952–53)

The dilemma that results from this conflict of aims has proved difficult to resolve, and the Annual Reports have time and time again attempted to pour oil on troubled waters.

We are of course already providing art-below-cost. The crux of this policy is 'How much below cost?' At what point in the arithmetic progression of subsidy are we to stop? The bearing of this problem upon the accepted scale of diffusion of the arts is evident. As the figure of subsidy rises, how soon will it become expended, in the main, upon the kind of diffusion which can only be a dilution? Or when will it cease to operate, whatever its size, because there develops a dearth of the product it exists to diffuse? There is, evidently, a limit to the 'potential' of the arts. (1952–53)

A meaningful answer to these questions depends on some quantitative estimate of the price-elasticity of demand for the Arts in different places and among different audiences. Are consumers more responsive to ticket prices in cities than in rural areas? If so, the distribution of subsidies can be altered so as to take such differences into account. If, for example, the demand in rural areas is relatively inelastic, prices can be raised and subsidies redirected to the cities. This is a separate issue from that of the principle of diffusion. What is not clear in the Council's statement is whether they wish to satisfy an existing demand (in which case demand may be taken to be comparatively inelastic) or whether to encourage new demand (which would undoubtedly require lower-priced tickets to attract those who now stay away).

This difficulty is largely confined to music and drama since the cost of 'diffusing' paintings and sculpture is comparatively low. The Arts Council itself, therefore, directly finances 'travelling art exhibitions' throughout Britain. The problem of rural isolation is, to some extent, mitigated by the provision of travelling grants to enable the less accessible areas to organise low-cost trips to the theatre: 'the Arts Council should be diligent in developing better facilities for the public

to see the arts at their best and one such facility is the provision of coach parties to concerts and plays.' (1955—56).

This was the most obvious and logical solution to the situation, and its widespread use would ensure a more equitable, albeit far from 'perfect' distribution of the Arts. However, in spite of some success with such policies, their analysis of the problem is puzzling. 'The achievement and preservation of standards in the arts is, primarily, then, the role of the professional just as the task of diffusing the arts outside the cities is largely the business of the amateur.' (1955—56). In the same report, moreover, they contradict themselves by asking:

A matter highly relevant to this problem of how far the Arts Council should carry diffusion is the transformation wrought by radio . . . With astonishing rapidity broadcasting is assuming the role of Universal Diffusor; and to that extent making it more vital than ever to preserve strongholds of standard in a limited number of places. (1955—56)

The residents outside the cities were, therefore, expected to be content with the 'mass media' plus participation in amateur activities. However, in recent years the emphasis has moved much more in favour of the regions. The 23rd Annual Report stated:

London presents a special problem: it is foolish to regard it as sufficiently served by artistic and cultural amenities to a point where it can now be neglected in favour of other areas, but simple justice compels us to call a relative halt to expansion in many London plans and institutions until at least something comparable to the London 'density' of culture is available in other parts of the country. (1967—68)

The previous year had stressed 'the view now firmly held in this country — that metropolitan culture, however rich and varied, cannot be a total substitute for local and regional institutions' (1968—69). Nevertheless, there is no evidence that the Arts Council has seriously attempted to achieve the goal of regional diffusion. Although public funds spent on the Arts in the regions has increased in absolute terms, the *proportion* has in fact remained constant since 1965.[9]

The third aspect of diffusion is concerned with the cultivation of *new audiences*, either for the Arts as traditionally conceived or for hitherto ignored and despised varieties, such as jazz, pop, folk music, etc. The

Report of 1966 emphasised 'the major purpose for which we must use our money . . . is to cultivate new audiences for the arts', and this goal has been reiterated in subsequent Reports.

However, there is no indication that the policy of cultivating new audiences has been given priority in the Council's objectives. To be sure, audiences for the Arts have grown over the years but so has the demand for privately produced and privately financed entertainment. Without launching a single survey of audience participation in the Arts, the Council nevertheless draws inspiration from what it takes to be a trend towards mass audiences: 'Within our society there is now a widespread feeling that the provision of drama and music and painting and all culture in its broadest sense is no longer to be regarded as a privilege for a few but is the democratic right of the whole community' (1968—69). How is this 'widespread feeling' to be made manifest? Is it by increasing Council grants to the RAAs so that local bodies are able to respond more fully to their particular needs, or by increasing aid to experimental projects which at present, together with the Arts Associations, arts festivals, literature and experimental projects, comprise only 11% of the Council's budget?

The present distribution of subsidies shows that, although 90% of the total *number* of grants are given to the regions, spending still remains disproportionately in favour of London. At present Covent Garden, Sadler's Wells, the National Theatre, and the Royal Shakespeare Company together receive 39% of the total budget for England. 17% is spent on music (including other grants to opera and ballet companies, *e.g.* The Festival Ballet). The fifty-odd repertory theatres throughout England together receive 6%, while expenditure on art (including regional exhibitions, films on tour, the Hayward and Serpentine Galleries) amounts to 5%. Literature (including grants for writers and poets and work in schools) receives less than 1% as do the experimental projects and art centres. Regional arts associations receive 5% and the remainder is spent on new buildings for the arts and education in the arts.

Some critics feel that Covent Garden is excessively subsidised. Whether true or not, the question in the present context is whether the amount spent on Covent Garden can be justified on the grounds of audience appeal? If not, what becomes of the goal of gaining new audiences? 'We have tried very hard', the Council says, 'to use our resources as sensibly and as equitably as possible. We have tried to supply the growing needs of a society increasingly conscious of the value of the arts to civilised

life' (1970—71). But what are the Council's criteria for deciding that funds are spent 'as sensibly and equitably as possible'? The 22nd Annual Report stated: 'We shall try to make our judgments more scientific and less rule-of-thumb, but to a large extent they must remain inspirational — others might find a less flattering word' (1966—67). Yes, indeed.

4. Criteria for Subsidy: A Pattern for Patronage?

The vague, imprecise nature of the statements concerning the aims of the Arts Council, as embodied in the Charters of 1945 and 1967 — 'that of developing a greater knowledge, practice and understanding to the people throughout the realm and to improve standards of execution' — has enabled the Arts Council to evade the problem of defining precise criteria in their selection procedures.

In discussing the issue, the Council has always emphasised the 'efficiency' of the recipient bodies in the sense of exemplary accountancy practices (1952—53). Efficiency in administrative practices appears to be the *only* justification which the Council has ever offered for selecting one artistic organisation rather than another, despite their own admission that 'the thrift and probity of financial administration, necessary as they are, do not vindicate the ultimate use of money' (1968—69).

The Estimates Committee to examine the Arts Council and its subsidised organisations found that: 'not one single instance was brought to their notice, or suggested, of extravagance or wastage by Arts Council customers. And there was not a vestige of a suggestion of anything but the most proper and scrupulous use of the funds which we so widely disbursed into so many quarters.' Consequently, they concluded that: 'what the Arts Council was doing was needed to be done and, what is more, that the sums of money it was administering were inadequate and should be augmented. . . .'

Budgetary efficiency is surely an inadequate justification for the activities of the Arts Council. Its effectiveness can only be judged in terms of 'what . . . was needed to be done.' This, unfortunately, remains undefined.

The issue is not only that of evolving criteria to evaluate *competing claims* for subsidy, but also one of deciding just *what areas* the Council

should be subsidising. Take, for example, the question of whether to support jazz or not. This turns on the vexed question of what is 'Art' and what is 'Entertainment'. The Annual Reports used to contain statements such as: 'The Arts Council's concern is with the fine arts exclusively which are only part of entertainment, however strongly we may hold that they are the best and most important part' (1963—64); the function of the Council is to 'nurture the arts, not provide popular amenities in that field' (1959—60).

This conservative bias was consistently maintained throughout all Annual Reports until 1969 — and then a new view made its abrupt appearance. In the 24th Annual Report the emphasis is on 'throwing a bridge across to the young', thereby manifesting a sudden consciousness of whole sectors of peripheral artistic activities hitherto ignored. The metamorphosis has produced so much controversy and heated debate that it has become more imperative than ever for the Arts Council to establish some basic principles rather than to continue its policy of allowing the respective expert panels to decide what, or what not, to subsidise.

How, for example, do they justify the recent decision to subsidise the Theatre Investment Fund? The 22nd report discussed the possibility of giving direct aid to commercial theatres in order 'to co-operate with its best elements.' The purpose of this Fund, however, is to encourage provincial touring of successful London productions of musicals, comedies, etc.[10] As these cannot possibly be defended in terms of the Council's usual standard of 'the best in the arts', the decision implies either that their standards of 'good drama' have now changed to encompass 'entertainment' or they have come to feel that it is their function to provide what the 'public' wants to see, regardless of whether or not it can be considered 'art'.

The Arts Council is proud of its policy of total freedom of expression for its recipient bodies and individuals. Since it lays down no principles — at least in print — it is difficult to see how competing requests for aid are in fact compared. 'More for one means less for another' is a truism which contributes little understanding to the problem. Neither do vague statements like:

> The test for eligibility for support is easier to sense than to define but in broad terms the beneficiary must have merit or promise of merit, appeal or prospect of appeal and must satisfy a discriminating need. (1969—70)

This statement is particularly interesting in view of the evidence given the previous year to the Estimates Committee:

> It would be complacent to suggest that we have not evolved any scientific principles because we are dealing, to a very large extent, with a historic backwash. We have started to introduce principles.[11]
> (1968)

If, indeed, there are underlying principles or guidelines to decisions, the Arts Council has appeared remarkably reluctant to give an account of them. There has been no attempt to clarify the situation in subsequent reports (and, surprisingly enough, the Estimates Committee did not ask for an explanation of the above statement).

5. The Confusion of 'Subjectivity'

There is a constant tendency in the Annual Reports to take refuge in the inherent subjectivity of all artistic judgments. 'We endeavour to discharge our duties with a very real consciousness of our own fallibility and the rooted imperfection of all artistic judgment' (1966—67).

Of course, in the final analysis artistic judgments are subjective, and so are the objectives that underlie all expenditures on the Arts. What is *not* subjective, however, is the degree to which spending on one activity rather than another achieves a particular objective. For example, if our goal is to promote opera in the regions, we may have difficulty in deciding whether to spend a given sum on Verdi or on Michael Tippett; but the question is, at least in principle, capable of being answered objectively. Or, alternatively, if our goal is to find new audiences for the Arts, it is not a question of deciding whether John Cage is better than Richard Rodgers but whether a Cage recital will attract as large an audience as a Rodgers concert. Thus, it is perfectly possible to lay down selection criteria even though artistic judgments are subjective.

One way out of the dilemma of subjectivity might be to rely on audience response. The Arts Council, however, seems to be less clear about its responsibilities to the consumers than to the producers of the Arts. They define their function for the latter as striving to 'improve the working conditions of artists and to preserve and enlarge their public', while asserting (1952—53) that 'it is not the business of the State, working through the Arts Council, to furnish a matrix of artistic

performances for a receptive and captive audience'! What role, then, *do* they envisage for the audience?

> The importance of an audience response is a variable factor. If it is a commodity which depends for its survival on the response of an audience — such as a theatre or a concert hall — it is nonsense to subsidise an activity that produces no such reaction. But it is equally wrong to measure its value solely in audience terms. Hence if a repertory theatre performs a range of relatively popular plays but fails to draw an adequate audience, it is plain it should be re-sited or change its policy, or even, as the final decision, be closed. But if the subsidy is for a poet, his recognition by a single perceptive mind can amply justify support to maintain an activity which can rarely find an adequate public. (1969—70)

The contrast between a single person's appreciation (on the one hand) and a mass audience (on the other) covers the entire spectrum of reactions. It neatly evades the question of what in fact is an 'adequate' audience size. The problem is whether the Arts Council should attempt to educate public taste in esoteric art forms, or whether it should merely confine itself to catering to established tastes. The Council, of course, has it both ways.

> We ought not to waste our resources on enterprises which prove in practice to be quite unacceptable to the public. There is a level of persistent failure, in this sense, that must be regarded as definitive. Between these two extremes the Council must find the best compromise, encouraging promise wherever it is found, but not losing touch with reality. . . . Within these general conditions, the Council acknowledges a duty to foster potentially interesting experiments. (1966—67)

Basically, this is a 'trade-off' problem. If the Council's basic objective is to gain *new* audiences for the Arts, it would surely be irrational to spend a large percentage of available funds on unpopular forms of art. On the other hand, if support of new artists is an overriding objective, then some of the money should be allocated to esoterica. In either case, is it not necessary to confront this issue just a little more explicitly than the Council has done in the past?

The Council is understandably sensitive to accusations of prejudice in favour of one or another form of art. It attempts to counteract these

by relying exclusively on the expert opinions of the specialist panels. As Lord Goodman put it:

> We can marshal to our aid the informed judgment of expert panels, uncoerced by rules and regulations of an academic and artificial character. If the administration of subsidy is left to the tender mercies of full-time bureaucrats, my experience compels the harsh judgment that we would be better to dispense with the system altogether. (1970–71)

Perhaps true, but there would seem to be a wide spectrum of selection techniques between the existing structure of the Arts Council and the bureaucracy of a government department. To encourage more diversity is no solution, although diversity is continually emphasised as a great virtue.

> One criticism of State patronage is that it puts too much power into too few hands and thus discourages the variety and competition of styles which patrons used to foster. . . . It is not by its network of Committees and panels that the Arts Council is restrained from acting like a cultural oligarchy. The fundamental check is the Council's own conscious determination not to dictate policies or impose fashions in the arts it tries to assist. So far as it enjoys a monopoly of State patronage it is, no doubt, theoretically capable of restrictive practices in the arts. But it steadfastly avoids such practices. (1952–53)

However, by avoiding the basic issue of selection criteria, the Council does in effect maintain 'restrictive practices' in the Arts; and the arbitrary judgments of many people is not necessarily less restrictive than the rational judgment of a few. Actually the Council's only defence of its procedures is that government departments do no better.

> If our methods are really slipshod, brash or doctrinaire, this is not because we are an independent chartered corporation . . . government departments also fall into the same failings. . . . Some people consider that a certain informality in our procedures is unbecoming seeing that the Council is entrusted with substantial sums of public money; they fear that our freedom from Parliamentary inquisition or official control in matters of policy makes us autocratic, and arbitrary in our choice of candidates for

support — irresponsible in the plain as well as in the technical sense. (1962 — 63)

Nevertheless, while acknowledging the criticism, Lord Goodman defends the need for something like the Arts Council on the grounds that sensible decisions about the Arts are unlikely to emerge from government offices — the Council, being composed of 'a body of people who breathe the fresh air of ordinary life in their normal day to day activities can — whatever mistakes we make — adjudicate on our problems with commonsense and appreciation of the needs of ordinary human beings' (1971—72).

The 11th Annual Report, however, admitted this: 'The Council is not, in the limited sense, a representative body. . . . They are chosen primarily as persons with a particular knowledge of, or concern for, one or more of the fine arts' (1955—56). A study by Harris (1969) on the composition of the Arts Council would seem to question Lord Goodman's assertion.[12] Harris found that the average age at appointment to the Council was 56.7, and that Council members came in most instances from upper income and better educated families.

It remains a matter for conjecture how far these facts may have influenced recent attempts to rebalance the age structure of the Council by the inclusion of 'youngsters to sit on their panels', not to mention conscious attempts '*to remain contemporary and "with it*" ' (1968—69). The 22nd Annual Report queries the past pattern of spending:

No one responsible for the disbursement of money for the improvement of standards in the arts in a country would ever claim that some of the money so spent might not, with hindsight, have been better spent in some other way. . . . The accounts for 1966—67 in this report are there to substantiate the Council's case that this money was well spent. (1966—67)

It would be interesting to see how much effect this kind of retrospective analysis will have on subsequent spending decisions. Without doubt, the Arts Council is performing a vital role, and it would be absurd to underestimate the contribution it has made to cultural activities. But without questioning whether or not the money was well spent, one might still ask whether or not it could in fact have been better spent some other way. Could it have been 'more cost-effective' in terms of its own objectives?

6. Conclusion

To evaluate an organisation like the Arts Council is to assess the effectiveness of its policies in achieving stated aims. Since any aim can be achieved by a large number of policies, we must also take account of the costs of attaining a given degree of effectiveness; having decided on the most effective policy per unit of costs for each stated aim, there is the further problem of ordering the aims in terms of a scale of priorities.

But the whole exercise cannot even get started unless the social and cultural aims themselves are expressed in some clear form. It is not good enough to say that the Arts must be diffused among new audiences. How can we possibly evaluate policies to achieve that end unless we distinguish between genuinely new audiences and additional participation of old audiences, which in turn implies definite knowledge of the composition of existing audiences? This is a small example, but we have seen many others throughout this article.

The Arts Council certainly has *objectives* — but most of them are too ill-defined to make evaluation possible. Indeed, reading the Annual Reports of the Council has proved to be a depressing experience. It is not too much to say that in 26 years of official reportage they have failed to produce a single coherent and operational statement of their aims.

1. All subsequent references of this kind refer to the dates of publication of the Annual Reports of the Arts Council. Chairmen of the Arts Council have been: Lord Keynes (1946), Economist; Sir Ernest Pooley (1946—53), Barrister; Sir Kenneth Clark (1953-60), Art historian and critic; Lord Cottesloe (1960—65), Businessman and public administrator; Lord Goodman (1965—72), Solicitor; Patrick Gibson (1972), Publisher.
2. W. Baumol and W. G. Bowen, *Performing Arts — The Economic Dilemma* (New York, 1966).
3. It is not clear that this is an additional reason. Preferences on the part of one individual about another individual's consumption of the Arts may be interpreted as a so-called 'consumption externality', in which case it is already dealt with under the heading of 'market failure.' For further discussion, see A. T. Peacock, 'Welfare Economics and Public Subsidies to the Arts,' *Manchester School of Economic and Social Studies* (XXXVII, December 1969), reprinted above as Reading 4.
4. Earlier we quoted a statement from the 1966—67 Report to the effect that 'Artistic activity would, happily, continue without us, and the contribution we can make to promoting artistic output will always be arguable' — which

appears to contradict the passage just cited. However, such inconsistencies appear throughout all the Reports.

5. Baumol and Bowen, *Performing Arts*, p. 92.

6. On other occasions, however, the Council has *denied* that it caters for minority tastes: 'We are not a luxury; we do not cater for a small élite out of the pockets of a protesting multitude. We supply a commodity which a great many people require and which can make a better life for a great many more once their appetite and interest has been awakened' (1966—67).

7. The fourth Annual Report said: 'It is a mistake to think that the Arts must necessarily be subsidised. A great number of concerts, plays and exhibitions are and should be, self-supporting. Financial support is frequently both unnecessary and undesirable' (1951—52). But this appears to be a momentary aberration from the constant theme.

8. Eighth Report of the Estimates Committee of the House of Commons, *Grants for the Arts* (London, October 1968).

9. P.E.P. Report, 'Public Patronage of the Arts', *Planning* (XXXI, November 1965).

10. *New Society* (3 August 1972), p. 249.

11. 8th Report of the Estimates Committee, 1968.

12. John Harris, 'Decision-makers in Government Programs of Arts Patronage: The Arts Council of Great Britain', *Western Political Quarterly* (XXII, June 1969).

7. The Arts Council and Its Critics *with* A Reply

by R. FINDLATER and K. KING and M. BLAUG

reprinted from Encounter *December 1973 pp. 91–4*

It seems to me bizarre that, although the Arts Council of Great Britain is now nearly 30 years old, no comprehensive critical assessment of its work throughout the arts has, to my knowledge, yet been published: nothing beyond sections in specialists' books (e.g. in John Elsom's *Theatre Outside London*), and the customary press comments on each year's annual report, half-reverential, half-reproachful, seldom long enough to make more than a couple of complaints about the proliferation of cultural activities subsidised and encouraged by one of the most valuable (and misunderstood) British inventions of the century. All the more astonishing, then, to find in *Encounter* an article — somewhat misleadingly dubbed 'an inquiry into public patronage of the arts' — asserting that the Council's work can't be evaluated. Why not? Because its objectives are 'too ill-defined to make evaluation possible'; and this is 'proved' by the annual reports. To read these is 'depressing', say Karen King and Mark Blaug, because the Council has never produced in them 'a single coherent and operational statement of their aims.' Yet, in the course of their 'inquiry', King and Blaug have apparently read little else; and there is no 'evidence' that they have seen any of the work which the Council actually does, as distinct from the words that are published under its name once a year.

One flaw of the curious King-Blaug exercise is that they seem to view the reports as the work of a single author, whose tactical evasions and true intentions (if not his real identity) will be revealed by textual and linguistic scholarship. They pounce gleefully on 'inconsistencies' between reports twenty years apart, unearthing contradictions and incompletions, unravelling strands of wool with scornful titters. But they wilfully ignore the political facts of life: notably, that the operational tone and outlook of the Council (including what it sees,

corporately, in the mirror) are inevitably influenced — like all committees — by the personality of its chairman, and — like all part-time public boards — by the work-style of its full-time executives (although, at the same time, it is its difference from other boards and committees which gives its role in the arts especial significance, for better or worse).

King and Blaug fail — among other failures — to allow for the dissimilarities of succeeding chairmen: Lords Clark, Cottesloe and Goodman were as different in office as chalk from at least six different varieties of cheese, not only in personality but in their changing views of the Council's function and the chairman's role in that function. What's more, King and Blaug don't even mention the secretary-general, the executive boss of the Council's day-to-day operations and the man who usually writes the reports with which the authors of the *Encounter* inquiry are so obsessed. The differences (and the similarities) between Sir William Williams, Nigel Abercrombie and Sir Hugh Willatt, and the shifts in the balance of power between them, their chairmen and their Ministers, are a vital part of any practical assessment of the Council's first quarter-century. Such an evaluation must also take into account the changing impact on Council policy of Westminster and Whitehall, which have, at the least, confirmed its empiricism and its reluctance to codify practice in explicit verbal formulae; and it should recognise the influence of the relationship between the Council in all its avatars and the hundreds of boards and trusts on its pay roll which are, like the Council itself, committees of part-time volunteers.

Again, King and Blaug omit, in scrutinising the annual reports, to note the change in attitudes towards the arts (and their patronage) during the period under their examination. To plead the case for public patronage in the 1970s is, they suggest, flogging a dead horse, *not* a cost-effective occupation; but in the 1950s, when Sir William wrote a series of reports outlining that case in clear and persuasive prose, the need for investment in the arts on anything but a token scale was far from self-evident in town halls, constituency-party caucuses and conferences of municipal officials or trade unionists. Some of us doubt whether it is self-evident now.

But perhaps the most absurd of the omissions from the King and Blaug 'inquiry' is the question of money: it is upon the size of the annual grant, not upon the phrasing of its annual report, that the Arts Council's work depends. It has never had anything like enough cash to cope with the enormous backlog of need and the rapid expansion of

demand, a process accelerated by its own injections of money (however tiny) and its role in reorganisation, training and advice, revaluing attitudes among those in and under authority. What use would it have been in 1945, with a budget of under £250,000, to declare a precise series of targets? In 1973, with over 50 times as much to spend, there may be more reason to expect a formulation of principle; but it is futile to deplore, in retrospect, the absence of such formulations in the past, as if the right words could make up for the wrong budget. And, what's more, for the absence of appetite, and goodwill, and allies, all of which have grown with the grant. Why *should* the Council have decided, for instance, that its 'basic aim' was *either* to gain new audiences *or* to support new artists? Why not try to do *both*? Which is what the Council has done.

The most glaring oddity of King and Blaug's inquiry is that they never drag their eyes away from the imperfect prose of those reports to look at the deeds, rather than the words, of an institution which has shown itself in action, if not in declarations of principle, dedicated to the *ad hoc* initiative and the empirical response. True, the authors pay perfunctory tribute to the Council. 'Without doubt', they say, it is 'fulfilling a vital role'; it 'would be absurd to underestimate the contribution it has made to cultural activities'; and 'that it has been successful in achieving the goal of raising artistic standards is almost obvious from the esteem in which British drama, music, ballet and opera is held throughout the world.' And all this has been achieved without the enunciation of precise aims and cost-effective priorities? Who'd have thought it. Not King and Blaug, it seems. Yet it isn't only a question of standards, but of quantity, too: look at the increase in the number of repertory theatres (and the virtual disappearance of weekly rep); in the volume of opera and ballet seen throughout the country, not only in London; in the number of travelling art exhibitions, orchestras, music ensembles. . . . You can find a lot of these facts by careful reading of the annual reports; although the Council still does tell us often enough and clearly enough *what* it is doing. Which is another matter.

Apart from the actual music, drama, ballet, opera, etc. which owes its performance — and sometimes its creation — to the Council's patronage, it has one major negative achievement to its credit. It has not imposed institutions on the arts. Nor has it imposed theories — theories of what arts are more important than others; of what principles should govern public subsidy; of what artists should be subsidised in preference

to others. It has made choices, inevitably, with which many people quarrel. That it has not made them to the accompanying fanfare of manifestos is, in my view, a cause for rejoicing not complaint. The Council has many faults of omission and commission to weigh against its virtues, a balancing act which must be performed by any more factual inquiry than that of King and Blaug; but these faults do not include the failure to lay down the tablets of the law from 4 St James's Square or 105 Piccadilly. Any tablets are bound to be broken: all manifestos are likely to seem inadequate — at the current rate of change — by the time, at least, that a new chairman, a new Minister or a new secretary-general has arrived.

In coping as an institution with cultural change in a democratic society, the readiness is — well, nearly all. Corporately considered, the Arts Council has known quite well, most of the time, what it has been doing; not least, in refraining from a running commentary on why it is doing it. For that reticence no moral glory or superior wisdom should be claimed, any more than it should be regarded, *à la* King and Blaug, as a sign of moral cowardice and intellectual confusion. It is in the nature of the beast. However they differ in other respects, English committees are bound to compromise, intellectually; they don't dictate and they can't prescribe; they are incapable of inaugurating a consistent ideology, consistently and cost-effectively applied. For me, that's a saving grace, if the relative — if diminishing — freedoms of the arts are not to suffer further interference from the state.

A Reply *by K. King and M. Blaug*

Shortly after the appearance of our iconoclastic essay on the Arts Council's declared aims and objectives (*Encounter*, September) Sir Hugh Willatt, Secretary-General of the Council, told a reporter:

> The article is an attempt to judge the Arts Council without assessing the results of the Arts Council's work. It is a criticism of our public statements and ignores what we've done. (*The Guardian*, 21 August 1973)

Sir Hugh is quite correct. We limited ourselves explicitly to the Council's public statements as *a first step* in an effort to evaluate the Council's accomplishments as public patron of the Arts. We will turn to

what the Council has done in a forthcoming piece, and we hope eventually to be judged in the round and not simply on our preliminary skirmishes in the field.

Mr Richard Findlater in this issue echoes Sir Hugh's reaction. But he goes further in denying that we have done justice to what the Council has said, after which he cannot resist the temptation of implying that published pronouncements do not really matter; results are everything. As we have said, we intend to move on to results in the near future but, in the meanwhile, Mr Findlater has raised so many red herrings that an immediate response is in order.

'One flaw of the curious King-Blaug exercise', he writes, 'is that they seem to view the reports as the work of a single author, whose tactical evasions and true intentions . . . will be revealed by textual and linguistic scholarship.' It is perfectly true that the reports in question span a period of 20 years which saw the Council headed by five successive chairmen. But as a matter of fact, there are glaring inconsistencies in the public statements of the Council within the life-time of a single chairman, *e.g.* the statements on the ultimate value of the Council's activities (p. 8). On the other hand, certain positions were steadfastly maintained despite changes in the chairmanship of the Council, not to mention the identity of the secretary-general: *e.g.* the policy of refusing to support jazz between 1946 and 1969 (p. 14). Quibbling apart, our exercise in what Mr Findlater chooses to call 'textual and linguistic scholarship' — otherwise known as 'actually bothering to read what publicly accountable bodies are forced to publish' — has demonstrated that the Arts Council is indeed committed to a definite set of objectives in terms of which it hopes presumably to be judged. This was far from obvious when we began our investigation; and it is still not obvious to many observers of the Arts. Mr Findlater, for example, concedes that the size of the Council's annual grant in 1973 does warrant 'a formulation of principles', but he questions the need for such principles in past years when the annual grant was much smaller. Unfortunately, the Council does not share his strange theory of financial management. The Council's clearest statement of aims appeared in the 11th Annual Report of 1955—56. Mr Findlater simply has not read the annual reports carefully enough.

When Mr Findlater turns to deeds instead of words, he is overwhelmed by the quantitative and qualitative advances in the Arts in this country since the War, all of which he credits to the Arts Council, complaining only that 'the Council still does not tell us often

and clearly enough *what* it is doing.' Mr Findlater thinks it is pointless to ask *why* the Council is doing what it is doing, and he is not sure precisely *what* it is doing. With friends like Mr Findlater, the Council hardly needs enemies.

Like Mr Findlater, we believe that public bodies should ultimately be judged by results but results cannot be assessed without a knowledge of intentions. If it is wrong to try to discover the intentions of a public body like the Arts Council by a careful reading of their official reports, why are such reports published at all and, by the way, published at subsidised prices?

8. Rationalising Social Expenditure—The Arts

by M. BLAUG

reprinted from M. Posner (ed.) Public Expenditure: Allocation between Competing Ends *Cambridge University Press (1976)*

A careful perusal of the annual reports of the Arts Council since 1946 leaves no doubt that the Council disburses its funds to satisfy a number of more or less clearly defined objectives.[1] These may be summarised as: (1) the diffusion of the Performing Arts (music, opera, ballet, drama and films), and to a lesser extent the Visual Arts (museums and galleries), throughout the regions of Britain — in a phrase, 'to break the culture monopoly of London'; (2) to diffuse the Performing and Visual Arts among wholly new audiences; (3) to maintain and raise artistic standards in the Performing Arts; and (4) to encourage the emergence of new art forms as well as new creative artists.

The first question that arises is whether the Arts Council's expenditure pattern actually succeeds in achieving any of its avowed objectives. But that is only the first question. As all four objectives carry some weight in reaching a set of final decisions, what does the Council do when a particular decision scores high in respect of one objective but low in respect of another? After all, any decision designed to achieve multiple ends must involve some order of priorities among ends. But 'score' is a numerical term, and we have yet to demonstrate that any of the four aims of the Council can be quantified, so as to permit us to infer after the event that a certain policy achieved one objective more effectively than another. Our principal task, therefore, is to show that it is at least possible, in principle, to measure the degree of success in achieving these objectives.

Before we proceed, however, we must begin by clearing the ground. The average economist probably feels in his bones that a 'scientific' evaluation of something like public expenditure on the Arts is a philosophical, if not a practical, impossibility. But I want to argue that

public expenditure on the Arts can be evaluated like any other public expenditure. Indeed, in so doing we may come to realise that the problem of multiple ends, which seems to loom so large in respect of the Arts, is really a general feature of the evaluation of all public expenditure.

What is cost-effectiveness analysis?

We all know what is meant by cost-*benefit* analysis: it is the attempt to calculate all the direct and indirect costs and benefits of a set of alternative projects or policies, subject only to the proviso that all costs and benefits can be expressed in terms of a common denominator, money. The purpose of the exercise is to choose that project which will maximise a single objective, namely, the excess of monetary benefits over monetary costs as a measure of the aggregate of consumer's surplus. But what do we do when we are concerned to maximise more than one objective and, in particular, when some of these objectives are by their very nature incapable of being reduced to money terms? What we then do is to use what I choose to call 'cost-effectiveness analysis' but which others have sometimes labelled 'systems analysis', 'output budgeting' or 'management by objectives'.[2] In other words, cost-benefit analysis is only a leading species of a much larger genus of evaluation techniques.

Cost-benefit analysis yields a single criterion for choice. Since cost-effectiveness analysis handles activities carried out for multiple objectives, it yields as many choice criteria as there are objectives. To choose at all, we will have to rank the cost-effectiveness ratios in order of importance. Ultimately, therefore, costs and degrees of effectiveness are once again reduced to a common denominator but the yardstick this time is not money but rather the subjective preferences of the decision-maker among his stated ends, goals, objectives, etcetera.

To become a little more specific. Cost-effectiveness analysis always consists of three steps:

(1) specify each of the multiple objectives in such a way that they can be scaled, preferably in cardinal but possibly in ordinal terms; notice that this can always be done, at least in principle, and obviously the very act of choice among alternative activities

to achieve multiple objectives implies that it has in fact been done: to choose A over B implies that the outcomes of A and B can be compared and that they have indeed been compared, at least ordinally;

(2) generate alternative policies for achieving the objectives, assess their effectiveness in achieving each of the objectives in terms of a scale, and express these degrees of effectiveness as a proportion of the costs of carrying out the policies (there will be as many of these effectiveness-cost ratios as there are objectives); and

(3) apply the decision-maker's 'preference function', indicating his order of priorities among the objectives in terms of numerical weights and choose that policy with the highest weighted effectiveness-cost ratio (if the first step has involved ordinal rather than cardinal scaling, this procedure may fail to yield an unique decision criterion).

No doubt, this sounds very forbidding but all we have really done is to write down in a formal way the implicit logical structure of every decision, whether private or public. It does not matter what the objectives are, or how many there are; provided the means for achieving the objectives are limited — and when they are not, decision-making is not a problem worth analysing — the final choice among alternative policies is 'rational' only if it goes through the three steps of cost-effectiveness analysis.

Steps (1) and (2) may present enormous practical difficulties in certain circumstances but, conceptually speaking, they are plain sailing in the sea of positive economics. It is step (3), however, that raises deeper normative questions. How on earth is one supposed to discover a decision-maker's preference function among objectives without imposing one's own? Asking him will usually produce a blank stare: if the decision-maker is a politician, he is committed first of all to maximising electoral support and that is best secured by blurring objectives, not by revealing them. Nor can we deduce his preference function by studying his past behaviour: he may be inconsistent between decisions; he may have altered his preference function over time as a result of learning-by-doing; besides, circumstances themselves are changing and this itself makes inference difficult. But if we cannot discover his preference function, we can neither evaluate his past decisions nor improve his future ones.

Further reflections along these lines begin to suggest that there is indeed something wrong with our purist view of cost-effectiveness analysis as a tool for evaluating decision-making. In the classic manner à la Robbins, we have implicitly drawn a rigid distinction between means and ends as if the decision-maker first chooses his goals and then hunts about for policies to achieve them. In point of fact, any decision-maker starts with on-going activities and gradually begins to define his objectives in the light of his experience with policies. In other words, decision-makers do not try to get what they want; rather they learn to want by appraising what they get. Means and ends are indissolubly related and evaluation of decision-making, or technical advice to decision-makers, cannot simply accept the preference function as given.[3]

This view of decision-making, so different from the traditional paradigm reflected in our sketch of the three steps that make up cost-effectiveness analysis, has been forcefully argued in recent years by a number of economists and political scientists and perhaps most eloquently by Braybrooke and Lindblom in their book, *A Strategy of Decision* (1963), with the revealing subtitle, *Policy Evaluation as a Social Process*. Braybrooke and Lindblom reject all comprehensive approaches to decision-making, purporting to lay down global rules for arriving at optimal decisions, and instead advocate what they call 'disjointed incrementalism': it is disjointed because decision-making, far from being swallowed whole, is repeatedly attacked in bits and pieces; it is incremental because it considers only a limited range of policies that differ only incrementally from existing ones; 'disjointed incrementalism' does not try to adjust means to ends but chooses means and ends simultaneously, in fact exploring ends while applying means.

It is perfectly clear that Lindblom and Braybrooke have achieved a much more realistic view of the role of advisors to decision-makers. Obviously, decision-making, particularly public decision-making, never achieves more than a second-best solution, if only because the time required to collect information is the ultimate scarce resource. Nevertheless, it proves useful to keep the three steps of cost-effectiveness analysis in mind as a sort of 'ideal type', while admitting and indeed emphasising that no decision-making process in the real world will ever closely correspond to the ideal. The general spirit, if not the letter, of cost-effectiveness analysis does provide a framework for organising our thoughts about the evaluation of real-world decision-making.

Having set the stage, we can now turn back to the Arts Council without claiming that we are going to solve all their problems. What we want to do is something more modest: we wish to show how to go about applying modern management techniques to the work of the Council. Fortunately, in declaring its objectives, the Council has already gone a long way toward carrying out step (1) of cost-effectiveness analysis. All that is really required is to argue through the logical implications of their stated aims and to show how the objectives could be scaled. Of course, by sticking to the Arts Council, we make things easier for ourselves. In 1972/73, the Arts Council grant of £14 m. was only just a little less than net government expenditure on 17 national museums and galleries, ignoring additional public funds devoted to local museums and galleries, and we have little basis for delineating the policy objectives that underlie public support for museums and galleries.[4] A further problem area is radio and television. Nevertheless, the Arts Council is the heart of the matter and we will, therefore, confine our attention largely, although not exclusively, to its activities.

Vertical and Horizontal Diffusion

The first two aims of the Council, as listed above, appear to be fairly similar, involving as they do the gaining of new audiences, either in London or in the provinces. Indeed, the Council seems so far to have concentrated its effort on regional diffusion of the Arts in the belief that this would simultaneously achieve both 'vertical' diffusion in terms of new audiences and 'horizontal' diffusion in terms of new regions. But it is much easier to provide the Arts for an eager audience which has been barred by distance than it is to create a new demand among members of the public who have hitherto been uninterested in consuming the Arts. The Council has in fact been more successful in achieving a better geographical distribution of the Arts than in attracting a wider cross-section of the population. There is evidence — however imperfect — that audiences all over Britain have shown themselves to be consistently homogeneous in age, education and social background. With hindsight, we may lay down the general rule that a changing composition of audiences does not come about as a simple by-product of increasing provision of the Arts. Only a determined

policy to attract a different type of audience will successfully achieve vertical diffusion.

The idea of diffusing the Arts horizontally to the regions is not specific enough to help us in evaluating alternative policies. 'The provinces' is a vague term: the cost of encouraging the Arts in cities, with a catchment area large enough to provide a ready-made audience, may be far less than that of providing it in small and inaccessible towns. In practice, of course, the Council has emphasised large and medium-sized cities.

Even so, the Council is always faced with the question of whether to implement a policy of horizontal diffusion by extensive touring of London-based companies or by the establishment of permanent Arts Centres in the regions. Though touring is essentially a short-term policy, and the provision of Arts Centres a long-term one, the shortage of funds implies conflict between them. In recent years, the balance has shifted increasingly towards touring. The goal of meeting an immediate demand, therefore, seems to have been given priority over the aim of investing in the long-term future of the Arts outside London. If supplying existing demand is indeed the overriding goal, an obvious first step would be to carry out surveys to determine the catchment area per unit of expenditure. The results could then be compared to the cost of attracting the same number of people by permanent Arts Centres. Unfortunately, the Council so far has failed to adequately survey potential demand and, even more, to pose the issue of touring versus Arts Centres in terms of the costs of meeting a current demand as against a potential demand.

Apart from touring, the Arts are also supplied outside London by means of regional theatres and orchestras, directly subsidised by the Arts Council, and by way of the many activities of the Regional Arts Associations, with an annual aggregate budget in 1973/74 of almost £2 m., of which the Arts Council supplies about two-thirds. Some local authorities also maintain their own Arts departments (as well as contributing to the regional associations). This haphazard system of patronage has led both to an arbitrary power, and an arbitrary division of identical responsibilities. Theatres, for example, receive grants from the Arts Council, the local authorities and, to a lesser extent, private industry. Regional Arts Associations also receive money from the same three sources but they act independently of the theatres. The Council has long realised that the aim of horizontal diffusion cannot be realised without more local participation and provision. The ultimate aim,

therefore, remains that of local self-sufficiency. But diverse sources of patronage do not necessarily encourage an overall growth of local Arts provision unless they are somehow coordinated. The Council has now acquired a Regional Department and money spent on the regions has sharply increased in recent years. But the present administrative structure continues to hinder the development of a comprehensive policy of promoting the Arts in the regions. In short, the question of how successful the Council has been in achieving its goal of diffusing the Arts to the regions, cannot be answered without a historical analysis of the provision of the Arts outside London since, say, World War II. Alternatively, a regional Arts policy, comprising the activities of all the local and central agencies involved, including the Arts Council, is required to rationally underpin the Council's involvement in the horizontal diffusion of the Arts.

Turning now to vertical diffusion, the evidence continues to point overwhelmingly to an educated, middle class audience, with a conspicuous absence of the working class. The composition of audiences for the Arts seems not to have changed significantly during the past 28 years of the Council's existence. Nor is there any indication that a change is now in the making. Even if it were, the Council would hardly be aware of it. It has commissioned only three audience surveys in its entire history, all of which date from the late 1960s[5] and the only comprehensive survey of London audiences was in fact undertaken privately by Baumol and Bowen.[6]

Actually, it is fair to say that the Council has so far refused to accept what little evidence there does exist about audiences. Its 1969 Report on Opera and Ballet contains results of surveys carried out in Leeds and Glasgow, and at Sadler's Wells in London, which showed an average of 5 per cent of the audience to be manual workers. But the same report blithely talks of opera and ballet attracting a growing audience from a cross-section of the community: 'There is hardly a limit to audience expansion . . . Ballet and dance theatre can draw an audience as large as any other branch of the theatre or cinema'.

Information about audiences is clearly of paramount importance to the work of the Council. It is the only way to ascertain the success of a policy of gaining new converts. It is not simply a matter of 'head counting'. A larger audience may mean more attendances by an identical number of people. The ideal census should show not only the frequency of attendance, age, education, occupation, and distance travelled, but also the level of family income. The distribution of

audiences by occupation or by social class does not necessarily reveal the ability of consumers to pay.

Surveys should be taken at a wide range of events. Those which have so far been carried out have been limited in scope, concentrating on opera, ballet and drama. No surveys have yet been undertaken of fringe theatre, poetry readings and jazz events, all of which are being increasingly subsidised. Having discovered the composition of existing audiences, the next step is to find out more about the causes of the apparently limited appeal of the Arts. It is here that in-depth interview methods, advocated by the 1969 Mann report on provincial audiences, would be most useful. It is irrational to talk of attracting new audiences, while subsidising Arts events (without further justification) which the majority refuse to attend.

With a limited budget and conflicting goals, the Council must decide on the relative importance of attracting the young, the aged, students, the working class, the poor, etcetera, categories of people which only partly overlap. Each category of audience could be assigned weighted values, according to the importance attached to attendance within that category. Audiences for each Art form would then be compared to the percentage of total subsidy absorbed by each event.

But all this presupposes a detailed specification of aims. For example, if the results of a survey showed that a major part of the subsidy was being spent on a particular Art form which had limited appeal, the Council would have to ask itself if the subsidy could be applied more effectively elsewhere. If the objective of the Arts Council is to provide the Arts, regardless of who benefits, the answer would be an emphatic No. But if the Council sees its aim as reaching entirely new audiences, positive action in redirecting subsidies might well be more cost-effective.

Both costs and the ability of the consumer to pay must be taken into account when allocating subsidies. Decisions on whether or not to withdraw subsidies will depend on the potential effect on demand. Obviously, such an evaluation depends on the consumer's income and the actual rate at which each set of prices is subsidised.

Take the case of subsidised theatre. To talk of average subsidy per seat is as meaningless as referring to 'the average price of a seat'. Ticket prices vary with the position of the seats in the theatre. The same level of overall subsidy is compatible with widely differing structures of ticket prices as between cheap and expensive seats in a house. The problem is to find by how much a subsidy has reduced the 'true' cost of

seats of different prices. Without this, there is no way of finding out which section of the audience is benefiting most. This, together with information about audience incomes, would show what proportion of the subsidy is going to whom. It would enable the Council to discriminate more selectively in favour of specific groups.

Ticket pricing policies are still based largely on conventional rules of thumb among theatre owners and producers. The belief is widely held that further increases in ticket prices would choke off demand. Yet a recent Arts Council report on seat prices concluded that many subsidised provincial theatres had scope to raise their prices; that ticket prices had lagged behind the rise in average earnings since 1963; that middle and high-priced seats were more frequently sold out than low-priced seats; that higher ticket prices on Friday and Saturday evenings went with larger audiences; and that, in general, audiences were more responsive to events than to prices.[7] Exactly the same phenomena were observed in London for opera, drama and concerts, with the possible exception of the most expensive seats at the Royal Opera House and at Sadler's Wells at the Coliseum. The report concludes that, 'in the provinces in particular, the grant [of the Arts Council] is used to keep certain prices below a level at which they could be kept without reducing the size of audiences; and this is the case for all performing arts which we have examined . . . In the case of the subsidised London theatres, we would certainly consider it feasible to increase the number of seats sold at middle prices'. Sir Hugh Willatt, the secretary-general of the Council, summarises its findings in these words: 'Although certain price increases are recommended . . . the council welcomes the fact that there is no recommendation for across the board increases' — which, while strictly correct, hardly does justice to the flavour of the report.

Vouchers

In general, the Council has shown little flexibility in considering alternative methods of financing the Arts. At present, subsidy applications in the Performing Arts are based on an annual estimate of revenues. There is an unwritten rule that no application is considered if box office receipts account for less than 45—50 per cent of total costs. But the present policies of the Council appear to give producers no

incentive to maximise ticket revenues. A company which shows a profit at the end of the year, gets a corresponding cut in subsidy. The Council's own report on orchestral resources suggested that 'too little drive and imagination have been shown in filling the 20 per cent or more of empty seats'.[8] Thus, few British theatres and concert halls lower ticket prices shortly before the performance begins. This is standard practice in some American cities.

The problem of inappropriate incentives could be tackled by switching the subsidies from producers to consumers, by means of a 'ticket voucher' scheme.[9] Theatres and concert halls would charge commercial prices, and a certain proportion of seats would be made available for a specific group (children, students, old age pensioners, trade union members), who would pay for their seats with issued vouchers. The vouchers would then be exchanged by the management for cash. Alternatively, the grant-giver could undertake to buy seats, and offer them directly to selected categories of individuals at a reduced price. This scheme has the enormous advantage of making the selection of beneficiaries as precise as possible.

A drawback of a voucher scheme — apart from possible voucher touting — is that the Arts would then become far more consumer-orientated. Programmes would passively reflect, instead of actively stimulating, prevailing tastes. In the past, the Council has emphasised the need to subsidise more esoteric art. The crux of the issue, however, is not simply 'arts for the masses' versus 'arts for the elite'. The trade-off is better seen as that of spending more on inducing the uninitiated to start attending artistic events tailored to their untrained tastes, as against spending more on educating existing audiences to demand modern music and poetry. It all depends on which sector of the population the Council considers to be more important, and whether or not 'art for art's sake' is sufficient grounds for a subsidy policy.

A study, commissioned by the Northern Arts Association to examine whether or not its youth voucher scheme was achieving its intended aims, illustrates the point.[10] The scheme was designed to encourage young people between the ages of 15 and 21 to attend artistic events — particularly uncommitted young people who would not attend of their own initiative and in their own time. Anyone under 21 years was eligible to receive a book of vouchers. When presented at any event subsidised by the Northern Arts Association, this entitled the holder to a cut in the ticket price. The scheme was extremely popular. Demand reached some 5,000 voucher-book applications per month. But

the report concluded that the goals of the scheme were not being achieved. Only 2–7 per cent of the uptake fitted the description of an ideal user: 'an apprentice or working person who left school at 15, who individually obtains and chooses tickets for arts events. Results showed that 96 per cent of the users were in full-time education, and 75 per cent attended artistic events in organised school parties. However desirable the attendance of schoolchildren may be, the spending of large subsidies on a captive audience was not the express aim. In that sense, the scheme was rejected as a failure. Even voucher schemes have problems.

Artistic Standards

So much for attempts at vertical or horizontal diffusion. From its earliest days, the Arts Council has been preoccupied with a third aim, namely, raising standards of performances. It is widely held that it is impossible to quantify success in achieving this endeavour, because artistic excellence is necessarily a matter of subjective judgment. Moreover, comparison between different productions is seen as being out of the question because a badly produced and a well produced performance are virtually different products.

But the issue is not how to convert subjective assessments into objective ones, but rather how to reduce the arbitrariness inherent in all aesthetic judgments. The total impact of a performance on a member of the audience can never be gauged accurately. But many of the contributory factors are purely technical. Lighting, seating, orchestral playing, the standard of acting, the amount of time spent in rehearsal, the quality of the scenery and costumes – these are all matters on which there is likely to be broad agreement among experts. 'Objective knowledge' is merely knowledge about which there is nearly universal agreement. 'Subjective knowledge' is knowledge about which there is usually no agreement whatever. A great many aesthetic judgments fall between these two extremes. Judgments about standards of performance – rather than about the lasting value of what is being performed – tend to lie nearer the objective end of the continuum. A panel of 'experts' could compare two performances in terms of 'better' or 'worse'. Given the costs of producing a 'better' performance, the panel

ould find itself gradually working towards judgments about 'how much better' or 'how much worse'. In this way the panel would, in fact, e learning to gauge the quality of productions in relation to their ubsidies.

The problem becomes more complicated in practice because the ttempt to raise standards of performance in certain Arts forms reempts subsidies that could have been devoted to other objectives. he Arts Council itself certainly recognises a conflict between the cost f raising standards and the cost of attracting new audiences. The policy f subsidising both Covent Garden and Sadler's Wells is a case in point. hough opera sung in English is more popular, many music critics, ightly or wrongly, regard it as inferior to opera sung in the original anguage. The Council has accordingly subsidised Covent Garden to aintain high standards (£1,750,000, or 17 per cent of its budget for ngland in 1972/73), and at the same time has subsidised the Coliseum £935,000 or 9 per cent of the 1972/73 budget), to encourage more eople to go to opera. As these figures show, opera sung in the original , unfortunately, more expensive to produce than opera in English. A iven subsidy for opera can produce either a modest rise in standards at ovent Garden, or a massive increase in audience size at the Coliseum. bjective measurement does not help us here. To reach a decision, we ave to rank our preferences among the two objectives. The Arts Council as never committed itself explicitly on this question. We can infer from s respective subsidies that it gives somewhat greater weight to raising rtistic standards. We cannot, however, draw that inference rigorously nless we knew by how much we would raise standards at Covent arden by an extra pound of subsidy, as well as how many new opera overs we could attract at the Coliseum by a given reduction in seat rices. This takes us back to step (1) of cost-effectiveness analysis and lustrates the point that ordinal scaling of objectives is not, in general, ufficient to justify an unique policy.

ew Art Forms

he Arts Council's fourth aim — that of encouraging young artists to xperiment with new art forms — has only recently come into rominence. So far, it is apparent that the Council attaches little weight

to this. Only a minute fraction of expenditure at present goes on direct aid to artists, either in the form of grants to individuals or in commissions of new works. In 1972/73, the total was £126,000.

If the goal is to stimulate the emergence of new art forms, the Council might in principle evaluate the success of its policy by asking not only how many nascent art forms have been encouraged by the provision of a grant, but also how many similar ventures exist without help from the Council. If, on the other hand, the goal is rather to encourage avowedly experimental artists, we run immediately into the problem that those artists requiring financial assistance are precisely the ones who have not yet found public favour and may, indeed, never do so.

It is very difficult to find criteria to distinguish the neglected genius from the neglected charlatan. It is perhaps simpler to earmark a given sum for the goal of encouraging experimental art and to hope for the best. Research councils in the natural and social sciences have long been in the habit of setting aside a fraction of their budget for pure research in some critical area, the outcome of which is totally unpredictable. There is nothing wrong with this. The sum set aside for this purpose automatically provides a measure of the importance assigned to a search for answers that may well not be there. At the moment, the Arts Council devotes about 1 per cent of its budget to encouraging new art forms. Yet it emphasises this goal in all its annual reports. Unless this is an area where the expenditure of small sums yields enormous results — which we doubt — this appears to be inconsistent.

Museums and Galleries

We have so far confined our argument to the Arts Council. But the debate on museum and gallery charges, which came into effect on January 1, 1974, highlights the danger of thinking about the arts in administrative compartments. Various arguments were used by the government to justify its decision to impose entrance charges. But the principal one was that if people were able and willing to pay for the pleasure of attending concerts and plays, they ought to be able and willing to pay for museums and galleries: there is no distinction in principle between the Performing and the Visual Arts. Some econo-

mists, however, have argued that the analogy is not tenable. One function of prices is to ration goods and services that are in scarce supply. If entrance to the opera and theatre were free, excessive demand would almost certainly result. But free entry to museums and galleries has not led to overcrowding. So there is no reason to charge for entry.[11]

This argument has obvious merit. But it does ignore the fact that the Visual and Performing arts compete with one another for resources. At present, the combined subsidies for both national and local museums and art galleries (about £30 million) exceed the Arts Council's subsidies to the rest of the Arts put together. This, of course, is due to the fact that the Visual Arts have been quite freely provided, while box-office revenue finances approximately 45 per cent of the costs of producing the Performing Arts.

If we assume that the clash between private and social interests is somehow more manifest for the Visual than for the Performing Arts, the argument implies that everyone is willing to pay taxes to guarantee the existence of museums and galleries, though no one is willing as a private citizen to pay to enter a museum or gallery. If museums and galleries were a 'public good', there would be nothing irrational in the willingness to pay taxes to support museums and galleries, while refusing to pay entry charges. But of course the 'degree of publicness' of museums and galleries is no greater than that of opera, ballet, theatre, etcetera; the consequences of free museums and galleries, therefore, is almost certainly to reduce the funds that might be devoted to supporting the Performing Arts.[12]

To be sure, the role of museums and galleries in preserving what already exists, is different from that of the live Performing Arts. But because most major museums and galleries are in London, finance for them circumscribes the diffusing of the Arts throughout the regions, not to mention the stimulation of new art forms. Yet how many museums and galleries purchase acquisitions with any attention to public tastes? The tendency of prices to ration what is scarce, is only one of its economic functions. Another is to reflect consumers' preferences. In that sense, there is an economic argument for museum and gallery charges. If the government does, in the long run, save on subsidies to museums, the money saved ought perhaps to go to the Performing Arts because horizontal and vertical diffusion is better satisfied by spending on these than on the Visual Arts.

Conclusion

Those who are shocked by this assertion are merely exemplifying the widespread tendency towards compartmentalised thinking about the Arts. Both the Arts Council and museum charges can only be satisfactorily discussed in terms of public patronage of the Arts as a whole. And in assessing such patronage, the technique of 'cost-effectiveness analysis', 'systems analysis', 'output budgeting', 'management by objectives' — it hardly matters what we call it — is just as applicable as it is to defence, health or education, areas in which it has been successfully applied in recent years. It may be impossible to agree on the ultimate value of Stockhausen's works. But it is not impossible to agree whether a 'new music grant' to an orchestra does, or does not, gain new converts to modern music. It may be impossible to reach a national consensus on what the regions 'deserve' by way of subsidy. But it is not impossible to reach a consensus on whether local initiative in the Arts is better stimulated by an Arts Council grant to the Regional Arts Associations, or by a matching grant from the Treasury direct to local authorities. And so forth, and so forth.

If this much be granted, the rest of my case follows. Ultimate ends are a matter of value-judgments, but means to achieve ends are capable of being objectively assessed. Often, in public expenditure analysis, the difficulty is that of discovering what the goals really are. The Arts Council, however, as we have noted, has in fact declared its objectives, though not always with sufficient precision. But having taken the plunge of being quite explicit about its aims, the Council has failed to investigate the degree to which its grants have succeeded in achieving the stated aims. It has neatly avoided the issue of self-evaluation up to now by assuming that the Arts cannot be assessed 'objectively'. This confuses aesthetic judgments with the question of measuring the consequences of disbursing funds to the Arts one way rather than another.

I close by conceding that the idea of applying cost-effectiveness analysis to public expenditure on the Arts can be made to look like an absurd attempt at Utopian social engineering: the problems are too complex and the data required are too great to complete the assignment within one lifetime. But I believe that a beginning can be made in a limited number of areas in the manner of 'piecemeal social engineering'. It is worth remembering in this connection that the grant to Covent Garden, Sadler's Wells, the National Theatre and the Royal Shakespeare

Company together absorb almost 40 per cent of the Arts Council's total budget for England. An application of cost-effectiveness analysis to the problem of, say, opera subsidies, which in principle seems to be perfectly feasible, would therefore make no small contribution to rationalising the total structure of subsidies to the Arts in this country.

1. The evidence is examined in detail in K. King and M. Blaug, 'Does the Arts Council Know What It Is Doing?', *Encounter*, September, 1973, reprinted above as Reading 6.
2. The field of management techniques is a veritable Babel of Tongues. For example, an H.M. Treasury *Glossary of Management Techniques* (London: H.M. Stationery Office, 1967) defines cost-effectiveness analysis as 'the cheapest means of accomplishing a defined objective', which misses the point I am making about multiple objectives. Suffice it to say that my definition of cost-effectiveness analysis is not the generally accepted one. Nothing depends, however, on the precise choice of terminology adopted.
3. This is one reason, at any rate, why the idea of value-free social science is apt to be misleading. The moment that social science becomes involved in advising governments, it necessarily ceases to be value-free.
4. A. Peacock, C. Godfrey, 'The Economics of Museums and Galleries', *Lloyds Bank Review*, January, 1974, reprinted below as Reading 11.
5. See P. H. Mann, *The Provincial Audience for Drama, Ballet and Opera* (Arts Council, 1969); *Report on Opera and Ballet in the United Kingdom, 1966—69* (Arts Council, 1969); and *Report on Orchestral Resources in Great Britain* (Arts Council, 1970).
6. W. J. Baumol and W. G. Bowen, *Performing—Arts — the Economic Dilemma* (New York: The Twentieth Century Fund, 1966).
7. *Report of the Committee of Inquiry Into Seat Prices* (Arts Council, 1973).
8. *Report on Orchestral Resources in Great Britain* (Arts Council, 1970).
9. A. T. Peacock, 'Welfare economics and public subsidies to the arts' *The Manchester School of Economic and Social Studies*, December, 1969, reprinted above as Reading 4.
10. Durham Business School, 'The Northern Arts Association youth voucher scheme' (Northern Arts Association, 1963, unpublished).
11. Lord Robbins, 'Unsettled questions in the political economy of the arts', *The Three Banks Review*, September, 1971, reprinted below as Reading 10.
12. Reports that museum attendance has sharply fallen since the introduction of entry charges (*Times*, March 5, 1974, p. 4) may be taken as supporting evidence that the Visual Arts are a 'private good'. However, not much can be made of evidence relating to the impact-effect over a period as short as two months.

9. A Survey of American and British Audiences for the Performing Arts

by W. J. BAUMOL and W. G. BOWEN

reprinted from Performing Arts: The Economic Dilemma
Twentieth Century Fund (1966) pp. 71–98

The relevance of an analysis of audience characteristics to a study of the economics of the performing arts may not be immediately apparent. After all, one might argue that, from a purely pecuniary point of view, the only pertinent factor is box office receipts, and not the identity of the individual who buys the tickets. If the box office does a sufficiently brisk business, a performing company's finances will be in satisfactory condition, no matter who purchases its tickets. Why, then, do we care about the make-up of the audience?

In fact, there are many reasons for our concern. First and perhaps most important, though not from an economic point of view, we care who attends because we believe participation in an audience contributes to the welfare of the individual. If the arts are a 'good thing,' we must concern ourselves with those who are deprived of the experience.

Second, we must know the characteristics of the audience if we are to evaluate ticket pricing and distribution policies. The complaints one hears about high ticket prices discouraging certain groups of people from attending can be evaluated ultimately only in terms of audience composition.

A third reason for concern with the nature of the audience is associated with the issue of government support. Both the desirability and the political feasibility of government support may depend, at least in part, on the composition of the audience.

Fourth, even if we consider the performing arts dispassionately as a product and nothing more, effective marketing policy requires that we know something about those who demand the commodity, just as an automobile manufacturer needs to know who buys his cars. This

information helps the manufacturer to merchandise his product and to plan his physical facilities: by giving him a better idea of his future market potential, it enables him to reach more rational decisions on investment policy and on the size and direction of his future activities.

Audience data are necessary, too, for a variety of analytical purposes which arise out of the questions with which we shall deal in later chapters. We have already mentioned one such fundamental question, the effect of ticket prices on audience composition. Equally significant is the relationship between the make-up of the audience and the extent of the contributions which the performing organization can hope to receive. However, the present chapter is primarily descriptive; it is essentially a report on who attends performances today, not an examination of the influences which determine attendance or a discussion of the possible effects of policy changes on the nature of the audience.

Survey Methods

Most of this discussion is based on our own data — on figures compiled from direct questioning of a sizable sample of audiences throughout the country — because, by and large, detailed statistics on the audience for the performing arts throughout the country are unavailable. There do exist a number of earlier studies treating particular sectors of the arts, especially the theater. We shall refer to some of these later, but their structure and specialized character restrict the extent to which they can be related to our findings.[1]

Some explanation of the nature of our survey and the procedures used in conducting it is necessary.[2] Our general procedure involved the use of questionnaires which were distributed to a predetermined sample of the audience (usually 50 per cent) at performances of various kinds, by inserting copies into the programs. Recipients were requested to complete the forms and return them to us before they left the hall. The respondent was asked about his age, education, occupation, income, distance traveled to the performance, the amount he spent on tickets, transportation, restaurant and other expenses associated with his attendance, his frequency of attendance at other types of live performance, his inclination to contribute, and so on. Critical to the success of our survey was the truly extraordinary cooperation we

received from the organizations involved. A request for permission to conduct a survey was rarely refused, and once it was granted we were usually offered all possible assistance.

The surveys were conducted from September of 1963 through March of 1965. In order to determine who should be surveyed, we first compiled a roster of professional organizations for each of the art forms, and then developed a sample which, though not random in a technical sense, gave us wide coverage in terms of art form, region and night of the week. In all, we surveyed 153 performances (88 theatrical, 30 orchestral, 8 operatic, 9 dance, 5 chamber music and 13 free open-air performances) and obtained 29,413 usable replies. The distribution of usable responses by art form corresponded closely to the distribution of estimated audience sizes (see Appendix Table IV—A). Only the Broadway audience was relatively under-represented by our survey, and this was deliberate, for we already had a great deal of information about the New York City audience from other sources.

As a direct consequence of the geographic distribution of the nation's professional performing organizations, most of our surveys took place in cities of substantial size. The geographic scope of our investigation is best indicated by the list in Appendix Table IV—B of cities in which surveys were conducted. The list includes Los Angeles, San Francisco, Portland (Oregon), Seattle, Oklahoma City, Dallas, Houston, Chicago, Ann Arbor, Minneapolis, Cleveland, Cincinnati, Pittsburgh, Atlanta, Abingdon (Virginia), Washington, Baltimore, Philadelphia, Brooklyn and Boston.

On the average, our response rate — the proportion of persons who returned the questionnaires they had been given — was almost exactly 50 per cent. This rate is high for a survey requesting information about income and other personal matters. Broadway and opera audiences produced the lowest rate of response — about 25 per cent in each case. While the low rate of return on Broadway is fairly easily accounted for by the special nature of its audience, which will be described later, our results for opera are less easily explained. The response rate is important not just because it affects the number of usable questionnaires, but also because it may have significant implications for the degree of bias in our results. For example, if bachelors were more willing than married men to provide the information requested, the tabulated results of the survey would report a proportion of married people in the audience much smaller than the true figure.

In order to determine whether, in fact, our results were seriously

biased, we undertook several tests. In general, the results are reassuring. There were no marked differences in rates of return from various classes of seats; that is, holders of expensive tickets did not reply at a significantly different rate from holders of less expensive tickets. There was a very slight relationship between response rate and median income, with a small increase in rate of response associated with increases in the median income of audiences; and there was also a slight relationship between response rate and proportion of males in professional occupations — the higher the number of professionals, the higher the number of returns. However, most of these relations were very weak and, in technical terms, did not satisfy the requirements of 'statistical significance' (see Appendix Table IV—C). From a more general point of view, what is most comforting is the great consistency of our results. The fact that they show the same pattern at performances differing widely in type and geographic location suggests very strongly that they are not the consequence of accidental biases imparted by the nature of particular audiences.

Characteristics of the Audience: Age

Before presenting the results of our survey we shall comment briefly on one important audience characteristic which, for a variety of reasons, we did not investigate directly — ethnic composition. Several persons experienced in the management of performing organizations emphasized that this is a crucial characteristic. As one commented, musical performances are often in trouble in a city without a large German, Italian or Jewish population. A Jewish holiday can decimate the audience even in a Midwestern city. Several managers noted that Negroes, on the other hand, attend infrequently, even where there is no overt discrimination, except perhaps when Negro themes and performers are presented. Of course, these are only casual observations, and we have no way of substantiating them — let alone any way of separating out the effect on attendance of ethnic characteristics *per se* from the effect of income.

What does our survey tell us about differences between the typical audience and the population as a whole? A succinct summary of our principal findings is given in Table 1, where we present a composite profile of the audiences at the various art forms, each weighted by

Table 1. Profile of the U.S. Performing Arts Audience, Compared with the Total Urban Population

	Performing Arts Audience[a]	Urban Population[b] (1960)
Sex		
Male	52.8%	48.4%
Age		
Under 20	6.9%	37.1%
Over 60	9.0	13.1
Median Age	38 yrs.	30.3 yrs.
Occupational Category		
Males:		
Employed Persons:[c]		
Professional	63.0%	12.7%
Teachers	10.3	1.1
Managerial	21.4	12.6
Clerical and Sales	13.0	17.2
Blue Collar	2.6	57.5
Students[d]	13.9	
Females:		
Employed Persons:[c]		
Professional	63.2%	14.0%
Teachers	25.4	5.6
Managerial	7.2	3.9
Clerical	24.9	34.3
Sales	2.8	8.5
Blue Collar	1.9	39.3
Students[d]	15.1	
Housewives[d]	35.2	
Education		
Males (age 25 and over):		
Grade School and Less Than		
4 Yrs. High School	2.2%	56.6%
4 Yrs. High School	6.5	22.1
1–3 Yrs. College	12.8	9.8
4 Yrs. College	23.1	6.2
Graduate School	55.4	5.3
Median Category	Grad. work	2 yrs. h.s.
Females (age 25 and over):		
Grade School and Less Than		
4 Yrs. High School	2.8%	55.1%
4 Yrs. High School	15.3	28.9
1–3 Yrs. College	23.6	9.5
4 Yrs. College	26.7	4.5
Graduate School	31.6	2.0
Median Category	4 yrs. college	3 yrs. h.s.

Table 1 (*continued*)

	Performing Arts Audience[a]	Urban Population[b] (1960)
Income		
Over $5,000	91.3%	64.8%
Over $15,000	39.5	5.4
Over $25,000	17.4	1.5
Median Income	$12,804	$6,166
Frequency of Attendance Average Number of Performances Attended in Last 12 Months:	Number	
Theater	8.4	
Symphony	5.1	
Opera	1.7	
Dance	1.2	
Other Serious Music	2.2	

[a]Based on Twentieth Century Fund audience survey; 24,425 respondents. The figures given here are weighted averages of the results for individual art forms. The weights are based on estimated attendance in 1963–64 and are as follows (on a 100 point scale): Broadway = 38, off-Broadway = 5, regional repertory theater = 9, major orchestras = 38, opera = 6, dance = 4. See Appendix Tables IV–A and IV–J for the derivation of these weights and a comparison of this profile with the profile which uses numbers of questionnaires completed as implicit weights.
[b]Data from *U.S. Census of Population, 1960: Detailed Characteristics, U.S. Summary,* Tables 158, 173, 185, 194, 203, 224. A composite profile could have been built for just those cities where we conducted surveys, but some experimentation indicated that this refinement would have made little difference.
[c]The number of employed persons is the base for the following percentages. The percentage of teachers is a component of the 'Professional' category.
[d]The base for these percentages is the total number of respondents.

estimated attendance in 1963–64, and a corresponding profile for the urban population of the United States as of 1960.

The first thing these data suggest is that the performing arts audience, contrary to what many people believe, seems to be somewhat more heavily male than the population as a whole. Nearly 53 per cent of our respondents were male, whereas only a little more than 48 per cent of the urban population is male. However, this probably should not be taken too seriously. It may simply reflect a male prerogative: if a husband and wife were present and the questionnaire was contained in

the wife's program, it is very possible that the husband would have filled it out.

Though the median age for the U.S. population is 8 years below that of the arts audience, this indicates simply that children do not often attend the theater although they are included in the Census. The rest of the data on age indicate that the audience is relatively young. This is shown most easily with the aid of Figure 1. In that graph, the dark bars represent the proportion of the audience in different age groups and the light bars the proportion of the urban population as a whole in these age groups. We see that relative to total population the arts audience is greatest in the interval 20 to 24 years of age. Twice as high a percentage of the arts audience (12.2 per cent) lies in that age interval as is the case for the total urban population (6.1 per cent). This ratio of 2.00 is what we call the *relative frequency*; it is equal to the proportion of the audience within a given category divided by the proportion of the total urban population in that same category. Calculation of such

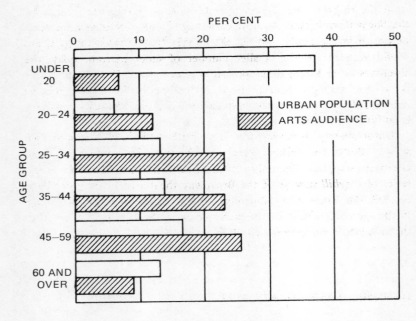

Figure 1. Age Distribution of the U.S. Performing Arts Audience and of the Total Urban Population (See Table 1 for the data on which this graph and others in this chapter are based.)

figures for each of our other age group categories (Appendix Table IV—D) shows very clearly that relative frequency declines steadily with age once we get beyond the interval under 20 years of age. These figures tell us that the audience at a typical performance is far younger than the urban population as a whole, and that the older the age group, the smaller is its relative representation in a typical audience. Consequently, older people (those over 60) are the scarcest members of the audience in relation to their numbers in the urban population of the United States. In a word, audiences are young. With the proportion of the nation's population in the younger age brackets growing rather rapidly, this fact may be quite significant.

Two alternative hypotheses can explain the relative youthfulness of the arts audience. If the same age patterns have always characterized the audience, it means that people attend performances when they are young and then gradually drop out of the audience as they grow older. They may become less interested, or attendance may become more difficult for them, or other interests and responsibilities may keep them from the theater. The second hypothesis is more sanguine. It may be that the performing arts are now attracting a younger audience than ever before. If young people did not attend very frequently in the past, this would account for the smaller number of older patrons today, the absentees never having developed an interest in live performance. If this is so and younger Americans are attending in far higher relative numbers than they did in the past, then we may be building a base for a great future expansion.

Unfortunately, because there is so little in the way of comparable survey results for earlier years, we cannot be sure which of these alternatives applies. The only source of historical data known to us is a series of *Playbill* surveys of the Broadway theater audience going back to 1955—56. These data (Appendix Table IV—E) show almost no change in the age composition of the audience and thus support the view that the audience is *not* growing younger.

Occupation, Education and Income

Turning next to the distribution of audiences by occupation, we see that roughly 15 per cent of all our respondents were students, and that among *employed males* only 2 to 3 per cent of the total audience

included in the survey was composed of blue collar workers, as compared to a figure of nearly 60 per cent for the urban population as a whole. We conclude that the audience for the arts is made up preponderantly — indeed, almost entirely — of people from the white collar occupations. In the typical arts audience all of the white collar groups are over-represented (in comparison with the urban population), with two exceptions, clerical and sales persons. The degree of over-representation is by no means the same, however. Among males there are roughly nine times as many teachers in the audiences as in the urban population of the United States, and nearly five times as many professionals of all sorts (see Figure 2 and Appendix Table IV–D). The arts' share of professionals is also much greater than their share of managerial personnel. In general, the very high proportion of members of the professions in the arts audience is characteristic of both sexes. However, the proportion of teachers in the audience is much higher for men than for women. As a possible explanation one might surmise that a high rate of theatergoing is characteristic of teachers at more advanced professional levels, and that female teachers are more heavily distributed in the lower grades of the schools.

Two numbers not shown on the table or the chart are of interest. Three per cent of our employed male respondents were themselves performing artists or performers and 5 per cent of the females were in this category. These proportions are surely significantly higher than those for the population as a whole, but the unavailability of related Census data prevents a direct comparison.

Next we turn to the educational attainment level of the audiences, reported in Table 1 and shown graphically in Figure 3. All of these results refer only to persons 25 years of age and over, in order to avoid the biases introduced by including persons who are still in school. We conclude that the audience is composed of *exceedingly* well-educated persons. Less than 3 per cent of the males and females did not graduate from high school, as compared to the more than 50 per cent of the U.S. urban population 25 years and over who did not do so. At the other end of the spectrum over 55 per cent of the males attending performances did some work beyond college — an educational level attained by only 5 per cent of the urban population. Almost one third of the women in the audience did some graduate work as compared with 2 per cent of the female urban population who did so. In Figure 3 the sharp decline in the length of the light bars as we move from top to bottom means that the proportion of the urban population at each

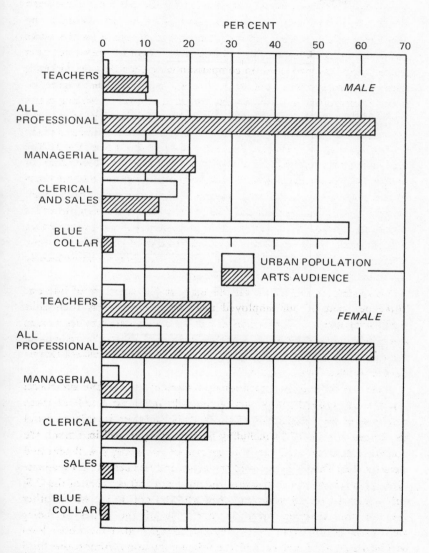

Figure 2. Occupational Distribution of the U.S. Performing Arts Audience and of the Total Urban Population

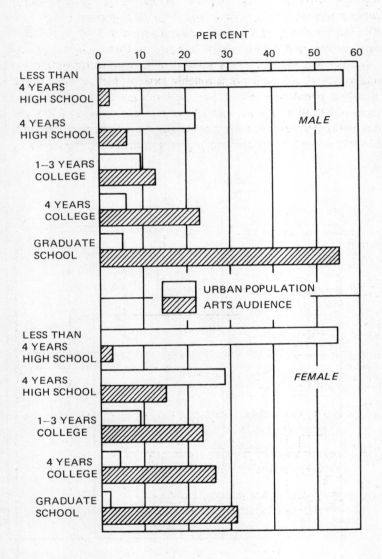

Figure 3. Educational Attainment of the U.S. Performing Arts Audience and of the Total Urban Population

educational level falls very rapidly as the level of educational attainment increases; the reverse is true of the arts audience.[3]

The last socio-economic characteristic reported in Table 1, audience income, is described in more detail in Figure 4. Once more the results are clear-cut and extreme. They show that the median family income among a typical arts audience is roughly *twice* as high as that for the total urban population. Forty per cent of our arts audience had incomes of $15,000 or more, and 17 per cent had incomes of $25,000 or more. The proportion of the arts audience in the category $15,000 to $24,999 is nearly six times as high as that of the urban population as

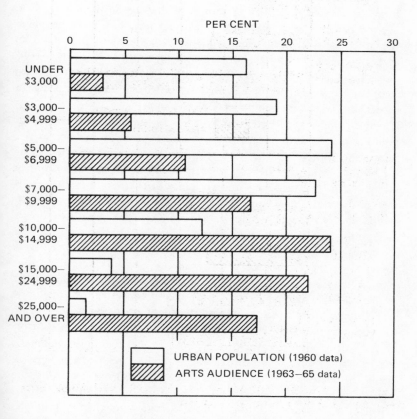

Figure 4. Income Distribution of the U.S. Performing Arts Audience and of the Total Urban Population

a whole; and about 11½ times as large a proportion of the audience earned over $25,000 as is true of the urban population generally.[4]

Differences in Profiles among Art Forms

What variations in audience characteristics can be observed when the several art forms are examined separately? Our findings are summarized in Appendix Table IV—F.

The most remarkable finding is that audiences from art form to art form are *very* similar. They all show a median age in the middle 30's; over 60 per cent of the audience for each art form consists of people in the professions (and this finding holds for both sexes); all exhibit an extremely high level of education, with 50 per cent of the males having gone to graduate school and 50 per cent of the females having at least completed college; and there is a consistently high level of income, in no case involving a median under $11,000.

Some moderate differences by type of performance are worth pointing out. For instance, there are differences in attendance by sex among art forms. Women tend to predominate in the audiences of symphonies and the dance, whereas men constitute the majority attending the theater, opera and programs of chamber music. There is also a slight difference in age among the various audiences, with symphonies having a higher percentage of persons over 60. However, we must point out that symphonies, perhaps more than other art forms, frequently have special young people's concerts, none of which were surveyed by us. The existence of these concerts must surely bias our estimate of the age distribution of symphony audiences, because many of the young people who attend such special concerts might otherwise have been found in audiences attending other performances.

As to occupations, we find that a relatively small number of students attend ballet, opera and the theater, but that chamber music audiences are heavily peopled by students, teachers and professionals in general. While the number of blue collar workers is low for all art forms, the highest proportion is found at the opera. This finding could reflect the effect of the culture of Europe, where opera is a popular art form, and may, therefore, report what is primarily an immigrant group. On the other hand, because of the small number of operatic organizations

surveyed, it may simply represent the influence of the New York City Opera with its low admission prices.

The number of blue collar workers remained consistently low throughout the survey. Their share of the total male audience reached 6 per cent in only 5 of our 35 theaters, never reached 5 per cent in any of the 12 major orchestras surveyed, constituted 5 per cent of the audience at the Brooklyn Opera, and 7 to 9 per cent of the audience for non-contemporary opera at the New York City Center. In dance, the proportion of blue collar workers was 7 per cent of the total at the performance of the Alvin Ailey Dance Theatre (a Negro company with a considerable Negro following), while in three of the other audiences surveyed there were no blue collar workers. In chamber music audiences the number of blue collar workers never reached 2 per cent.

Educational level was the most consistent element of all, with chamber music drawing the most highly educated audience — over 75 per cent of the males and 52 per cent of the females having attended graduate school.

Incomes also were consistently high, though theater patrons had an income about $1,500 higher, on the average, than members of the audiences of other art forms. In only 2 of the 35 theaters surveyed did median audience income fall below $10,000. The highest median income was not found on Broadway, but at a West Coast theater, where it was over $18,000. A Broadway theater did, however, come in a close second. In 29 of our 35 theater audiences, median income was between $11,000 and $15,000. The top figure for any *single* performance was almost certainly higher, because these figures represent the average of all the surveys taken at each organization (there was more than one in almost every case). All 12 major orchestras surveyed showed median audience incomes above $10,000, the highest being $15,000. Again, the results varied little; 8 of the 12 exhibited median incomes between $11,000 and $13,000. Audience incomes at dance and chamber orchestra performances were slightly lower than those of audiences in general. Two of our five dance surveys reported median incomes under $10,000. Three of the five chamber group audiences were in this category, but one of the string quartet audiences had a median income over $16,500.

A distinct pattern emerges from the responses to questions about frequency of attendance. Theater is shown to be the most popular art form. With one exception, the patrons at *all* types of performance — members of dance, opera or chamber music audiences — indicated that

the theater was the art form which they attended most frequently. Even in the exceptional case, the symphony, theater came in a very close second in frequency of attendance; that is to say, members of the symphony audience indicated that they attended theaters almost as frequently as they went to orchestral concerts.

The New York Audience

We also investigated the audience in New York City by itself. This enabled us to deal with a constant basic population, one drawn primarily from a single region. It also permitted us to make a direct comparison between off-Broadway and Broadway audiences, casting some light on differences between audiences for more and for less experimental theater groups. The detailed data for the New York audience are given in Appendix Table IV—G.

In general, the off-Broadway audience resembles more closely that of the other art forms than it does the audience of the Broadway theater. On Broadway the age distribution is concentrated in the middle range — comparatively few persons under 20 and over 60 attend. Similarly, the Broadway theater audience includes fewer members of the professions than does any of the other art forms in New York, both among males and females. But even there, professionals constitute more than 50 per cent of the audience. Broadway seems to draw a larger proportion of its audience from among the managerial group than do the other art forms. More housewives are represented in the Broadway surveys and, incidentally, in the orchestral audiences, than at other art forms. The educational level is slightly lower on Broadway, though even there it is remarkably high, with nearly 50 per cent of the men having done some post-graduate work. While income levels are highest in the orchestral audiences, they are not very much higher than median incomes of attendees on *and* off Broadway, and the Off-Broadway incomes are surprisingly close to the incomes of the Broadway audience. In terms of socio-economic characteristics there is no evidence to support the notion that off-Broadway attracts a clientele significantly different from that of any other art form.

The only reasonably comparable series of historical data on audiences which we have been able to find applies to the New York theater. The *Playbill* survey of the audience for the commercial theater

on Broadway has been conducted for more than a decade, though at some point there was a change in procedure so that the data are not strictly comparable.[5] What is most noteworthy in the figures for the six years that are usable (summarized in Appendix Table IV—E) is how little change in audience composition has occurred during the decade. One can only say that today's audience is about the same as that of a decade earlier except that it earns more money now than it did then. Even this is a misleading observation, for incomes per capita in the United States have also been rising. Indeed, the figures suggest that in this respect, too, the theater audience has remained about the same in relation to the rest of the population.[6] Thus, if there was a 'cultural boom' — a movement toward 'mass culture' — there is little sign of it in the composition of the audience of the commercial theater.

Audiences Outside New York

Since our investigation of the audience outside New York City showed the same patterns reported for the New York audience, a few brief comments on the subject will suffice. Three differences stand out (see Appendix Table IV—H). We found a relatively high proportion of students in the theater audience outside New York, a group which was comparatively poorly represented on Broadway. About 21 per cent of the theater audience was composed of students, as compared with figures of 8 per cent for Broadway and 11 per cent for off-Broadway. The same general pattern was evident in the orchestral and operatic audiences. Members of the professions made up a slightly larger proportion of the audiences outside New York City, and, if anything, the educational level was higher in other parts of the country. Income, however, was slightly higher in New York, though the median outside New York City was over $11,000. Frequency of attendance was somewhat greater inside the city, but not nearly as much greater as one might have expected, given the availability of performance in New York. Indeed, attendance at chamber music concerts was, if anything, somewhat higher outside the city.

The main point, then, is that the general features of our over-all audience profile are by no means due solely to the characteristics of New York audiences — as a matter of fact many of its most noteworthy elements are even more apparent outside New York City.

The British Audience

Because our results for the United States suggest that the audience of the performing arts comes from such a very limited segment of our population, it is important to ask whether this reflects a peculiarity of the American culture — whether in other countries, with other traditions and other educational systems, the audience represents a broader spectrum of the general public. For this reason (though we did not know our American results at the time) we decided that a few audience surveys should be undertaken in Great Britain, along with other kinds of research to be described later.

When we discussed our plans with British colleagues, they offered two general predictions: first, that our response rate would be lower in Great Britain than in the United States because the Englishman is particularly sensitive to any invasion of privacy; second, that the British audience would indeed be drawn from a wider group because British education places greater emphasis on the humanities and less on the sciences than does education in the United States. Both conjectures proved to be wrong.

We received a total of 2,295 usable responses at seven surveys conducted in the spring of 1965, two at the National Theatre (formerly the Old Vic), one at the Ballet Rambert, one at a performance of the New Philharmonia Orchestra, one at the London Philharmonic Orchestra, one at the London Symphony Orchestra, and one at an operatic performance at Sadler's Wells, all of them in London. Our over-all response rate was 50.3 per cent, almost exactly the same as the rate for the United States.

The similarity of the British and American results is remarkable. Table 2 provides data for Great Britain analogous to the figures given in Table 1 for the United States. The precise figures for British audiences should not be taken at face value. They are almost certainly distorted by the unrepresentative weighting of different art forms, a source of error for which we could not correct because of the small number of surveys conducted. Nevertheless, the results once again are very consistent from survey to survey and from art form to art form, and the orders of magnitude of the figures can, therefore, be accepted with considerable confidence. (The only noteworthy difference among British audiences by art form is that the British theater seems to draw its audience from a particularly exclusive group. In our sample the members of theater audiences have higher educational levels and higher

Table 2. Profile of the British Performing Arts Audience, Compared with the British Population

	Performing Arts Audience[a]	*Population*[b]
Sex		
Male	54.3%	47.6%
Age		
Under 20	12.0%	30.8%
Over 60	5.5	16.6
Median Age	31 yrs.	. . .
Occupational Category		
Males:		
Employed Persons:[c]		
Professional	60.5%	7.5%
Teachers	11.7	
Managerial	19.1	10.9
Clerical and Sales	15.9	12.7
Blue Collar	4.6	68.9
Students[d]	17.8	
Females:		
Employed Persons:[c]		
Professional	54.8%	9.7%
Teachers	22.8	
Managerial	5.3	4.2
Clerical	35.0	25.9
Sales	1.9	11.4
Blue Collar	3.0	48.4
Students[d]	20.1	
Housewives[d]	16.2	
Education (school-leaving age)		
Males:		
14 or Under	7.1%	57.9%
15	6.9	20.2
16	13.5	9.3
17, 18, 19	24.0	5.9
20 and Over	48.5	3.7
Median Category	age 17–19	14 or under

[a] Based on Twentieth Century Fund audience survey; 2,295 responses. Implicit questionnaire weights. No attempt has been made to weight according to attendance at different art forms.

[b] Figures obtained from preliminary tables to be included in the 1961 Census volumes, from special tabulations made for us by the Central Statistical Office, and from the *Demographic Yearbook* of the United Nations.

[c] and [d] See notes to Table 1.

Table 2. (*continued*)

	Performing Arts Audience[a]	Population[b]
Females:		
14 or Under	3.8%	59.7%
15	5.9	19.2
16	16.0	9.2
17, 18, 19	32.0	6.8
20 and Over	42.3	2.7
Median Category	age 17–19	14 or under
Income		
Over £499	96.1%	78%
Over £1,749	47.3	14.5
Over £2,500	29.2	5
Median Income	£1,676	£990 (est.)
Frequency of Attendance Average Number of Performances Attended in Last 12 Months:	Number	
Theater	10.2	
Symphony	7.9	
Opera	4.6	
Dance	1.7	
Other Serious Music	2.9	

incomes and are more frequently in the professional classification than the members of other audiences. The theater also has the highest frequency of attendance, with orchestral performances second.)

All of the special features which characterize the American audience are apparent in the data for Great Britain in Table 2. The same high proportion of professionals was found: among male members of the audience, 60.5 per cent were in the professional classification in Great Britain and 63 per cent in the United States; for females the figures are 55 per cent in Great Britain and 63 per cent in the United States. There was a somewhat larger representation of blue collar workers (4.6 per cent in Great Britain and 2.6 per cent in the United States), but this group still constituted an insignificant part of the total audience; and, as in the United States, the operatic audience contained an unusually high proportion of blue collar workers — nearly 8.5 per cent of the

males were in that category. The educational level of the British audience was extraordinarily high, just as was true of the American audience. Since there is not so well organized a system of post-graduate education in Britain, a direct comparison with the American results is not possible, but the similarly high level of educational attainment is shown by the fact that nearly 50 per cent of the males in the British audience left school at age 20 or over, while this level of education is reached by only 3.7 per cent of the entire British male population. The British audience, like ours, seems also to be very well off financially. Its median income of nearly £1,700 is a little less than twice that of the general public. Incidentally, frequencies of attendance were slightly higher than those in the United States, but their ordering by art form was the same, with theater attended most frequently in both countries, orchestral performances second, opera third and dance last.

Some noteworthy differences were found between British and American audiences. While the American audience was young, the British audience was even younger. The proportion of the American audience aged 20–24 was twice as high as that in the general population, but the British audience proportion was about 3½ times as large (Appendix Table IV–D). And while the proportion of the American audience aged 60 and over was only 0.69 per cent of that in the general population, the comparable British audience ratio was less than half as large. Thus Englishmen are even more likely than Americans to attend when they are young, and even less likely to attend when they are older. An even higher proportion of British professionals seems to attend the arts than is true in the United States. In Great Britain the proportion of male professionals in the audience was over eight times that in the British population, whereas the corresponding American ratio was about five. There was also a somewhat higher proportion of clerical-sales occupations represented in the British audience.

The relation between income and attendance differs somewhat for the British and American audiences Low income groups are about equally represented in the audiences of both countries. However, the British lower middle income groups are a little more heavily represented, while in our country it is the upper income groups who are relatively more frequent in their attendance. This, then, is about all that can be said in support of the view that the British audience represents a broader segment of the population than does that in the United States. Even here, however, the differences are small.[7]

The Frequent and Infrequent Attenders

It should be clear by now that 'the common man' is fairly uncommon among those who attend live professional performances. But one may well ask whether he is much better represented among those who go only very occasionally. To some extent this turns out to be the case. A breakdown of our data by frequency of attendance shows that people who are well educated, well-to-do, and who are engaged in professional occupations constitute a particularly large proportion of those who attend performances frequently. Conversely, those who attend only rarely have lower incomes, are a bit more frequently blue collar workers and have a slightly lower level of educational attainment. This relationship, the fact that the infrequent attenders more closely approximate 'average citizens,' was first observed by Moore among the members of the Broadway audience.[8]

Our regional theater surveys show that among males who attended only once during the year of our survey 59 per cent were professionals, 8 per cent were blue collar workers, the median educational level was four years of college, and the audience's median family income was $9.500. But for those who attended at least 10 other performances that year the corresponding figures were 67 per cent professional, 3 per cent blue collar, the median educational level was graduate school and the median annual income was $14,500. Appendix Table IV—I, which presents these data in detail, shows that similar differences between frequent and infrequent attenders hold (but to a small degree) for the major orchestras and (much more markedly) for the Broadway theater. Moreover, with few exceptions, the relationship between these variables and frequency of attendance is perfectly regular. For example, among the audiences of the major orchestras one observes the following pattern:

Number of Performances Attended Per Year	1	2—5	6—10	over 10
Family Income	$9,500	$10,500	$12,500	$13,000

Curiously, students are generally better represented among the infrequent attenders, perhaps because their studies or their social activities keep them too busy or because they cannot afford to attend

very often, though the availability of reduced rate student tickets may cast doubt on the latter explanation.

On the whole it appears that the group that attends performances very rarely is more similar to the general population in its composition than is the audience as a whole. Yet even the infrequent attender is no 'common man.' His (median) family income is over $9,500, his (median) educational level is at least four years of college, and, if he is an adult, there is a better than even chance that he is engaged in a professional occupation. This is still a highly select group.

The Size of the Arts Audience

The data we have just discussed permit us to estimate the size of the audience for the live performing arts. We saw in Chapter III that in 1963—64 approximately 20 million tickets were sold by Broadway, off-Broadway and regional theaters, major and metropolitan orchestras, opera groups and (American) professional dance companies. But since most of the individuals who purchased these tickets attended more than one performance, we can be sure that the number of different persons purchasing tickets was considerably under 20 million. Table 3 summarizes our estimates of the number of different individuals who attended each of these art forms.

How large, then, is the number of Americans attending some type of live performance? That number must be considerably smaller than the total of the corresponding figures for the individual art forms because of the overlap in the audiences of different types of performance. If 50 persons attend only theater, 50 attend only opera and 50 attend both, then the theater and opera will each have 100 patrons even though, in all, only 150 individuals are involved. An intense examination of our data has led us to estimate that (excluding 'the road' and summer stock) the audience of the live professional performing arts in the United States totaled 2½ to 3 million persons in 1963—64. We suspect that this figure and the estimates for the individual art forms in Table 3 are a little low since, as any student of survey techniques would affirm, respondents tend, perhaps unconsciously, to exaggerate the frequency with which they attend performances. In addition, the frequency figures are inflated by our inability to remove from them attendance at non-professional performances. If average frequency of attendance is

Table 3. Average Estimated Attendance, by Art Form

	Average Estimated Attendance[a]	*Average Number of Times Attended in Last 12 Months*[b]	*Number of Individuals Attending (col. 1 ÷ col. 2)*
	(1)	(2)	(3)
Broadway	7,000,000	4.5	1,555,556
Off-Broadway	900,000	6.5	138,462
Regional Theaters	1,500,000	4.5	333,333
Major Orchestras	6,600,000	4.8	1,375,000
Opera	1,700,000	2.6	653,846
Dance	750,000	2.3	326,087

[a]Taken from Table 1.

[b]An average weighted inversely by frequency of attendance to correct for over-representation of frequent attenders in our sample (if individual A attends twice as often as B, he is twice as likely as B to be included in our sample). Specifically, let i represent any of our frequency of attendance categories (once, 2—5, 6—10, over 10), let f_i be the average frequency of attendance for the given art form and category, and let N_i be the number of individuals in the category. Then our weighted average figure in column 2 is obtained from the expression $\Sigma f_i (N_i/f_i)/\Sigma(N_i/f_i)$ or, more simply, $\Sigma N_i/\Sigma(N_i/f_i)$.

lower than our figures indicate, then the 20 million tickets sold in 1963—64 must have been distributed among a correspondingly larger group of people. Nevertheless, it seems to us quite unlikely that the audience comprises more than 5 million individuals, a figure which would be 4 per cent of all residents of this country 18 years of age and older.

In this chapter we have tried to provide an extensive profile of the audience of the live professional performing arts in the United States. Two of its features are especially significant.

The first is the remarkable consistency of the composition of audiences from art form to art form, from city to city and from one performance to another.

Second, the audience is drawn from an extremely narrow segment of the American population. In the main, it consists of persons who are extraordinarily well educated, whose incomes are very high, who are predominantly in the professions, and who are in their late youth or early middle age. This finding has important implications for the nature of whatever growth has occurred in audience demand for the arts. Even

if there has been a significant rise in the size of audiences in recent years, it has certainly not yet encompassed the general public. If the sociological base of the audience has in fact expanded, it must surely have been incredibly narrow before the boom got under way. This result indicates also, in a larger sense, that attempts to reach a wider and more representative audience, to interest the less educated or the less affluent, have so far had limited effects.

Yet there is also evidence that something can be done to broaden the audience base. As will be shown later, when professional performances are given free of charge or with carefully set low prices, the audience is drawn from a consistently wider cross section of the population. But even here there are no easy and overwhelming victories — in these audiences the number of blue collar workers is almost always under 10 per cent and the number of professionals is always well over 50 per cent; over 50 per cent of the males have completed college; and median incomes are almost always well over $9,000. Obviously, much still remains to be done before the professional performing arts can truly be said to belong to the people.

1. For a few other audience survey results see: Moore; survey of the Tyrone Guthrie Theatre audience (Minneapolis); survey of the Charles Playhouse audience (Boston); *Playbill* surveys; survey of the Sadler's Wells audience (London); survey of the UCLA Theater Group audience (Los Angeles); survey of Baltimore Symphony subscribers; survey of the national FM radio audience by *Broadcasting* magazine and two Carnegie Hall surveys. Full references to all of these will be found in the Bibliography.
2. Appendix IV—I gives a detailed description of our survey methods, including copies of the questionnaires, a list of organizations surveyed and a tabular summary of response rates. (All Appendices referred to in this Reading are to be found in Baumol and Bowen, *Performing Arts: The Economic Dilemma.*)
3. The only serious disagreement between the results of other surveys and our own relates to the quantitative effect of level of education. While other investigations also report that the audience is very highly educated, their conclusions are not quite as extreme as ours. In general they show a plurality of persons with college degrees rather than a plurality of persons who have attended graduate school. Examples are the Baltimore Symphony audience survey: college graduate 41 per cent, graduate school 21 per cent; the UCLA Theater Group audience survey: college 55 per cent, post-graduate 13 per cent; the 1964 *Playbill* survey (males): college 50.3 per cent, graduate school 28 per cent; the Guthrie Theater audience survey (males): college graduate 25.4 per cent. post-graduate 45 per cent. These figures suggest that our questionnaires, perhaps because of their length, were answered more readily by highly

educated persons. But, despite some disagreement on the magnitudes involved, all of these results confirm fully our qualitative conclusion: that the audience for the arts is *very* highly educated.

4. Since the income figures for the urban population of the United States are based on the 1960 Census, and income in 1963—1965, when our survey results were obtained, was undoubtedly somewhat higher, the true differential between the income of the audience and that of the general public is a bit smaller than our results suggest. Nevertheless, the differential is so substantial that a correction for this discrepancy would alter our numerical comparisons only slightly.

5. Unfortunately, we have been unable to locate a complete set of survey reports either from *Playbill* or any of the library theater collections. In fact, we have not seen the original report on the 1955—56 survey; our data for that year had to be reconstructed from figures quoted in an article by Max Frankel in the *New York Times* (May 20, 1956, Theater Section, p. 1).

6. This can be seen as follows. The median income of the audience in 1959—60, the first year for which this statistic was calculated, was $9,650, whereas the figure for 1963 was $11,011. (As already indicated, the 1964 jump to $16,700 should probably be ascribed to the influx of World's Fair visitors and so is irrelevant for a calculation of the basic trend.) This represents a rise of a little over 14 per cent during the three year period. Now, according to the U.S. Census, median family income in the United States rose about 9.5 per cent over the same time interval. (*U.S. Census of Population, 1960: Occupational Characteristics,* Final Report PC[2]—7A.) Since incomes of people in the professions have recently been rising more rapidly than those of the population as a whole, one suspects that the incomes of members of the audience of the commercial theater were perhaps just about keeping up with the incomes of others in the same socio-economic classes.

7. The differences between the income distribution relationships in the two countries are shown more clearly in a fairly technical diagram (Appendix Figure IV—A). All of the relative frequency ratios for both countries are summarized in Appendix Table IV—D.

8. See Moote, Chapter IV.

C. Special Problems

0. Unsettled Questions in he Political Economy of he Arts

by L. ROBBINS

reprinted from The Three Banks Review *September 1971* pp. 3–19

I

he export of an important Velasquez, the continual uncertainty garding the destination of the even more important Titian, the position of entry charges to public museums and galleries and the ntastic anomaly of the tax system revealed by the fate of the Hart quest to the National Gallery have all contrived to make discussion of e principles of state support for the arts a matter of urgent portance. This paper is an attempt to sort out some of the main ues.

II

hy should the taxpayer provide money for the arts? Why should not e whole business be left to consumer demand? If people want art ey will buy it: if not, why should it be produced? It is not only the thors of the coarser contributions to the correspondence columns of e press who take this line. I have known quite sophisticated people ith slightly doctrinaire inclinations who have thought themselves, or lked themselves, into attitudes of this sort.

Now clearly this is not a question which can be answered by ference to scientific economics. It is a question of ultimate values, a estion of what you think to be the purpose and function of the state the authoritarian element in society, a question of political

175

philosophy. Economics comes in only when you want to know t
implications of your decisions in this respect, implications as regar
proportions, incentives and machinery.

On this plane therefore of political objectives, I personally ha
never had any difficulty in regarding some cultivation of the arts a
higher learning as part of my conception of the state obligation. Mo
of us would admit the desirability of some assumption by authority
the educational function — though doubtless there is much room f
argument as to what form this should take — and I would argue that
the purpose of education is to provide anything beyond the me
essentials of vocational competence — which I certainly think
is — then the provision of examples of the highest standards of cultur
achievement in the visual arts, in music, in the theatre and, I would ad
in the less remunerative section of pure scholarship, comes within th
function.

But personally I would go beyond this and regard the provision of
accompaniment of enjoyment and amenity as part of the legitimate a
psychologically desirable manifestations of state activity. Most of us
fancy, would wish the apparatus of authority to be pleasing to the ey
both internally and externally, and for the opportunities of pleasu
afforded by parks, galleries, libraries and the maintenance of the be
practice in music and the theatre to be supported by state expenditur
and we feel a debt of gratitude to those who have held this view in t
past and provided us with handsome buildings, agreeable open space
the great collections and a tradition of public theatres, opera hous
and concert halls. A man can test his fundamental instincts in th
respect if he imagines the contrary state of affairs — the state as t
mere guarantor of law and order, operating in buildings providing on
resistance to weather and the elementary requirements of hygiene — r
parks, no public galleries, no nationally supported cultural activiti
beyond the bare minimum of vocational education. The tapestry
history would certainly have had a different appearance had su
principles been prevalent; and my value judgment is that it would ha
been radically inferior.

To avoid misunderstanding, I ought perhaps to add that there
nothing in this conception of the requirements of state functions whi
would lend any support to the view that the provision of culture shou
be a state monopoly. To me, at least, nothing could be mo
antipathetic than the view that such matters should be *controlled* —
distinct from *encouraged* — by the state or by similar authorities. O

need not look far afield to see the utter sterility which descends on creative — as distinct from executive — art when that is attempted. All that is implied is that, without in the least pretending to monopolise, the state should provide the resources necessary for the adequate maintenance of a sufficient volume of the various activities involved. And no sensible person will deny that this is a matter for argument and will vary from time to time and from place to place.

III

This brings us to the very hot contemporary question of charges. Should entry to state-subsidised cultural enterprises be subject to a charge or should it be free?

Let me say at once, as one who greatly regrets the Government's proposed departure from the custom of free entry to most of our national museums and collections, that I am afraid that a great deal of nonsense has been talked by the opponents of this policy. It is not true that the custom has been universal. The Tower of London charges. The Hampton Court Gallery charges. And it is not necessarily true that attendance is going to fall in any catastrophic manner by the imposition of charges — though the idea that it will not tend to fall at all seems to me equally implausible. I personally hope, with my fellow trustees of the National Gallery, that the categories of free entry will be extended — particularly for young people. But to pretend that the price of a few cigarettes or a pint of beer is going to cause severe hardship or deprivation to many classes of people is to treat the subject less seriously than it deserves.

For there are, indeed, very good arguments in favour of the continuance of free entry to permanent collections. The advocates of the policy of charging take too much credit to themselves if they think that all the reasonable presumptions are in favour of change. In my judgment, the balance goes the other way: the only technical argument they have adduced is invalid.

The crux of this argument lies in a comparison with the theatre and the opera house. If people are justly charged for admission to the Old Vic and Covent Garden, why should they not be charged for admission to the National Gallery and the British Museum? This is the thesis which was strongly urged by the Minister for the Arts when the matter

was recently debated in Parliament. Indeed he seemed to think that i established a position of incontestable strength *vis-à-vis* his adversarie:

But this rests on a false analogy. It is true that both types o provision are state assisted. But, in the nature of things, in the one cas there is a *need* to charge and in the other there is not — a need based o capacity in relation to the demand for it. If there were no price charged for (most) performances of state-subsidised theatrical o operatic performances, there would be far more people applying fo tickets than there was room for them in the house concerned — ther would be mile-long queues from Covent Garden to the river. In sucl circumstances it seems more sensible to ration by price rather than b capacity to sleep out on the pavements so as to be at the head of th queue when the doors open. And this of course is the policy actuall followed. Broadly speaking, the pricing of seats at publicly supporte performances should be designed, not to secure maximum profit, bu minimum unsatisfied demand at prices commensurate with a high use o capacity. That it does not always hit the mark — that for the mos favoured performances there may develop a black market in tickets — i a matter of human fallibility.

But the position of the national museums and galleries is radicall different. Where there is a danger of overcrowding at special temporar exhibitions, there has, indeed, never been any hesitation in charging a entrance fee.[1] But for the permanent collections, at present at any rate the demand at a zero price is not of this order. There is no sucl overcrowding that grave discomfort is caused by free entrance. In thi respect, I submit, the correct analogy is not with the publicly subsidise opera or theatre but rather with the parks and libraries, also publicl subsidised, where equally the use is not such as to involve seriou overcrowding. I notice that libraries have been specifically exempte from the new order of things and I have never even heard of any projec of installing turnstiles by the Serpentine or in Regent's Park. Ye libraries and parks involve just the same sort of running expenses. Th onus of proof surely rests with those who argue that there i justification for charging for the use of one but not for the other.

Thus there is no question of principle compelling the application o charging to all types of cultural provision whatever the demand fo them. The most that can be said for it is that it is a matter of financia expediency — of getting a little more for the arts than can be otherwis squeezed out of a reluctant Chancellor. And although it cannot be seriously contended that what is done in most galleries of continental

Europe is utterly repugnant to decency and morals, I find it difficult to convince myself that our own tradition is not greatly superior. Once it has been decided in the interests of amenity or culture to provide a park or a gallery — admittedly a non-commercial enterprise — there seems no very convincing argument against making the amenities available to a larger rather than a smaller number of people, until the point at which increased use becomes gravely inimical to individual enjoyment. To impose a charge is likely to keep away just those members of the public in whom — in the interests of the educational and amenity function — it would be most desirable to kindle interest. And the amount that is likely to be yielded by the proposed, admittedly very moderate, scale of charges is so small in relation to all the trouble to administrators and annoyance to the public that will be caused by the change of ancient practice — the government must have already lost the support of many thousands of voters in this way — that it is difficult to believe that this is not an example of how, with the best will in the world, a somewhat half-baked doctrine can get the better of good sense.

IV

Keen as has been the discussion of the charges question, it would be to lose all sense of proportion to regard it as having anything like the significance for the future of culture in this country as the problem of the continued export of great masterpieces.

This problem can be stated quite simply. The stock of historic works of art in this country is being continually depleted by export, induced, not wholly but to a very large extent, by penal rates of taxation. This has been going on for many years; and now, so far as pictures are concerned, there cannot be left in private hands more than a few hundred works of minimum, or above minimum, National Gallery quality and only a modest fraction of this number of the first order of excellence. It is abundantly clear that, if nothing is done, then, within a very few years, the number remaining will be negligible.

Now there can be no case for the view that in no circumstances should there be migration of important works of art. The great collections, public and private, in this country were built up in the past to a large extent by purchases from abroad; and although I personally

deeply regret the departure in the same way of some of the exports from private ownership in this country to enrich public collections elsewhere, yet I would not argue that, so far as the world is concerned, this must be regarded as a dead loss. But this is not a matter which can be usefully discussed in the light of stratospheric abstraction: it must be judged in relation to particular historic situations. And it must surely be conceded, even by the most philistine, that it is at least possible to conceive of impoverishments of national culture which can come in this way. I think that this would be conceded where objects of *indigenous* culture are concerned. We should regard it as an outrage if, for instance, what will never happen, the Vatican were to strip the Pauline chapel of the two Michelangelo frescoes there and export them to California. But equally it should be conceded when works which have come from elsewhere and have become, or can become, part of a national heritage, are involved. If we think of other times, I hope it would be agreed that it was a cultural catastrophe for this country when the collection of Charles I was auctioned by the Puritans. And in our own time, if we think of the pleasure and inspiration which it has already given to millions and will give to many more in the future, it would surely have been a grave loss if Mr Macmillan's government had not intervened and helped save the Leonardo Cartoon for the nation. This last example is typical of the situation with which we are now confronted. There is a real danger of a landslide in which the few great works of art now in private hands in this country may be irreparably lost.

In similar circumstances, the governments of other countries have not hesitated to impose a total prohibition of export save with explicit permission; and, where the objects concerned are in the hands of churches and charities which have long enjoyed special privileges as regards taxation, I should not regard this as unjust and indeed I hope very much that our Government may adopt a similar policy. But, where the objects in question are in private hands, a real problem of equity arises. To say to the owner of, say, one Rembrandt, 'this is of national importance and must not be exported', and to the owner of, say, another, 'we are not interested in this and you may sell it as you wish', involves a degree of the arbitrary which is repugnant to a sense of justice. It is surely very hard luck on the man who has had the good taste to hold his wealth, whether acquired or inherited, in the shape of works of art, to deprive him of the value of his property, whereas if he holds it in the form of stocks of tin or securities, he is allowed what the markets award. This is discriminating nationalisation without

compensation — a practice which hitherto, at any rate, has been unacceptable to all responsible parties in this country.

It was this view which was adopted by the Waverley Committee which investigated the matter in the early fifties. This committee (of which I was a member) held that there was good justification for the system of export licensing which had grown up during the war in that it brought to the notice of the custodians of the national collections the possibility of sales abroad of objects which might be conceived to be of national importance, and, by affording the possibility of delay in the issue of licences, permitted scope for the raising of the funds necessary to retain such objects in the country. But it held, too, that if funds were not forthcoming sufficient to purchase at current international values, then export should be permitted.

This recommendation was adopted; and with its apparatus of a tribunal which can hear appeals against refusals to issue export licences immediately, it forms the basis of present practice in this respect. I think it has commended itself as equitable to all parties concerned; and it is certain that it has done much to permit the re-establishment of London as the principal art market of the world. But, as the committee also recommended with all the force it could command, in such circumstances, the national interest could only be safeguarded if the adoption of these rules were accompanied by the provision for public collections of sufficient funds to finance desirable purchases. If that were not done, then the whole business of licensing and review would be a mere formality and an empty formality at that.

It would be wrong to give the impression that there has been no response to this recommendation. At the time of the publication of the Waverley Report the annual purchase grant of the National Gallery was £7,000. The Government of the day screwed itself up gradually to advance this princely sum to £12,500, where it remained for some time. Then, to the eternal credit of Lords Amory and Boyle and the officials advising them, in 1959 a discontinuous change of policy was introduced. The grant was advanced to £100,000 plus £25,000 for replacements for the Lane collection in respect of which special loan arrangements had been made with Dublin; and since then it has increased at intervals until at the present time it stands at £480,000.

Unfortunately during the same period prices in the art markets have also increased. The Cézanne *Vieille au Chapelet*, for instance, for which it is an open secret that the Gallery paid a French owner not much more than £30,000 in 1954 — for which incidentally it was denounced for

waste of public money by Sir Gerald Kelly — would now unquestionably go for over £300,000; and this is typical of the general movement. The position today is that, for most of the greatest masterpieces now remaining in this country, to say nothing of those which it would be desirable to obtain if they were marketed abroad, even grants of the order of magnitude now prevailing are quite inadequate — as the present position regarding the Titian *Death of Actaeon* shows. Certainly it would have been impossible in the last ten years for the galleries to do what they have actually done without the aid of the special extra grants which have been forthcoming.

Special grants, however, are cumbersome *vis-à-vis* the surprises of the market. If a gallery has adequate funds at its disposal, there are many occasions on which it can take the initiative or purchase before international repercussions complicate the situation: there are many owners and dealers who, without being unduly quixotic, are willing to deal on generous terms with national institutions. Moreover, it is not reasonable to expect that the momentary political situation will always be favourable to the use of this mechanism. Chancellors of the Exchequer are sensitive creatures, apt to be deflected from action which may well be in the long-run interests of everybody, by transitory and irrelevant circumstances which make it seem an unsuitable moment to give extra money for a particular purchase. As we know to our cost, we cannot always expect so splendid a response to a special appeal, as was forthcoming at a time of severe general financial crisis from the late Minister for the Arts, Lady Lee, in the matter of the Tiepolo *Venus*.

To meet this problem the Reviewing Committee and others have long suggested the creation of a special fund, similar to, or perhaps identical with, the Land Fund, which could be drawn upon, on suitable disinterested advice, in circumstances of special emergency. This of course would have to be voted year by year. Its use would be subject to parliamentary criticism as is any other item in the estimates. But, once voted, there could be great speed and flexibility in its use — an instrument of incomparable superiority to the special grant. It is difficult to see any rational objection to this, once the general desirability of the Waverley recommendation is accepted. Moreover, in present practice the Land Fund itself is actually used to provide finance off-setting the acceptance of works of art surrendered in lieu of death duty. The Reviewing Committee proposals involve a very slight extension of this function. But, for reasons which I have never been able to discover, the proposal has always been rejected. Yet with recent

developments in the art markets, the policy of preserving for the nation the more valuable works of art here domiciled becomes more and more precarious.

In recent months the prospect has been rendered even gloomier by the apparent antagonism of the present Minister for the Arts, Lord Eccles, even to the general policy of acquiring the more expensive masterpieces. It is his contention that what is chiefly needed in the world of visual arts in this country is not acquisition of great works of art but better and larger accommodation for existing collections. And with characteristic vigour, even before the sale of the Titian, he announced his sentiments in this respect.

Now Lord Eccles is a man who has done much for education and learning. He was a great Minister of Education. His rescue of the British Museum from the most hamhanded decision ever made by any government in this country regarding the national heritage is an achievement which must never be forgotton: and the same must be said of his success in extracting the promise of £36,000,000 for the construction of the new Library — *Though he slay me yet will I praise* thought in this connection. But, important as they are, new buildings is quite wrong and may easily be productive of great and irreparable damage. Agreed that better accommodation is desirable — Lord Eccles' experience at the British Museum must have done much to influence his thought in this connection. But, important as they are, new buildings and improvements of existing ones can be begun at any time in the future; whereas, once a great work of art has been exported, it would require something of a miracle to bring it back — for all practical purposes the loss must be regarded as irreparable. It is a fine and inspiring thing to have as Minister for the Arts someone who is willing to look ahead and plan a splendid building programme stretching out to the year 2000. But it will be a tragedy if preoccupation with this aim leads to indifference to the urgent needs of the present. It is really not sensible to believe that the public collections have all that they need in the way of precious possessions; and that what remains in private hands of the heritage of the past can be allowed to be dissipated without cultural impoverishment. And in saying this, I am not thinking of a handful of aesthetcs and art historians — as Lord Eccles sometimes appears to argue — I am thinking rather of the millions who yearly visit our na ional museums and galleries and get obvious pleasure and inspiration from their contents — such as the Titian until recently. Why should we, who can reasonably be said nowadays to lead the world in

art history and connoisseurship and the crafts of conservation and display, sit down quietly and let the treasures within our grasp slip away and proclaim to all the world that, so far as the acquisition of masterpieces is concerned, our collections, although doubtless exhibited with great care, must henceforward remain forever static?

v

In my judgment, therefore, increased support by the state for acquisitions is certainly urgently necessary in the years immediately ahead if we are not to fritter away our last chances. In another generation or two the great transfer of rare objects — books, works of art, historic manuscripts — from private to public ownership which began towards the end of the last century with the agricultural depression and the coming of death duties and progressive taxation, will have been completed. But, if we do not do more to offset what is happening on the sellers' side — which is a matter about which reasonable men may differ — the transfer will be to the public overseas rather than to the public in our own country.

There are ways, however, by which the necessary public effort in this respect may be reinforced from private sources, if we are willing to make certain changes in the tax system; and there is some reason to hope that such changes may not be as much out of harmony with the present way of thinking of those who rule over us, as seems to be the policy of direct assistance. There is no doubt there are easily practicable changes in this sphere which might greatly alter the prospects both of art and learning in this country.

Take first the sphere of the death duties. Here some attempts have already been made to take some account of the importance of retaining works of art of national importance. If an object is certified to be in this category, then, if it is not sold at the time of the passage of the estate, it is not charged with death duty until it is; and, if it is then sold to a national collection, the revenue will allow some of the difference between its gross and net values to be shared with the owner. This creates a certain presumption in favour of sale by private treaty. The trouble is that, with prices rocketing in the art markets, the owner may prefer to take his chance of a higher price than he can settle with the gallery and decide to go to auction. An increase in the so-called 'sweetener' might do something to redress this bias though, save in the

case of purchases through the Land Fund, this would increase the burden on the funds of the institutions concerned.

Outside this area of possibility, however, the most ludicrous and damaging inconsistency prevails. The value of a bequest to a national collection of an object certified to be of national importance need not be aggregated for estate duty purposes; a bequest of cash to the same value must be. Moreover, if the owner giving such an object dies within a year, the gift is not subject to duty, whereas he has to live for another year, if his cash is to be exempt. A classic example of the way these rules work is afforded by the fate of the recent bequest to the National Gallery of the estate of the late Sir Robert Hart. This estate was worth £500,000; yet under the present system the gallery will not receive much more than £100,000. If he had left a picture worth £500,000 there would have been nothing to pay.

I have racked my brains to find justification for the distinction; and I do not believe that there can be any. If a cretinous village imbecile had set himself to do something perverse he could not have done better. Now of course, in an evolving system, unforeseen inconsistencies emerge and need remedy by conscious action. But this inconsistency has been known to successive Chancellors for some time; and nothing has been done. Need I say more? Perhaps I should add that it is not in the least the fault of the Treasury, that much abused and much misrepresented institution, whose officials have always shown themselves highly sensible and sympathetic where art and learning are concerned. The blame rests fairly and squarely on successive Chancellors in their capacity as head of the Inland Revenue, a separate sovereign state from the Treasury.

Reform of the estate duties, as the current report of the National Gallery says in its masterly review of the tax situation, is a matter mainly important for its influence on wealthy donors or owners. Much more significant from the quantitative point of view is the possibility of reform of rules governing direct taxation of incomes. Our present arrangements in this respect offer no inducement to contribute to the arts or to learning – apart from the covenant system which gives no advantage, other than perhaps some prestige, to the donor. The road to reform here clearly lies in the direction of exemption from aggregation of gifts to scheduled institutions to a certain maximum percentage of the donor's income. There can be little doubt that a provision of this sort would have a powerful effect on the volume of gifts.

What is the argument against this? Anyone who does not know it

after the bleak and sterile reiterations thereof whenever the subject has been raised, should certainly go to the bottom of the form. Who, concerned with the future of the arts in this country, is not acquainted with the dreary insistence that such a system puts the power of subsidy in private hands and enables the donors in question to avoid their 'due share' of taxation? One must at least admire the incapacity for being bored by the repetition of one's own sentiments which is evinced by the so-called experts who advance it.

But what myopic and second-rate stuff it really is. Has the tax instrument never been used to give special privileges to persons who do special things deemed to be desirable by duly elected governments? Are there not forms of tax prevalent in decent and civilised communities the incidence of which on individuals can be diminished if they spend their incomes in one way rather than another? The position of the opponents of reform in this respect is perilously near the denial of usefulness to all forms of *indirect* taxation and insistence that every penny should be raised by 'straight forward' levies on incomes. Moreover, is it so undesirable that some at least of the financial provisions for culture should be partly furnished as a result of decentralised decisions by individuals, encouraged thereto by tax easements, rather than all voted directly by political assemblies which seldom have time to give more than perfunctory attention to the subject?

Surely there is something supremely unworldly about all this parade of high principle in sublime disregard of the object to be attained. If instead of tying themselves into knots asking whether changes of this sort are or are not inconsistent with the abracadabra of Somerset House, Ministers would concentrate their minds on the contrast between the concrete results of the American system and our own, they might not have such difficulty in deciding on practical action. There you see great galleries and museums, splendid libraries and research centres, and superb institutions of learning, all springing from private donations induced by the tax incentives. Here you see the springs of private benefactions virtually dried up by the incidence of penal taxation and all cultural institutions more and more dependent on state initiatives which more often than not are too little and too late. If one has any regard for the long-run interests of culture in this country, can there be any serious doubt as to which system is preferable and therefore as to the good sense of doing what can be done by reform of the tax system to revive the flow of private donations? It is not as though there are

serious technical difficulties. There exists already a schedule of institutions to which bequests in kind which need not be aggregated for death duties may be made. It should be easy enough to devise suitable extensions (including, I should hope, contributions to learned institutions) which would cover, not only cash passing at death, but contributions from current income.

VI

And the loss to the revenue? One hears the tones of *der Geist der stets verneint* gravely raising this apparently formidable objection to anything further in this direction. Of course we should look at the loss to the revenue of any form of tax remission or increase of expenditure: and no sensible person would deny the general financial stringency of our contemporary situation. But the fact that there has been much overspending in some directions does not mean that there has been in all. It does not mean that, while some expenditure should be diminished, no expenditure should be increased. Because one has wasted one's substance on wine and women that does not mean that it is wise to economise the proper care of one's eyes and teeth. What is at issue here, in this matter of the finance of the arts, is what, in the final analysis makes the difference between the memorable and the mediocre in the spiritual life of the community. What is at stake in the matter of the Titian is the possibility of retaining in this country one of the finest works of one of the greatest masters of painting, a work of superlative intrinsic beauty and of pivotal importance in the history of art of its period and subsequently, capable of affording unalloyed happiness and enlightenment to the many hundreds of thousands of our fellow citizens — 1¾ millions on the last count — who visit the National Gallery yearly. And if one turns from the pompous declamation of financial platitude to an examination of the amounts actually involved in comparison with other items of public expenditure, a sense of proportion is at once established. In the context of GNP or aggregate public expenditure the proportionate amount ever likely to be spent on the arts in this country is miniscule. A tiny fraction of what has been spent on the Concorde for instance, provided either by increased

grants or tax remissions of the kind suggested, would be sufficient to solve all the problems discussed in this article and many more besides.

1. Where there are specific costs incurred in respect of insurance and transport, there is also a case for charges.

11. The Economics of Museums and Galleries

by A. T. PEACOCK and C. GODFREY

reprinted from Lloyds Bank Review *January 1974 pp. 1–15*

The government first announced its intention to charge entrance fees for museums and galleries in October 1970 but it was not until January this year that charges were actually introduced. The intervening three years have seen a lively debate, which has raised some major issues of principle in public policy towards the support of cultural recreation. This article seeks to show that economic analysis has something to offer in clarifying some of these issues.

The paper begins with a short survey of the finance of national museums and galleries, which provides some necessary background information. Subsequently an attempt is made to review the activities of a gallery or museum as a 'firm' producing an unusual type of product and with a rather complex 'objective function'. This analysis helps us in the discussion of the rationale of public financial support and operation of museum and gallery services. Finally, we consider present government policy, including charging for these services.

The Present Financial Situation

There are eighteen national museums and galleries: twelve in London, five in Edinburgh and one in Cardiff, as follows:—

British Museum
British Museum (Natural History)
Geological Museum
Imperial War Museum
London Museum
National Gallery

National Maritime Museum
National Portrait Gallery
Science Museum
Tate Gallery
Victoria and Albert Museum
Wallace Collection
National Gallery of Scotland
National Museum of Antiquities of Scotland
Royal Scottish Museum
Scottish Gallery of Modern Art
Scottish National Portrait Gallery
National Museum of Wales

As they are owned and operated by the state, it is not surprising to find that their 'income and expenditure accounts' are similar to those of other units in government departments, i.e. by far the largest part of gross receipts takes the form of Parliamentary votes, and wages and salaries represent the bulk of gross expenditure. There are, however, one or two special features about the finance of museums and galleries which are relevant to the ensuing discussion.[1]

Sources of income

Table 1 sets out sources of income for sixteen of the national museums. Appropriations-in-aid, although not very significant, are not negligible They consist largely of the sales of publications and reproductions, admission fees and fees for the loan of collections. In the case of the British Museum (Natural History) research grants from various scientific foundations are also included.

It will be seen that the total fluctuates considerably from year to year, when considered alongside the growth pattern of total expenditure (see Table 2). Votes for museums and galleries are authorized *net* of appropriations-in-aid and, in keeping with normal practice, if appropriations-in-aid are greater than expected, the excess is submitted to the Treasury.[2]

The purchase grant-in-aid is earmarked for a specific kind of expenditure. The grant-in-aid is fixed for a five-year period and administered so that if, in one year, the grant is not completely spent, it can be carried over to the next year. Hence the item 'Balance of grant-in-aid account' in Table 1. In the case of an unusual purchase, for

Table 1. Sources of Income of 16 of the National Museums and Galleries[a]

	Appropriations-in-aid £'000 (%)	Purchase grant-in-aid £'000 (%)	Donations £'000 (%)	Other receipts grant-in-aid account £ (%)	Balance of grant-in-aid account beginning of period £'000 (%)	Gifts[b] £ (%)
1963/4	394 (39.2)	529 (52.6)	33 (3.3)	130	48 (4.8)	1,425 (0.1)
1964/5	436 (23.7)	1,057 (57.4)	273 (14.8)	3,617 (−0.1)	73 (4.0)	400
1965/6	413 (31.0)	696 (52.2)	51 (3.8)	545	173 (13.0)	365
1966/7	271 (21.2)	841 (65.8)	20 (1.6)	−2,859 (−0.2)	149 (11.7)	100
1967/8	262 (18.8)	822 (58.9)	96 (6.9)	1,794 (−0.1)	206 (14.8)	8,278 (0.6)
1968/9	326 (22.1)	807 (54.8)	87 (5.9)	215	252 (17.1)	–
1969/70	332 (17.7)	1,232 (65.7)	61 (3.3)	−1,991 (−0.1)	238 (12.7)	13,749 (0.7)
1970/1	366 (14.3)	1,959 (76.4)	91 (3.6)	–	147 (5.7)	270
1971/2	466 (17.6)	1,836 (69.4)	85 (3.2)	–	257 (9.7)	1,137

[a]These figures exclude the Geological Museum and the National Museum of Wales.
[b]These gifts do not include items which have been offered to the Commissioners of Inland Revenue in part settlement of estate duty and which have been directed to the museums and galleries by the Treasury.

example, the Leonardo cartoons, the gallery or museum can apply for a special supplementary grant. This may carry with it certain conditions, e.g. a fixed amount must be raised by private donations. Thus, although certain museums receive regular contributions, donations do vary considerably. In particular, it can be seen that both the total of purchase grant-in-aid and private donations were unusually high in 1964/65. Several museums received supplementary grants-in-aid for this year, but the principal item was the extra grant of £266,000 to the National Gallery. This sum included £125,000 for the purchase of Cézanne's *Les Grandes Baigneuses* and also a £100,000 advance from the National Gallery's 1965/66 annual grant-in-aid. The remainder (£41,000) was granted for the purchase of Courbet's *Les Demoiselles des Bords de la Seine*. Private donations to the National Gallery reached the considerable sum of £237,500 during this year.

Expenditure

Table 2 sets out expenditure of sixteen national museums. Salaries and general administration are items which appear in each museum's accounts and are met by the government. Technical expenses and publication departments' net expenditures appear in the accounts of only the British Museum and the British Museum (Natural History). As the museums have a separate grant-in-aid account, annual purchases made need not match the grant-in-aid. This system prevents unnecessary purchases by museums simply to use up their annual grant and also allows more freedom to save the grant for a possible larger purchase in some future year. (This tendency may be curbed, however, if museums fear that evidence of a large balance may reduce future levels of their grant-in-aid.) Hence, the figures for actual purchases do not exhibit the same trend as the purchase grant-in-aid figures of the previous table.[3]

The government further subsidizes the national museums and galleries to the extent that they use the common governmental services: maintenance, furniture, fuel and light, rent, rates, stationery, printing, superannuation and other miscellaneous services. These expenditures are met from the Department of the Environment's vote. This vote is not subdivided in the civil appropriation accounts to show how much the museums and galleries use, but yearly estimates are given. These estimates are shown in Table 2A and refer to the same museums and galleries as in Tables 1 and 2. These sums add considerably to the government's financing of museums.

Table 2. Current Expenditure of 16 National Museums and Galleries[a]

	Salaries £'000 (%)	General administration £'000 (%)	Museum[b] technical expenses (net) £'000 (%)	Publications[b] department (net) £'000 (%)	Actual purchases £'000 (%)	Publications[c] £'000 (%)
1963/4	3,234 (77.1)	177 (4.2)	215 (5.1)	29 (0.7)	537 (12.8)	4 (0.1)
1964/5	3,747 (68.7)	196 (3.6)	259 (4.7)	18 (0.3)	1,234 (22.6)	2 (0.1)
1965/6	4,153 (76.3)	238 (4.4)	261 (4.8)	17 (0.3)	770 (14.1)	3 (0.1)
1966/7	4,620 (78.1)	256 (4.3)	240 (4.1)	−4 (−0.1)	801 (13.5)	3 (0.1)
1967/8	5,172 (78.9)	298 (4.5)	222 (3.4)	−17 (−0.2)	874 (13.3)	3 (0.1)
1968/9	5,860 (79.1)	329 (4.4)	281 (3.8)	25 (0.3)	909 (12.3)	3 (0.1)
1969/70	6,415 (76.5)	386 (4.6)	204 (2.4)	2 (0.1)	1,370 (16.3)	7 (0.1)
1970/1	7,684 (73.0)	514 (4.9)	288 (2.7)	79 (0.8)	1,951 (18.5)	7 (0.1)
1971/2	9,220 (77.3)	646 (5.4)	370 (3.1)	6 (0.1)	1,671 (14.0)	9 (0.1)

[a]This covers the same museums and galleries as Table 1.
[b]These items cover the British Museum and British Museum (Natural History) only.
[c]This item concerns only the Wallace Collection.

Table 2A. Department of the Environment's Expenditure on Common Governmental Services for 16 of the National Museums and Galleries[a]

	Maintenance[b] £'000 (%)	Rents and rates £'000 (%)	Stationery and printing £'000 (%)	Superannuation £'000 (%)	Miscellaneous £'000 (%)	Total £'000
1963/4	1,771 (68.9)	144 (5.6)	250 (9.7)	359 (14.0)	47 (1.8)	2,571
1964/5	2,132 (71.4)	150 (5.0)	269 (9.0)	377 (12.6)	60 (2.0)	2,988
1965/6	3,276 (73.1)	182 (4.1)	288 (6.4)	663 (14.8)	71 (1.6)	4,480
1966/7	3,073 (71.3)	315 (7.3)	477 (11.1)	411 (9.5)	36 (0.8)	4,312
1967/8	3,224 (71.6)	283 (6.3)	526 (11.7)	429 (9.5)	40 (0.9)	4,502
1968/9	2,068 (60.5)	293 (8.6)	540 (15.8)	451 (13.2)	65 (1.9)	3,417
1969/70	2,429 (58.0)	484 (11.6)	602 (14.4)	547 (13.1)	127 (3.0)	4,189
1970/1	3,198 (61.9)	460 (8.9)	745 (14.4)	631 (12.2)	129 (2.5)	5,163
1971/2	4,017 (64.7)	527 (8.5)	861 (13.9)	652 (10.5)	153 (2.5)	6,210

[a]These figures are only estimates. The actual amounts spent on these institutions are not separated out in the Appropriation Accounts.
[b]This column is entitled 'Maintenance, Furniture, Fuel and Light'.

In view of the growing interest in comparative spending by the government on cultural pursuits, it is useful to record both the past and future trends in current expenditure on museums and galleries alongside the Arts Council grant-in-aid. Table 3 sets out past expenditures. Although expenditure on museums has always been higher than the Arts Council grant, the proportional gap has diminished over the period. No projections of current expenditure with the same coverage as the figures of this paper were available. There are, however, projections for some museums and galleries available in a recent White Paper (Cmnd 5178 1973) and these show a low growth rate of current expenditure. It has been announced that the Arts Council grant is to rise considerably from £11.9 millions for 1971/72 to £17.4 millions for 1973/74 at constant (1970/71) prices. This suggests that the Arts

Table 3. Net Government Expenditure on 17 National Museums and Galleries[a] and the Arts Council Grant-in-Aid

	Net expenditure on museums and galleries[b] £m	Arts Council grant £m
1963/4	6.7	2.7
1964/5	8.2	3.2
1965/6	9.8	3.9
1966/7	10.4	5.7
1967/8	11.2	7.2
1968/9	10.8	7.5
1969/70	12.6	8.2
1970/1	15.9	9.3
1971/2	18.6	11.9

[a]These figures exclude expenditure on the Geological Museum and the schemes administered by the Victoria and Albert Museum and the Royal Scottish Museum for other institutions. Actual appropriations-in-aid earned rather than the estimates are subtracted. The actual amount spent on common governmental services is not given, and the estimates of these expenditures is therefore included.
[b]The expenditure on the national museums and galleries is current expenditure only, excepting the provision for capital expenditure in the grant-in-aid to the National Museum of Wales. The Arts Council grant includes some provision for capital expenditure through the Housing of the Arts scheme.

Council grant will eventually exceed the current expenditure on the national museums. However, the government has also announced new capital schemes, in addition to capital projects already approved, averaging £2 millions per year until 1975/77, perhaps reflecting a change in emphasis of the government's expenditure on the national museums.

In conclusion, the small number and regional distribution of the national museums must be considered when reviewing government expenditure. Central government help to local museums and galleries is very small. Considering the financial administration of the museums, it should be noted that the government has now agreed that revenues from admission charges, after deduction of VAT, can be retained by each museum to be used for agreed purposes other than acquisitions which are covered by the quinquennial grant. Similarly, the museums, as their finances are now organized, have no real incentive to increase their appropriations-in-aid. Lastly, there seems to be some indication that the government is also reconsidering the composition of expenditure. More emphasis is being given to capital schemes than to further acquisitions. It is difficult to know whether this will affect the special supplementary grants, which have been used to prevent the export of valuable works of art.

The Museum/Gallery as a 'Firm'

It is, of course, obvious that museums and galleries are not designed to operate as private concerns or as public utilities charging for their products and services. However, this is not to say that it is not useful to apply standard economic analysis normally used to explain the operation of commercial concerns, in order to elucidate the economic problems of the gallery/museum, although somehow such an approach always encounters emotional resistance!

On the 'output side', a gallery/museum presents a range of products in the form of exhibits which satisfy a desire for visual enjoyment or for instruction. The important characteristic of this range of products is that enjoyment of them *cannot be traded*. Consumer participation is essential to the 'process of production', as, for example, in the case of a surgical operation. Of course, the enjoyment may be prolonged without attendance at a gallery/museum by those with an excellent visual

memory or by slides and reproductions of pictures and exhibits. (There is a parallel here between a 'live' performance and 'recorded and relayed' music and drama.) In other forms of consumption, it is not unreasonable to postulate that even those who do not themselves enjoy the products in question may derive a satisfaction from their enjoyment by others.

On the 'input side', labour consists of a combination of highly specialized skills — art experts, restorers of pictures and exhibits, historians and cataloguers — and relatively unskilled (but responsible) staff in the form of attendants, cleaners and sales staff. The *stock* of capital inputs in the form of pictures, exhibits, etc has three important characteristics: it is normally large in relation to the additions to stock; frequently a large part of it has been gifted, although maintaining the stock intact will require an annual provision for restoring, repairing, cleaning, etc;[4] although the situation varies from one museum to another and is inordinately complex, a large proportion of stock may have been gifted on condition that it is not to be sold, i.e. alteration in the composition of the structure of assets may be severely constrained.

It is clearly extremely difficult to specify the relation between the outputs and inputs by some kind of production function, principally because of the difficulty of defining output. A museum/gallery may produce a range of alternative outputs requiring different input 'mixes'. Thus, if the main concern is the general public's desire to see exhibits, resources will be devoted much more to preserving and mounting exhibits than in the case where the main concern is to help researchers who are more interested in an efficient cataloguing service. For the former, we might settle for number of attendances as a rough measure of output. Our description of the inputs of a museum/gallery suggests that the production of extra output does not call for a concomitant expansion in inputs, at least up to the point where congestion in galleries produces diminishing returns as viewing becomes difficult or impossible. Beyond some point, extra input will require extra capital costs in the form of additional exhibit space, as well as more attendants. A greater supply of exhibits is probably not required in most national museums, which can call up 'reserves' from their basements. Accordingly, one may say that the short-run marginal cost curve for a museum/gallery will fall as output increases, up to some point where there will be a discontinuity produced by the need to counter the congestion factor.[5]

Our speculations are bound to enter the realm of fantasy in

discussion of the 'objective function' of museums and galleries. Who *are* the decision-makers – the trustees, the director, the Minister for the Arts? What objectives do they pursue and how are these 'traded-off' against one another? Are research services or educational services more or less important than display services? How far is contemporary taste relevant in the display of existing stocks and in purchases of new exhibits? How far is a conscious attempt made to anticipate future public taste? What 'success indicators' are considered relevant – number of attendances, number of research enquiries? Our investigations have not yet reached the stage at which we are certain what questions to ask and to whom they should be put! One thing is certain: 'maximizing' the relevant objective function is subject to one major constraint in the form of the 'frozen' nature of the capital stock. If collections cannot be broken up because of the contractual conditions of the bequests, it is impossible, for example, to buy artistic treasures by the sale of assets. The situation is now under review and it will be interesting to observe how far policy will be affected by modification of such a constraint.

The Rationale of Public Support for Museums and Galleries

Our analysis above shows that there is no particular *technical* characteristic of museums and galleries which precludes their operation like ordinary commercial concerns. Those who were not prepared to pay for the 'product' could be excluded from enjoying it by denying them admission. If this is so, what arguments can be advanced to support the position that museums and galleries should be operated by the state and also subsidized? We need to answer this question before reviewing charging policies.

The common approach of economists faced with the question of subsidization is to ask whether or not commercial operation of museums and galleries would result in the 'correct' level of provision of the services which the public wants. If the market fails to provide the 'optimal' output of the services of such institutions, this must mean that they provide some benefits to the community at large other than the benefits enjoyed by those willing to pay an economic price for their services. Do such 'external' benefits exist?

Lord Robbins has argued very forcibly that they do:

the benefit is *not* merely discriminate . . . the positive effects of the fostering of art and learning and the preservation of culture are not restricted to those immediately prepared to pay cash but diffuse themselves to the benefit of much wider sections of the community in much the same way as the benefits of the apparatus of public hygiene or of a well-planned urban landscape.[6]

However sympathetic one may be with Lord Robbins' general position — and the present authors are — one may have a certain amount of difficulty in discerning how exactly these 'spillover benefits' reveal themselves and how, given a government budget constraint, these spillovers — if they exist — compare with the spillover benefits resulting from alternative uses of government funds.[7]

An alternative approach, embodying the idea of external effects, which seems to us somewhat more convincing, is to postulate — which seems reasonable enough — that consumer preference schedules are *interdependent*, so that the consumption of one group of individuals (the 'donees') may, under certain conditions, confer benefits, at the margin, on other groups, (the 'donors'). This idea has been used to explain why one may expect that the acceptance of consumer preferences as the ultimate guide to the size and structure of the government budget will lead to redistribution from rich to poor, without invoking a separate value judgement to guide distribution policy.[8] What has to be ascertained is why any particular group of citizens would derive a benefit from the subsidized consumption of cultural services in general and those of museums and galleries in particular, and which would require state intervention.

It is not difficult to accept that rich donor's utility is increased by the pleasure of conferring benefits on present and future generations, other than heirs, in the form of access to their art treasures. They may be guided by a general concern for the cultural welfare of others or by the simple wish to perpetuate the memory of themselves and their family.

However, there are some differences between the usual rich/poor example and the cultural subsidy case which are worth exploring. The willingness of the rich to make transfers in kind to the poor presupposes an efficient sharing arrangement among the rich. The costs of such an arrangement arrived at by voluntary action are high and the social pressure to reveal preferences may be weak. A political solution may be the only way to overcome this problem.

We can distinguish two processes of transfer in the 'art treasure' case. There is, first of all, the initial endowment of the capital stock. Here the problem of the preference revelation of donors does not seem to be important and, indeed, donors may seek to emulate one another in their desire to confer benefits on others. It is, therefore, not surprising that effect is often given to donors' wishes through the preservation of private collections open to the public, although many of these may receive direct or indirect support from public funds. At the same time, ignoring the complication presented by exemption from death duties of certain forms of bequest, some donors may derive satisfaction solely from gifts of collections made to central or local government, as the only organizations willing and able to enter into a commitment not to disperse the collection and to allow free or subsidized access to it. (Dispersion would defeat the object of 'memory preservation'.)

This brings us to the second process of transfer, by which the running costs of the services performed by museums and galleries, including maintenance and improvement in the capital stock, are paid by the state. If the interdependence of consumer preferences were a crucial element in the explanation of continuing fiscal support, then one would have to assume either that these preferences were not adequately reflected in the political system or that they were very weak, at least judging from the low annual sum from public funds devoted to the development of museum and gallery services. For obvious reasons, we shall not attempt to elaborate the first explanation, but something more might be said about the second one. The pressures to develop these services are bound to be weak because they lack an obvious connection in the public mind with, say, the state education services, which have spillover benefits which are commonly assumed to be widely disseminated, and also because the national museums and galleries are concentrated in what to many potential beneficiaries (who are also taxpayers) is an inaccessible part of the country.

Therefore, a rationale for public support and operation of galleries and museums based on individual preference revelation offers at least some justification for the present mode and amount of central government provision. One does not have to be a paternalist in order to argue that the present level of provision is inadequate, provided one agrees to the proposition that improvements in the level and regional distribution of public provision should be brought about by persuading individuals to alter their preference functions rather than by seeking to have the values of a cultural *élite* imposed on others. But if such

changes in preference functions are to be brought about, it can be agreed that there is a lot of persuading to do!

Government Policy for Museums and Galleries

Despite recent official publications and ministerial statements in debate, it is difficult to translate them into policy objectives by which the associated financial proposals for museums and galleries can be tested for consistency.

Broadly speaking, it seems correct to say that government policy is designed to put more emphasis than hitherto on widening public appreciation of the arts, rather than on catering for the more specialized interests of scholars and connoisseurs. This is reflected in the emphasis placed on improvement in general amenities in galleries and museums so as to make them more attractive, on the stocking of extensions to national museums with the reserve collections rather than with expensive additions to the existing stock, and by the concern expressed at the state of provincial museums and galleries which receive such a small amount of public money.[9] It is claimed that charging for entrance can be so designed that it does not defeat this main purpose and, indeed, is an effective means of raising revenue from direct beneficiaries towards the costs of the building programme.

If this is a correct interpretation, then certain general observations may be offered. First, the policy, to be effective, may require much closer control than hitherto on individual gallery and museum 'objective functions'. If we are right, we can expect continuous and lively debate about the relative merits of acquisition of masterpieces, as against conservation and display of existing collections, and the role of the state in influencing cultural development.[10]

Secondly, the expanded programme of new building and improvement will benefit primarily those within easy reach of the three national capitals. Those who live 'in the sticks' will have to wait. Therefore, any spillover benefits in the form of a more culturally sensitive population are likely to be unequally distributed. Of course, one must consider educational and cultural policy 'in the round' in offering this conclusion, for those living in areas to which London is inaccessible may derive compensating benefits in the form of easier access to centres of natural beauty. The fact remains that the 'cultural

package' supported by the state, the performing arts included, is still available much more readily to those in the largest urban centres. Unless and until the provincial museums and galleries receive much greater support than hitherto, it would seem to square better with the general policy objective if some attempt were made to extend the present practice of supporting provincial tours of *ad hoc* exhibitions by the lending out, even on a limited basis, of important items in national collections, despite the high cost of doing so. It is conceivable that this would pay dividends, for a wider awareness of the satisfaction to be derived from viewing national art treasures might engender more public support for the improvement of public galleries and museums.

Lastly, our economic analysis suggests that charging is both feasible and also compatible with the policy aims as stated. Moreover, our discussion of the rationale of public support above does not support the view that all categories of beneficiary should be given completely free access to the services of museums and galleries. Therefore, the general principle of charging less than short-run average cost accords with the view that there are some spillover benefits generated from general consumption, and exempting educational parties, library readers and scholars fits with the policy of supporting education and research, as a source of additional spillover benefits derived from specialized consumption.

The pricing policy has been defended as being in line with the general principle of Conservative economic policy by which divisible services provided by government should be subject to a charge as a method of reducing the net claims of the government on real resources, i.e. after allowing for appropriations-in-aid. Until the announcement that admission charges could be retained, little opportunity had been open to museums to develop and improve their services to the public on their own initiative.

Galleries and museums seem to us to be an area where some further, if limited, experimentation might be made in this direction. A gallery might be subjected to the following central government controls: it would be given a fixed annual grant for running expenses; the exempt categories of customer would be specified; minimum and possibly maximum charges for other categories of customer would be specified; and an annual financial target would be fixed.

These controls would be so devised that a gallery of 'average efficiency' could adjust its charges within the prescribed limits and still earn an amount over and above the target which it could also retain for

itself. The 'trustees' could then decide for themselves how their public responsibilities, other than those directly imposed on them by the government, should be discharged, trading off an objective such as maximizing attendance against, say, improving quality of exhibitions, always subject to the constraints already listed.

No such scheme would be without flaws. The costs of acquiring information on the structure of costs, price and income elasticities of demand and so on would be considerable and the results would offer no more than a rough guide in the fixing of financial targets and the span of charges. Adjustments to the targets and charges would have to be made in the light of experience, and the rules of adjustment carefully laid down, so that no gallery or museum would be forced to adopt a strategy of minimizing its surplus in the fear that too much 'success' might lead to a downward adjustment in its annual grant. If reliance continues to be placed on private donations in order to add to the capital stock, donors may be deterred from offering gifts if museums and galleries are turned into public utilities able to charge the customer, even if these institutions continue to be heavily subsidized. But at least a scheme of this sort draws attention to the realities governing a situation in which the dissemination of cultural benefits is recognized as requiring a considerable growth in committed resources. In such circumstances, rightly or wrongly, cultural services can no longer expect to be sheltered from politics and/or the market.

1. Although this paper concentrates on the national museums and galleries, it is worth noting that the central government offers further funds to local museums and galleries. The two main schemes are a grant-in-aid for purchases, administered by the Victoria and Albert Museum and the Royal Scottish Museum, and assistance to the Area Museums Council. Local museums may also receive further assistance from the Arts Council. In sum, however, amounts are very small, totalling less than £300,000 in 1969/70, excluding any expenditure by the Arts Council.
2. The publications departments of both the National Gallery and the Tate Gallery are financially independent of the Exchequer. These activities are financed from private funds available to the trustees of these two institutions. The accounts are subject to audit but not published by the government. The expenditure and income of these two departments are not included in the tables in this article.
3. The Wallace Collection has no purchase grant-in-aid. The last item in Table 2 refers to this museum's expenditure on publications, administered in the same way as salaries and general administration expenditures.

4. The Wallace Collection was wholly bequeathed and three-quarters of the pictures in the National Gallery have been given by private individuals.
5. The 'peak load' problem is ignored in this analysis. We have not made a detailed study of attendances in order to ascertain whether or not there are particular events, e.g. a new and well-publicized exhibit or particular days of the year, when congestion costs rise rapidly.
6. Lord Robbins, 'Art and the State' in *Politics and Economics: Papers in Political Economy*, London, 1963, p. 58. See also his development of this argument in 'Unsettled Questions in the Political Economy of the Arts', *The Three Banks Review*, September 1971, reprinted above as Reading 10.
7. Cf. Alan Peacock, 'Welfare Economics and Public Subsidies to the Arts', *The Manchester School*, December 1969, reprinted above as Reading 4.
8. Cf. H. D. Hochman and J. D. Rodgers, 'Is Efficiency a Criterion for Judging Redistribution?', *Public Finance*, No. 2, 1971, and references therein.
9. Cf. *Parliamentary Debates, House of Lords*, Cols 1394–1399, 16 December 1970; *Future Policy for Museums and Galleries* HMSO, 1971; *Parliamentary Debates, House of Commons*, Cols 1003–1009, 21 June 1971.
10. For a forceful view on these matters, see Lord Robbins, *The Three Banks Review*, September 1971, *loc cit.*, reprinted above as Reading 10.

12. Are Museums Betraying the Public's Trust?

by J. MICHAEL MONTIAS

reprinted from Museum News *May 1973 pp. 25–31*

If art historians are to be consulted on major museum decisions, as the board of directors of the College Art Association recently recommended, economists may perhaps be pardoned for butting into a controversy about which they may also feel they have some competence. Economists, of course, cannot pretend to know what the goals pursued by a museum should be, but given these goals, they may have something to say about the choice of scarce means available to attain them. Whatever these goals might be, I suspect that few economists, if any, would support the view, widespread among academic art historians, that museums should desist from selling major works when their directors and trustees believe that such sales would be legal and in the best interest of their institutions.

To reason as a social scientist, I must be explicit about the assumptions on which I shall base my argument. My first and principal assumption will be that directors and trustees of major museums are reasonably competent and rational people. If they are not, then it may make perfectly good sense to hedge their decision-making powers with all sorts of rules that will keep them from squandering the possessions with which they are entrusted. But I should judge that almost all art museum directors have the minimum training in art history and museum management necessary to ensure that this assumption is satisfied.

The purpose of this discussion is to determine whether a rule barring the sale of major works would cause museum managers to accomplish their mission more efficaciously. I shall start from this premise and, as a concrete example, focus on the Metropolitan Museum of Art's problems.

The Public, Scholars or Students?

To define the goals for a museum is a much harder task than might at first appear, but if a museum's policy is to be rational and consistent, its director and trustees must be reasonably clear about the objectives they wish to pursue. Given a tight budget and a lack of exhibition space — and the Metropolitan's budget and space are both strictly limited — decisions on acquisition and sales, display, storage, conservation, insurance and expansion are likely to differ according to whether the Museum chooses to cater to the preferences of art lovers everywhere or to those of the inhabitants of New York only, to the interests of professional art historians or to those of students, to the tastes of the present generation or to future generations for which the director and the trustees might feel responsible.

A museum orienting its policies to the interests of art lovers everywhere, for example, might choose to specialize a good deal more than one that was concerned mainly with the pleasure and the enlightenment of its local citizens. Thus, the Pinacoteca of Siena, which possesses a host of Italian primitives, would never trade its third or fourth Giovanni di Paolo for its first Manet, because it essentially caters to tourists from the world over and not to its own indigenous population.

From this worldwide viewpoint it might be argued that the Metropolitan should not have disposed of one of its several Henri Rousseaus or Van Goghs to help finance the purchase of its first Annibale Carracci, because everyone knows that New York is 'strong on Post-Impressionists and weak on the Bolognese School.' The itinerant connoisseur will tell you that if you want to see paintings by Annibale, Augostino or Ludovico Carracci, you must go to Bologna. Why then should the Metropolitan give up the kind of painting that 'one goes to see there' for the sake of a single representative of a school that was virtually *tabula rasa* before this purchase? The average citizen of New York, who is less mobile, may feel otherwise. The specialization argument against 'deaccessioning,' incidentally, sits well with Londoners and Parisians who already have a balanced representation of any school of painting or sculpture within subway distance and who can well afford, when they find themselves in Siena or in New York, to admire the specialities of the house.

But suppose instead that the Metropolitan's management had at heart mainly the needs of the scholars and students, as a recent letter by

City University of New York faculty members to the trustees of the Museum would suggest. Art historians' interests are quite distinct from those of the public at large. Because art historians generally have access to the reserves, they are less concerned about the quality of the works on permanent display. Most of the established art historians, and many students as well, also have entrée to important private collections, such as Denis Mahon's where the Annibale Carracci bought last year by the Metropolitan used to hang. Many scholars, particularly European ones, view a museum as an institution akin to the library of a monastery in Merovingian times, where the finest fruits of civilization were preserved from the destruction of barbarians and the ravages of time. Their objective is that every work of art salvaged from the past, whether great or small, should find a place in the library. And since no two paintings or sculptures are ever quite alike, none should ever be allowed to escape its responsible custody. Bernard Berenson, writing at the turn of the century, when many important Renaissance paintings were still in private hands and 'inaccessible,' held an opinion on the subject that was very much in this spirit.

Which of these potentially divergent interests should the Metropolitan's director and trustees satisfy? At the risk of antagonizing my friends who are art historians, I would opt for a policy that aims to satisfy mainly, though not exclusively, the preference of the public of the City of New York, which pays taxes that help keep the Museum going and represents the Museum's principal clientele. Accordingly, the objective of the Museum should be to display before the New York public the most beautiful and historically significant objects within the constraints imposed by its limited space and restricted acquisition budget.

That the welfare of the public should be the Museum's first consideration surely does not imply that scholars should have no say in the Metropolitan's decisions to acquire or deaccession works of art. The point is that their contribution should be instrumental to the principal aim rather than be an end in itself. For, if the preferences of the public are to be satisfied in the long run, the fashion of the moment cannot be the only criterion of selection.

Art historians on the staff and elsewhere must be consulted to ensure that, irrespective of the vagaries of taste, the New York public will be able to view some of the best representatives of every school that was once considered important and may one day become important again. That it took the Metropolitan so many decades to buy a

distinguished Mannerist painting by a Northern artist – the recently acquired *Moses Striking the Rock* by Abraham Bloemaert – suggests that historians of art, who have tried to draw our attention to the importance of the Mannerist School since the early 1920s, have not been sufficiently consulted.

Granted it would be theoretically desirable if the Metropolitan's director were to manage the Museum's collections in such a way as to 'reflect' the preferences of New York's citizens, would this be strictly possible? Not if some citizens prefer Rousseau to Annibale Carracci and others prefer Carracci to Rousseau, and if everyone believes that each painting or sculpture is a uniqve work of art and can be replaced by no other. But if every art lover is willing to 'trade off' his favorite artist's works against one or more of another's, the problem becomes less intractable. How then can art lovers convey their preferences precisely to the Met's director?

Testing the Tastes

About the only visible indication we have of people's tastes is the relative degree of crowding of the Met's different rooms. To judge by this criterion, on typical Sundays, the lovers of Impressionist and Post-Impressionist painting surely predominate. Does this speak against Hoving's trading Rousseau and Van Gogh for Carracci via the market? Not necessarily. For even people with a preference for modern art might be willing to countenance the loss of lesser examples by Rousseau and Van Gogh for the sake of acquiring a masterpiece by Carracci.

Moreover, if Mr. Hoving is to take into account the preferences of generations to come, he must have in mind that the Carraccis, who were so admired in Stendhal's time, are likely some day to return into popular favor. (By buying a Carracci now, the Met will help to move people's tastes back toward the classical tradition, which further complicates the problems of selection.) On the other hand, I have some sympathy with the citizens who would claim that the Metropolitan has no business buying a painting by Clyfford Still or a sculpture by David Smith with funds raised from the sale of Post-Impressionist or Cubist 'classics.' For while the works of these contemporary artists are at the height of fashion today, there is no reason to believe that they will

escape the fate of the overwhelming majority of artists successful in their time whose works greatly depreciated within a generation after their death. The art of museum management consists at least as much in the timing of purchases as in the selection of artists worthy of being represented.

Fortunately, not all the decisions the Metropolitan's management has to make involve pleasing Peter at the expense of Paul. Nobody — or almost nobody — gets hurt when the Metropolitan sells off works that it never exhibits or intends to exhibit. A second-rate Gérôme or Rosa Bonheur, no matter what happens to the future popularity of these now somewhat neglected 19th-century artists, can surely be dispensed with, although it would be a great mistake to sell an artist's masterpiece like Bonheur's *Horse Fair* presently on exhibit at the Metropolitan. Of course, there is always someone with access to the reserves, if only a graduate student writing a dissertation on an obscure dauber, who will be unhappy over the decision, but I am willing to make the value judgment that his interests can, and should, be sacrificed.

In any case, the student's loss is not necessarily irremediable. The painting he is interested in may be sold to a public collection. If it enters a private collection, he will normally have excellent chances of tracking it down and getting an opportunity to see it (at least if it does not go to Japan). The time is long past when most pictures of significance to art historians were secreted away in private caches.

Instruments for Operating

So much for the potentially divergent interests that a museum's management may have to recognize. We should now dwell a moment on the 'instruments' that a museum director has at his disposal to further the goals he chooses to pursue, together with the financial or space constraints that limit him in this pursuit.

A director always has a budget for operating expenses, including guards, insurance and utilities. He normally has an acquisition budget, although it may be a very modest one. He may have an expansion budget which, in the long run, can help ease limitations on exhibition and storage space. Expenses in these broad budget categories are normally not fungible. When a director is confronted with special needs — a great picture coming on the market, a strike of security personnel — he may

go to the trustees or to other affluent friends of the museum and request a special donation. By the unwritten rules of the game, however, dunning missions must be spaced out at decent intervals. The sum of regular and extraordinary appropriations over any one budget period is not an arbitrary magnitude: every director will know what this sum is for his museum, at least within five or 10 percent margins of uncertainty.

The last source of funds to cover the expenditures a director will wish to make when his other resources are insufficient to finance the improvement of the collection, will be from the sale of less desirable works in the museum's collection (normally works that are rarely exhibited, that duplicate objects already on hand, or both).

Needless to say, a director's cash budget is not the only resource he has at his disposal to build up a museum's collections. An important part of his job is to establish close contact with collectors in the hope that they will donate or bequeath some of their possessions to the museum. But these are uncertain and limited prospects which cannot be counted on for filling all the important gaps in a museum's holdings. (Witness the National Gallery in Washington which has been stocked mainly from donations and as a result is extremely unbalanced in its representation of different schools of art. The bequests it has received since its founding reflect mainly the tastes of wealthy collectors of the first half of this century.)

A director faced with strict limitations on his expenditures and on his expectations of bequests and donations may still have considerable leeway about how he distributes his resources over time: he may sell works when his other resources are at an ebb; he may save his acquisition budget over several years before lavishing the accumulated sums on a major purchase; he may rent paintings from galleries instead of buying them outright. If he cannot afford to buy in certain areas and if the prospects for donations are dim in this regard, he may decide to exhibit only works borrowed from other museums or from private collectors to represent these artists or schools. In the event that he exercises this particular option, he will, in effect, be substituting operating funds (to pay for insurance and exhibition costs) for acquisition funds. By displaying these borrowed works before the public, he will be pursuing the same goal as if he had bought them outright. The main difference lies in the length of time during which the items will be available for display, although one should perhaps recognize the nominal capital gains (or losses) that might have accrued

after a certain time if these monies had been spent on permanent acquisitions.

All the stress I have put so far on the constraints and limitations hedging about the director's decisions is aimed at driving home my central argument — a contention that also happens to be central to most problems in economics. A director with fixed resources, if he does not sell a duplicate or an otherwise less essential object to supplement his acquisition budget, will have to forego the purchase of a work of art that, had it been acquired, would have improved the collection. There is no way of getting around this 'opportunity cost' of conserving for the sake of conservation. The argument is not met, incidentally, by assuming that if a Carracci or a krater painted by Euphronios was on the market once, it can always be bought on some other occasion when the museum will have enough funds from its regular budget or from donors. The overwhelming chances are that these high points of artistic achievement will have been gobbled up by other museums or collectors by the time the funds do become available. Furthermore, new opportunities are sure to arise by this latter date which also may have to be financed. There is no justification for neglecting the opportunity today of exchanging more desirable for less desirable works, when 'desirability' is properly defined in terms of the museum's sanctioned goals.

Culling the Reserves

If we admit that the director and trustees are entitled to control the inputs (donations and purchases) and the outputs (deaccessions) of the museum, then surely one of the critical factors that must be taken into account in making such decisions is the relation of works in reserve to works exhibited, a problem very similar to that of 'optimal inventory policy' in a private business.

The ratio of works in reserve to works exhibited is sometimes too small. Even the average member of the public may get tired of seeing the same paintings and sculptures Sunday after Sunday, and may prefer, from time to time, to look at a somewhat inferior work for the sake of variety. It may also be instructive to show art students second-rate objects and copies next to authentic masterpieces. Keeping a large inventory in reserve and using it to mount temporary exhibits may also

help to offset the lack of funds to finance exhibitions of works borrowed from outide the institution. However, given the objectives I have postulated, I have the impression that the reserves of most large museums are relatively too large and that these museums should weed out items that essentially duplicate works on permanent exhibition, if this can be done to finance purchases that will improve the main body of the collections.

A frequently encountered argument against museums' disposal of paintings and sculptures in their reserves is that there is a risk that these works may be of much greater value than they were assessed at the time. Among notable examples are the sale by the Smith College Museum of a Claude Lorrain, then thought to be the work of an imitator, and the Metropolitan's sale (for a piddling price) of a painting of the German School back in 1956, which years later was bought by a Swiss museum for an appreciable sum as the work of a fairly obscure, but historically significant artist.

One way to guard against such mistakes is to require museum directors to consult specialized art historians in cases where there is any possible chance that a work of art may be more important than would appear. By selling in an important competitive market, such as the London and New York auction houses provide,[1] the risks of error are also diminished. (Few great 'discoveries' have been made at Sotheby's or Christie's in recent years.) But we should also have in mind that the funds raised by a museum director from the sale of works that he considered second-rate or duplicates may be used toward purchases that may also be worth more than the price at which they were bought. Shouldn't we expect a curator of paintings or sculpture at a respectable museum to do at least as well as a discerning private collector (or even a dealer) in selling and buying works of art on the open market?

What about the benefactors to the City who gave art works to the Metropolitan? How will they or their descendants feel when their treasured possessions are put on the market, when their Van Goghs, Cézannes and Matisses are traded for Baroque or Mannerist paintings which *they* would not have hung in their maid's closet? There are those critics of museum management who would confine all sales and barters to works of art purchased by museums from unrestricted funds. Indeed, some of the recent Metropolitan sales came from just such funds. At the other extreme, some critics of existing arrangements would urge that the provisions under which gifts were made should be ignored (insofar as the law permits), arguing that no institution can be bound forever by

the whims of donors. I would favor some position in between, which would take into account the following arguments.

Placating Donors

While the Metropolitan's director and trustees should be mindful of the strong feelings of pride and possession donors have about the works of art they own or may once have owned, their solicitude should not get in the way of the Museum's main goal as we have defined it: to serve the public by displaying the most beautiful and historically significant works of art. It is important to placate donors and maintain their good will to ensure that the flow of gifts to the Museum will not be interrupted and that they will be made under advantageous conditions. At the same time donors cannot be allowed forever to retain an emotional hold on the art works they donate and prevent the Museum from weeding out inferior items and buying better ones in their stead.

Why can't the Met's benefactors be placated with the promise, normally made by all major museums, that in case their donated treasures are sold, any works bought with the money so raised will carry their names on the label? By such a mention, the Museum expresses its gratefulness for a donor's generosity, without necessarily providing a permanent monument to his discriminating taste. The main exception is that when an entire collection has been donated, a donor may rightly feel that its dispersal through the sale of some items would seriously violate the spirit in which it was given. Here I would think that preliminary negotiations between the benefactor and the Museum should establish the principle of the integrity of the collection.

Can the Nation Benefit from Donations?

At this juncture we come to a parting of ways between the interests of the Metropolitan, reflecting more or less accurately the welfare of the New York public, and the interests of the nation as a whole. The case for allowing donors to put a virtual lien on their gifts is much weaker when one considers the welfare of the public at large, including both lovers of art and Federal income taxpayers — if the two categories of

citizens can be distinguished at all. From this wider perspective, the owners should be given no more inducement than is necessary to bequeath their treasures to some public museum in the United States.

Many prospective donors are courted by museum directors who vie with each other in the restrictions they are willing to accept on donations (permanent exhibition rooms named after the donor, prohibition on lending the works to special shows organized in other museums, the imposition of doubtful attributions on works donated, etc.). The public's welfare is adversely affected as soon as the incentives that a museum is willing to offer exceed those that would be necessary to induce a donation to any public institution during the donor's lifetime or after his death.

In many, if not most instances, donors are swayed by tax considerations as much as by a sense of generosity. Although the Internal Revenue Service has recently tightened the terms by which donations could be deducted from income or inheritance taxes, the cost to wealthy owners or their heirs of giving or bequeathing works to a museum is often minimal. When large estates are liquidated, it is frequently more advantageous to leave works of art to institutions and earn deductions equivalent to the retail prices of the works rather than sell them at lower prices to dealers or auction them off at uncertain prices. I would guess that the real cost to donors generally does not exceed 30 to 40 percent of the estimated value of their gifts. This of course implies that the taxpayers of the United States contribute an average $600 to $700 for every $1,000 worth of bequests. A donation, in sum, is a joint contribution by a private owner and the public, with the peculiar feature that only one of the parties to the transaction — the owner, who usually has the smaller stake — has a say in setting the conditions under which the work will be transferred to a public institution.

One serious problem affecting the distribution of art works among museums is that there is virtually no incentive for a museum director to refuse a bequest. The only cost to the institution is in storage space and insurance, neither of which usually acts as a serious constraint on the director's decision. As a result, paintings, sculptures and other *objets d'art* often end up in places that have no need for them. The misallocation acquires a most unfortunate permanence when, in addition, the conditions of the bequest bar resale, or when the director or trustees of the museum so benefitted have inhibitions about getting rid of less-wanted items to supplement its acquistion funds.

A recent case will illustrate several of my points. An acquaintance asked an art historian to appraise a painting by a Dutch painter of the second half of the 17th century. The painting, a putative self-portrait by the artist, had some historical interest, but it was clearly not a work of major importance. It was estimated by the expert to be worth about $10,000. The painting was then donated to one of the richest museums in the United States. The deduction taken by the owner must have saved over $6,000 in taxes. Now it is manifest that this museum will very rarely, if ever, exhibit his painting. (It has not left the reserves since it entered the museum's collection about three years ago; it was not even rescued for an exhibition of self-portraits for which it might at least have had a chance to qualify.) The Federal government has thus contributed over $6,000 to a cause that has not increased the welfare of the public by one iota — and which is not likely to in the foreseeable future. If the painting had been donated to a small city or university museum, it could have been exhibited, studied and even admired, for lack of better things to admire, by some local connoisseurs. There must be something wrong in the present system if it brings about such a flagrant misallocation.

An Art Auction Scheme

What can be done to reconcile the interests of the public and of the donors and to ensure that works of art will end up in museums where they can be seen to their best advantage? One idea would be for Congress to amend the present tax laws to require that all donated works that donors wished to deduct from income taxes be sold at auction. After deduction of a certain percentage paid to the auction house, the sum of money a work of art would realize at auction would accrue to the public institution designated by the donor. If this particular institution was the highest bidder for the item, it would acquire the work at a net cost equal to the share of the auction house in the gross proceeds of the sale (say, 10 or 12 percent of the highest price bid). In this manner, the institution receiving the donation could obtain a sought after work at a nominal price, but the museum could also let the work go to another museum that would make better use of the acquisition if the recipient of the donation had a better way to spend the money.

An important side benefit of the proposed scheme would be to provide an objective basis for the valuation of works of art for tax purposes, a far more objective basis than the present system. The Art Dealers' Association generally delegates the responsibility for appraising works to dealers who may have a strong interest either in raising the valuation above the market value or in depreciating the item.

One interesting issue is whether the auction scheme just proposed should be restricted to buyers representing public institutions or should be open to private collectors as well. Art historians who oppose any transfers of art works from the public to the private domain would presumably favor the exclusion of private collectors. (If an object donated to a museum by an individual was bought by a private party and the money raised was used by the museum to purchase a work sold by another museum, the net results would be the forfeiture of one acquisition by the public domain as a whole.) Yet if our objective is the welfare of the U.S. public, this conclusion need not follow.

Consider a painting donated via the auction scheme that happens to be of marginal interest to a museum, but would be salable at an appreciably higher price to a private collector (e.g. a work of art that was highly attractive but not of 'museum quality'). The museum buying it at restricted auction might exhibit the painting one-third of the time. The museum designated for the donation would realize a much lower price for the work than through an unrestricted auction and would not be able to purchase works as fine as it might have obtained from other museums. The public would surely benefit from the removal of the restriction in this case.

Mix and Match Museum Policies

Like many other issues raised in this article, the choice between private and public ownership depends on the precise way in which we wish to define the citizen's welfare. To the extent that we are willing to take into account the preoccupation of the art historian with the preservation of works of art, great or small, in public shrines, we should have to bend our recommendations toward a 'mix' of policies that would tend to accelerate the trend from private to public ownership, irrespective of the primary interests of museum visitors. But the optimal mix of policies meant to further the public's welfare will also depend on how

badly museums are actually strapped for exhibition space and acquisition funds. If the Metropolitan's resources are as depleted as Mr. Hoving makes them out to be, and if exhibition space is fixed to the present wall capacities for the foreseeable future, then his decision — to sell essentially duplicate items to make room for paintings and sculptures that will fill serious gaps in the Museum's collections — appears largely justified.

1. There may be situations, however, where a sale to a dealer may be more advantageous for an institution than disposal through auction. In the absence of solid evidence to the contrary, Mr. Hoving should perhaps be given the benefit of the doubt regarding his decison to sell Van Gogh's *Olive Pickers* and Henri Rousseau's *Tropics* to the Marlborough Gallery. After all, he has every interest in getting top prices for the works of art he and the trustees choose to deaccession. That a dealer made a large profit from a transaction with the Metropolitan does not, in and of itself, constitute evidence against the decision to sell. For the Museum management may simply not be in a position to find the private buyer who will pay the highest price for the item (especially if he happens to live in Osaka or Hong Kong).

13. On the Performing Arts: The Anatomy of their Economic Problems[1]

by W. J. BAUMOL and W. G. BOWEN

reprinted from American Economic Review *May 1956 pp. 8–14*

I. The Setting

Romanticism long ago fixed in our minds the idea that there is something inevitable about the association between artistic achievement and poverty. The starving artist has become a stereotype among whose overtones is the notion that squalor and misery are noble and inspiring. It is one of the happier attributes of our time that we have generally been disabused of this type of absurdity. We readily recognize that poverty is demeaning rather than inspiring — that instead of stimulating the artist it deprives him of the energy, time, or even the equipment with which to create or perform.

While we have come to accept the idea that artists are often impecunious, even a cursory encounter with the facts of the matter usually proves surprising. One may or may not see something shocking in the fact that the median total income in 1959 of males classified by the census as actors was $5,640; that for musicians and music teachers the comparable figure was $4,757; and that for dancers and dancing teachers, $3,483.[2] But one must recognize that these figures include income from all sources, some of them (e.g., truck driving, lobster fishing, waiting on tables) rather unrelated to the performer's art.[3]

A detailed and specific investigation of economic conditions in the performing arts was conducted by Senate and House Committees in 1961 and 1962, and the volumes of *Hearings* which resulted are very revealing.[4] At that time the minimum weekly salary for Off-Broadway actors was $45 per week (it is currently $60); and what makes this figure significant is that most Off-Broadway actors are at the minimum. In such circumstances it is not difficult to see why Joseph Papp,

producer of the New York Shakespeare Festival, was able to report that 'Banks and landlords consider him [the actor] a credit risk without visible means of support'.[5]

Mrs. Helen Thompson, of the American Symphony Orchestra League, presented figures indicating that in 1961—62 the average salary paid to musicians in the twenty-six major orchestras in this country was $4,512; if the four highest-paying orchestras are excluded, the average for the remaining twenty-two major orchestras (again as of 1961—62) falls to $3,500.[6]

Dancers are in even worse financial circumstances, as illustrated by the case of a leading modern dance company whose members normally receive $25 after a trip which frequently includes four days of travel, a day of rehearsals, and a public performance.

In the main, performing artists are employed by organizations — by orchestras, opera and dance companies, producers and impresarios, resident theater companies — and the underlying economic pressures which manifest themselves in low performer salaries are transmitted through these organizations. Inadequate financial flows to these groups can threaten not only the welfare of individual performers but also the very existence of the institutions serving the entrepreneurial and managerial functions in the field of the performing arts. And, notwithstanding the publicity that has been given to the alleged 'cultural boom' in America, we continue to hear frequently of theatrical groups which collapse, of opera houses whose seasons are in danger, and performing arts organizations of all kinds for whom financial emergency seems to have become a way of life. It is this situation and the threat that it poses for the cultural prospects of our society which constitutes the setting for the study we have undertaken.

The first objective of our study is to explain the strained economic circumstances which beset performing companies, to determine whether they are attributable mainly to fortuitous historical circumstances, to mismanagement or poor institutional arrangements, or whether there is something fundamental in the economic order which accounts for these difficulties. On the basis of our analysis we hope to produce some conditional forecasts of the financial future of the performing arts, the prospective costs, the operating revenues likely to be associated with various levels of activity, and the proportion of the resultant financial gaps which one can expect to be met from current sources of contributed income.

This session is intended to deal with theoretical matters and, while

much of our work has been empirical, we welcome this opportunity to try to describe the basic economic relationships which seem to us to underlie the financial problems of the performing arts.

II. Basic Economic Characteristics of Nonprofit Organizations

Before we turn to the special economic properties of the performing arts, it is useful to devote some discussion to the economics of nonprofit-making organizations in general, for only in this way can the difficulties which beset the performing arts be seen in perspective.

Nonprofit organizations as a group share at least two characteristics: (1) they earn no pecuniary return on invested capital and (2) they claim to fulfill some social purpose. These two features are not wholly independent. Any group which sought to fulfill no social purpose and earned no financial return would presumably disappear from the landscape. Moreover, its goals themselves often help explain why no money is earned by such an organization. While an automobile producer may take pride in the quality of his cars, he is much less likely to regard product quality per se as an ultimate objective of the enterprise than is the head of a nonprofit organization. Nor is the auto producer likely to be nearly as concerned about the social composition of his clientele.

The significant point is that the objectives of the typical nonprofit organization are by their very nature designed to keep it constantly on the brink of financial catastrophe, for to such a group the quality of the services which it provides becomes an end in itself. Better research, more adequate hospital facilities, more generous rehearsal time, better training for those engaged in these activities — all these are not merely incidental desiderata. They are fundamental goals in themselves, and with objectives such as these, the likelihood of surplus funds is slim indeed. These goals constitute bottomless receptacles into which limitless funds can be poured. As soon as more money becomes available to a nonprofit organization, corresponding new uses can easily be found, and still other uses for which no financing has been provided will inevitably arise to take their place. Any lively nonprofit organization always has a group of projects which it cannot afford to undertake and for whose realization it looks hopefully to the future. Once this

fundamental fact is grasped, it is hardly surprising that such groups feel themselves constantly strapped. It becomes clear that they are simply built that way.[7]

Nor is it just through its quality aspirations that the social goals of the nonprofit enterprise contribute to its financial difficulties. The concern of the typical nonprofit organization for the size and composition of its clientele often causes operating revenue to be lower than would be the case if services were priced to satisfy a simple profit-maximization goal. Since such a group normally considers itself to be a supplier of virtue, it is natural that it should seek to distribute its bounty as widely and as equitably as possible. The group is usually determined to prevent income and wealth alone from deciding who is to have priority in the consumption of its services. It wishes to offer its products to the needy and the deserving — to students, the impecunious, to those initially not interested in consuming them, and to a variety of others to whom high prices would serve as an effective deterrent to consumption. In short, a low price for the product of a nonprofit group is normally an inevitable consequence of its objectives, and indeed sometimes becomes an article of faith. The ancient doctrine of 'just price' is imbedded in the operations of these groups and carries with it all the difficulties which inevitably accompany an attempt to put it into practice.

The desire to provide a product of as high a quality as possible and to distribute the product in a manner other than that which maximizes revenue combine to produce a situation which is unusual in yet another respect. For such an enterprise a substantial increase in the demand for its product may well worsen the organization's financial health! Marginal costs may well exceed marginal revenues over the relevant interval. An increased number of student applications, an increased number of hospital patients, an increased number of orchestral performances may well increase the size of the contributions required for solvency. More generally, it follows that, contrary to widespread impressions, the much publicized cultural and educational 'booms,' whatever their composition, may in many cases prove a very mixed financial blessing.

Yet even in such circumstances the organizations cannot simply refuse to expand their activities in response to an increase in demand. By such a refusal the organization would renege on its fundamental objectives, and, incidentally, it might even produce a loss in private and community support.

III. The Performing Arts in Particular

It is apparent that all of the standard problems of nonprofit organizations which have just been discussed beset the performing arts. It is not surprising, therefore, that the survival of the great majority of its organizations requires a constant flow of contributions. We can then easily understand why the arts find themselves in their present unhappy financial circumstances. But, up to this point, our discussion has offered no portents for the future. Here we don the inherited mantle of the dismal scientist and argue that one can read the prospects of the arts tomorrow in the economic structure which characterizes them today. The evidence will suggest that the prospects offer no grounds for complacency — that there are fundamental reasons to expect the financial strains which beset the performing arts organizations to increase, chronically, with the passage of time.

To understand the prospective developments on the cost side, it is necessary to digress briefly and consider in general terms the implications of differential rates of growth in productivity within the economy for the relative costs of its various outputs.[8] Let us think of an economy divided into two sectors: one in which productivity is rising and another where productivity is stable. As an illustration, let us suppose that where technological improvements are possible they lead to an increase in output per man-hour of 4 percent per annum, but that output per man-hour remains absolutely constant in the stable productivity sector. If these sectors are assigned equal weights in the construction of an economy-wide productivity index, the aggregate rate of increase in output per man-hour will be 2 percent per annum. For the moment let us assume that there is only one grade of labor, that labor is free to move back and forth between sectors, and that the real wage rate rises *pari passu* with the aggregate rate of change of productivity, at 2 percent per annum. Finally, let us suppose that the money supply and the level of aggregate demand are controlled in such a way that the price level is kept stable. Assuming that there are no changes in the shares of capital and labor, this means that money wages will also increase at the rate of 2 percent a year.

The implications of this simple model for costs in the two sectors are straightforward. In the rising productivity sector, output per man-hour increases more rapidly than the money wage rate and labor costs per unit must therefore decline. However, in the sector where productivity is stable, there is no offsetting improvement in output per man-hour,

and so every increase in money wages is translated automatically into an equivalent increase in unit labor costs – 2 percent per annum in our example. It should be noted that the extent of the increase in costs in the stable productivity sector varies directly with the economy-wide rate of increase in output per man-hour. The faster the general pace of technological advance, the greater will be the increase in the overall wage level and the greater the upward pressure on costs in those industries which do not enjoy increased productivity. Faster technological progress is no blessing for the laggards, at least as far as their costs are concerned.

It is apparent that the live performing arts belong to the stable productivity sector of our economy. The legitimate theater, the symphony orchestra, the chamber group, the opera, the dance – all can serve as textbook illustrations of activities offering little opportunity for major technological change. The output per man-hour of the violinist playing a Schubert quartet in a standard concert hall is relatively fixed, and it is fairly difficult to reduce the number of actors necessary for a performance of *Henry IV*, Part II.

Moreover, from the standpoint of long-term developments, the essence of the matter is not absolute or relative levels of productivity at a given date but the rates of change in productivity over time. This means that even if the arts could somehow manage to effect technological economies, they would not solve their long-term cost problem if such savings were once-and-for-all in nature. In order to join the ranks of the rising productivity industries, the arts would somehow have to learn not only to increase output per man-hour but to continue to do so into the indefinite future. Otherwise, they must at some juncture fall behind the technologically progressive industries and experience increases in costs which stem not from their own decisions but from the inexorable march of technological change in other parts of the economy.

True, some inefficiencies of operation are to be found in the field, and their elimination can help matters somewhat. Moreover, performing arts organizations can reduce the rate of increase in their unit costs by permitting some deterioration in the quality of their product – by fewer rehearsals, the use of more poorly trained performers, shoddy costumes and scenery. But such a course is never popular with organizations dedicated to quality, and, furthermore, it may lead to loss of audience and community support. Nevertheless, it is not an uncommon 'temporary' expedient, imposed by the realization that the

cutting of corners may be the only alternative to abandonment of the enterprise.

There is one other important avenue for cost saving open to the performing arts which has so far not been considered. We refer to wages paid performers. In the simple model sketched above, we postulated a situation in which a single, market-clearing wage was paid to all persons regardless of the industry in which they were employed. In actual fact, the live performing arts constitute a rather special labor market — a market in which the need for great native ability and extensive training limits the supply, but in which the psychic returns to those who meet these tests often offer a very substantial inducement to remain in the field. For these reasons, the performing arts are relatively insensitive to general wage trends, especially in the short run. It is largely for this reason that performing arts organizations in financial difficulty have often managed to shift part of their financial burden back to the performers — and to the managements, who also are generally very poorly paid by commercial standards. The level of the incomes in this general field must be considered remarkably low by any standards, and particularly so in light of the heavy investment that has often been made by the artists in their education, training, and equipment. And it is surely explained at least in part by the willingness of those who work in these fields to sacrifice money income for the less material pleasures of their participation in the arts.

However, there are limits to the financial sacrifices society can extract from the performers in exchange for psychic returns. One may reasonably expect that rising incomes in other sectors will ultimately produce untoward effects on the supply of talent. At what point this will occur depends partly on the income elasticity of the demand for psychic income. As the general level of real income rises, it may well be possible to persuade performers to accept a lower relative position in the income hierarchy. However, there are symptoms which suggest that, in some specialized areas, effects involving both quantity and quality are already being felt, though, overall, excess supply continues to be one of the market's most notable characteristics.

In sum, the cost structure of the performing arts organizations promises them no easier future. One might anticipate, therefore, that this structural problem would produce discernible effects on pricing policy. Certainly, in most of the industries in which productivity is stable, we would expect the price of the product or service to rise relative to the general price level. And there is a widespread impression

that the arts have indeed behaved in accord with this anticipation — that ticket prices have been soaring. Yet our preliminary evidence suggests strongly that this view is incorrect and is largely a product of money illusion. Indeed, our preliminary data indicate that the rate of increase of ticket prices has barely managed to keep up with the price level and has lagged substantially behind increases in costs.

One might undertake to account for the surprisingly modest rate of increase in ticket prices in terms of a revenue maximization model — on the hypothesis that arts organizations believe the demand for their product to be highly elastic. We suspect, however, that a more valid explanation is the role of a doctrine of just price in the objectives of these organizations.

The tendency for increases in prices to lag behind increases in costs means simply that arts organizations have had to raise larger and larger sums from their contributors — and our analysis leads us to expect this trend to continue. Thus our analysis has offered us not only an explanation for the current state of affairs; it has also provided us with a basis for speculation about the future. What it has shown will not, we are afraid, be reassuring to those to whom ready availability of the arts constitutes an important objective of society. If our model is valid, and if, as may be suspected, there are limits to the amounts that can be obtained from private contributors, increased support from other sources will have to be found if the performing arts are to continue their present role in the cultural life of this country and especially if it is intended that they will expand their role and flourish.

1. This paper is based on a study being prepared by the authors for the Twentieth Century Fund, through the administrative channel of Mathematica. The study is still in progress and this paper is nothing more than a brief introduction and a statement of certain theoretical ideas. The Fund has facilitated our work, not only by making generous financial provision for the extensive job of data collection and analysis which has been necessary, but also by helping to secure the cooperation of organizations and individuals and by allowing us full freedom to proceed as we wish. In the volume which will emerge from this study, we shall acknowledge our debt to the many people whose patient assistance has been essential to our work.
2. U.S. Bureau of the Census, U.S. Census of Population: 1960, Subject Reports, *Occupational Characteristics,* Final Report PC(2) — 7A, Table 25.
3. As the Department of Labor's career guidance publication stresses: 'Many performers . . . supplement their incomes by teaching, and thousands of others

have to work much of the time in other occupations.' (U.S. Dept. of Labor, Bureau of Labor Statistics, 'Employment Outlook in the Performing Arts,' Bulletin No. 1300–65, 1961, p. 214.) The BLS goes on to warn: '. . . The difficulty of earning a living as a performer is one of the facts young people should bear in mind in considering an artistic career' (*loc. cit.*).

4. U.S. House of Representatives, *Hearings Before the Select Subcommittee on Education of the Committee on Education and Labor*, 'Economic Conditions in the Performing Arts,' 87th Cong., 1st and 2nd Sess., 1962 (cited hereafter as 'House *Hearings*'). U.S. Senate, *Hearings Before a Special Sub-Committee of the Committee on Labor and Public Welfare*, 'Government and the Arts,' 87th Cong., 2nd Sess., 1962.

5. House *Hearings*, p. 111.

6. House *Hearings*, p. 47.

7. The fact that any nonprofit organization can always find uses for a temporary excess of funds — and indeed may be embarrassed to report to its contributors that it has some money left at the end of the year — makes it very difficult to determine its cost functions. If an auto producer finds that a sudden increase in demand has swollen his receipts, he is only too happy to report higher profits; a nonprofit enterprise, however, may well use the extra revenue in a way which, in effect, deliberately raises it costs.

8. There is, of course, nothing new in the following observations on the effects of differential rates of productivity change on costs and prices. See, e.g., Tibor and Ann Scitovsky, 'What Price Economic Progress?' *Yale Review*, Autumn, 1959. Only its application to the state of the arts is novel.

14. The Demand for Broadway Theater Tickets[1]

by T. MOORE

reprinted from The Review of Economics and Statistics *February 1966 pp. 79–87*

Broadway attendance during an average week in February of 1963 was only 20 per cent better than it had been in 1933.[2] Yet over the same period, spending on the performing arts more than tripled, ticket sales for spectator sports more than doubled, and real per capita GNP advanced 160 per cent.[3] The purpose of this paper is to determine why the demand for seats to the most professional, most polished, and most popular legitimate theatre in the United States should have grown so slowly. In the process, elasticity estimates of the relationship between income-quantity, income-quality, price-quantity and cash costs-quantity are derived. From these figures, computed from cross-sectional data and from time-series data, a reasonably clear understanding of the theatre's problems emerges.

The cross-sectional data were developed in April of 1962 by means of a survey of theatregoers conducted by the author. Questionnaires were inserted in all *Playbills* distributed in seven Broadway houses. A total of 18 performances were involved. The form requested only one member of a family to answer. Those replying were asked to drop the completed copy in one of several large boxes in the lobby and near the exits.

Twenty-six per cent of the evening audience was represented by the returns; only 16 per cent of the two matinees surveyed responded. In a trial run, the respondents were given business reply envelopes and asked to mail back the questionnaires. There were no significant differences in any way relevant to this paper between the responses of the audience from the mail survey and from those collected within the theatre.[4] The results of this survey were compared to the figures from the annual *Playbill* survey of the theatregoers[5] and to an earlier study of audiences conducted by Weiss and Geller Research of Chicago;[6] the differences were small.

The questionnaire asked, among other things, the amount paid for each of the tickets bought, the expected length of time to go home that evening, the respondent's family income, the anticipated cost of the evening and the number of individuals this covered. The last mentioned figure was taken as the size of the group; the total of all groups is the number accounted for. Only those who answered 'no' to the question, 'Are you a guest?' were counted. Since a larger percentage of those sitting in cheaper seats tended to respond than those in the more expensive areas, the responses were categorized by the list price of the ticket. Each questionnaire was considered a single random draw of a group from the groups sitting in seats of a particular price. If the size of the group was three, the questionnaire was considered as representing three responses from that area. Each response from a price range was then weighted by the total number in the audience that evening sitting in a seat of that price, divided by the number of individuals accounted for from that area. Thus the statistic for any performance was a weighted average of responses from the various priced seats.

For the entire sample, the totals for each performance were added together before any calculations were made; the end result was a doubly weighted average. The questionnaires were weighted, first by the proportion of individuals sitting in a certain area in the theatre divided by the proportion of total responses from that area, and then by the number of people in the audience for that performance. All the data in the paper refer to individuals who reported that they were from New York City or lived within commuting distance.

Unfortunately, we cannot be perfectly confident that the responses received from each price category of seats constitute a random sample of those sitting in that area. We are faced with the problem of self-selection, that is, did those who answered differ in any meaningful way from those who did not? We can never be sure, but the fact that our data correspond so well to those collected by other means and by other people gives us confidence.[7]

In addition, we must recognize that the responses may sometimes be inaccurate. The question dealing with income touches on a sensitive point. A few individuals refused to answer, some may have exaggerated their income, while others may have minimized it. Our hope is that there is no bias in either direction.

One more problem with the data should be mentioned. The returned questionnaires were not representative of a random sample of the population in the New York area or even of theatregoers and potential

theatregoers. To generalize about the effects of variables such as income on theatregoing, one must say something about the whole population. It is only possible to generalize from a selective sample of people to the whole population if the differences between that portion of the population found in the sample and the general population are known.

The ratio of the proportion of individuals falling in each income class in the audience to the proportion for the population as a whole measures relative frequency of attendance by income for the population. For example, if ten per cent of the audience earned over $20,000 a year, and ten per cent of the audience made under $5,000 a year, and these same proportions held for the total population, then income would clearly be unrelated to attendance. On the other hand, a finding that five per cent of the house earned under $10,000 while 50 per cent of the population received under $10,000 and 50 per cent of the house made over $20,000 while ten per cent of the population earned over $20,000 would indicate a strong income effect. The total population is assumed to be the total number of families and unrelated individuals in 1960 in the New York-New Jersey Consolidated area.[8] Correlating relative frequency and income, the income elasticity of demand for theatre tickets at the mean is 1.135. The regression explains 98 per cent of the variance, and the F statistic is 107.2. The same regression in logarithms produces a slightly better result; 98.6 per cent of the variance is explained, the F statistic is 142.3, and the income elasticity of demand is 1.03. Both regressions are significant at the one per cent level. In neither case is the income elasticity of demand — computed at the mean in the linear case — significantly different from one. Roughly, therefore, an improvement in income will lead to a proportional growth in theatregoing.

Per capita earnings influence more than just the frequency of trips to the Rialto. Higher incomes can be presumed to lead to greater expenditures on theatregoing. As incomes advance, individuals will buy a higher 'quality' night at the theatre by paying more for tickets, going to more expensive and presumably better restaurants, and transporting themselves in easier ways to Times Square. Simply correlating income and cost of evening will measure the effect of income on quality. Because our concern is with the expenditure of Broadway playgoers as a function of income, the proportion of the population which frequents the theatre need not involve us.

From table 1, which presents the results of these regressions in logs,[9] it can be seen that income is positively related to expenditures per

Table 1. Survey Regression Results of Income and Time to go Home on Selected Cost Items[a] (in logarithms)

Dependent Variable	Income		Time to go Home		
	Regression Coefficient	Standard Error of Regression Coefficient	Regression Coefficient	Standard Error of Regression Coefficient	F Statistic
Cost of Evening	.408	.026	.120	.033	133.1
Cost of Evening per Person	.258	.019	.114	.025	100.8
Cost of Tickets	.191	.014	−.005[b]	.019[b]	88.2
Cost of Everything but Tickets per Person	.345	.036	.229	.046	59.5

[a]All data are from an audience survey for the evening performances and for respondents who were not guests and were from New York City and the surrounding area. There were 1,228 questionnaires in this category with all the relevant data filled out. The mid-point of each income category except the highest, $50,000 and over, was used as the income observation. Those checking $50,000 and over were excluded. Also excluded were those under 18, those over 60 and those on an expense account.

[b]Time to go home was included in this regression in order to test the hypothesis that higher costs of travel might lead to lower expenditures for tickets — a trade off. While the sign is right the variable is not significant.

evening. The time to go home is included in the regression so that the cost of travelling to the theatre for any income group can be held constant. A one per cent rise in income would lead to a 0.2 per cent increase in the average price of tickets bought, a 0.35 per cent increase in expenditures on other items per person, and a 0.41 per cent increase in total outlays for the group as a whole. The results are hardly encouraging for the legitimate stage. When earnings expand, expenditures on non-theatre activities, such as dining out, transportation, baby sitters, and so forth, increase noticeably but spending on tickets goes up by less. Higher incomes lead individuals to buy only slightly better seats.

As total and per capita wealth continue to rise and are reflected in increased income, we can predict a proportionate growth of attendance on Broadway, a rise in the price of tickets bought, and a larger jump in the amount spent on complementary goods. One result of the desire to buy better quality seats as people become richer is that the higher priced tickets will become relatively more popular. Greater dispersion in prices should have occurred, but we have no data to check this hypothesis.

Time-Series Results

Without knowing how price and cost affect theatregoing, a full understanding of the forces at work is impossible. From the audience survey, since ticket prices are fixed, price-quantity and cost-quantity elasticities cannot be derived. It is necessary, therefore, to consider a more explicit time-series model in which ticket charges vary.

Our model will be as follows:[10]

$$A_i = f(Y_i, C_i, S_i) \tag{1}$$

$$S_i = g(A_i, P_i, M_i) \tag{2}$$

$$C_i = h(P_i, T_i, O_i) \tag{3}$$

where A_i is attendance in the ith period, Y is income, C is the cost of attending the theatre, S is the number of shows (musicals and non-musicals) playing on Broadway, P is ticket prices, M is the dummy variable for sound motion pictures, T is transportation cost to the theatre, and O is other costs of attending a Broadway show. Function

(1), simply stated, says that attendance in any period is a function of income in that period, costs of attending the theatre in that period, and the number of shows playing. Function (2) says that the number of shows playing in any period is a function of attendance in that period, ticket prices at that time, and the length of time since sound motion pictures were introduced. Function (3) expresses the relationship between the cost of attending the theatre in any period, ticket prices, travel costs, opportunity costs,[11] and other costs (such as babysitting, dining out, etc.).

Clearly, attendance is a function of income and prices. In addition, the number of different shows playing will affect theatregoing. The greater the number, the more people will find something that interests them and that they have yet to see.

Population clearly will affect theatregoing. The greater the population in the New York area, ceteris paribus, the more tickets will be sold. Unfortunately, accurate annual data on the population of the area are unobtainable. Even if such statistics were available, the appropriate area to include would be uncertain. In the late twenties, Broadway undoubtedly drew from a smaller region than in the sixties. New York City population has shown little trend since 1930 and it is uncorrelated with attendance. If the population of the appropriate area has grown steadily, as seems likely, then the coefficient of the income variable will be too large. This follows since income has also had an upward trend. In interpreting our results, we must keep this in mind.

While seats are being demanded, shows are being supplied. The number of theatres with shows during a week depends on the prosperity of Broadway (if demand is high some shows will remain in operation that would have closed up when conditions were bad) and on the number that opened recently. The former factor is reflected in price and attendance while the latter depends at least in part on the availability of factors of production.[12] Normally, if factors of production are scarce, costs and prices will rise. In the late 1920's and early 1930's, as sound motion pictures were introduced, a unique situation developed; Hollywood bid away directors and playwrights, from Broadway. As a consequence, the number of productions declined, leaving many New York theatres dark. Hence while costs of producing rose considerably, theatre rentals declined, and the result was that prices only inched up. The following substantiates this account: The expansion of the motion picture industry with the introduction of sound was phenomenal. Motion picture receipts of downtown New

York film houses doubled between February 1925 and February 1928 and tripled between 1925 and 1931.[13] Actors who could talk, singers, and directors who could deal with the spoken word were avidly sought. The result was higher costs and fewer shows. Performances per theatre fell from between 221 to 267 for the 1928–1929 season to 139 for the 1931–1932 season. Theatre rent fell from about 45 per cent of the gross to 30 per cent or less.[14] Note that the top ticket price of straight shows, after adjustment for price changes, increased each year, with the exception of 1932, from 1927 through 1935 when it reached $5.80 in 1947–1949 dollars. The average top ticket price in February 1963 for a straight show was $5.78; two cents less than it was in 1935. Musical prices also increased rapidly. In 1927, the average price of the best seat was $6.23, the next year it jumped to $7.39, by February 1930 it had risen to $8.33, and in 1963 it was $7.06 in 1947–1949 dollars.[15] In a separate part of this study, the author found that production costs and operating costs rose considerably more rapidly during the 1930's than during any other period. In fact, operating costs in the 1960–1961 season were not appreciably higher than operating costs in the 1939–1942 season, yet they were considerably higher than they had been during the 1927–1929 period. Production costs tripled between 1927–1929 and 1939–1942. In the face of the great depression, therefore, production and operating costs increased and prices rose even though many theatres were dark. Something must have been affecting supply. That something, it seems most likely, was the fact that film producers were bidding artists away from Broadway. Hence, our supply function will include a dummy variable for sound movies. Since the introduction of sound motion pictures would most likely have the greatest effect the first year, a smaller effect the second, and so on, the variable will be $1/t$, where t is the years since 1928. Before 1929 the value of the dummy variable will be one.[16]

Although in most economic formulations, price is an endogenous variable, in this model, ticket prices are assumed to be a function of costs and a random element. This is not an unreasonable approach. The house scale is usually established weeks before opening by considering the costs of the show, the prices charged by previous productions in that theatre, and by expectations concerning the probable success of the venture. Our price variable is an average of the cost of the most expensive seats for a regular performance of each production playing during the month of February. Since the house scale normally remains unchanged throughout the run whether tickets are being scalped or

discounted, list prices fail to reflect demand. Unfortunately, the top ticket price may be a poor estimate of the average ticket price. We shall assume, however, that our measure of ticket prices is an unbiased *index* of the average over time.[17] The measure, therefore, while reflecting costs, expectations, and other elements, is probably reasonably independent of demand and can therefore be treated as exogenous.

In the long run, average attendance is probably a constant. If that is true, then the long-run equilibrium condition for our model can be expressed as $A = aS$. With the addition of this equilibrium condition there are four endogenous variables A, S, P, and C and four equations. But in the model tested, it is assumed that the market is not necessarily ever in long-run equilibrium, hence, price must be taken as exogenous.

Unfortunately, no data, or insufficient data, on travel expenses and on other expenses of attending the theatre exist for the period. This lack, however, may be tolerable. Even though the population has been moving to the suburbs, with improved transportation, the cost in time and money may have remained approximately the same. Assuming that travel costs and other expenses of theatregoing have no trend in time and are uncorrelated with the other variables, there would be no harm in excluding them. To the extent that they may have had an upward trend, they would be reflected in the income coefficient and would tend to lower it. Consequently, function (3) has been dropped from the model and P_i has been substituted for C_i in equation (1). The model is now:

$$A_i = f^*(Y_i, P_i, S_i) \tag{4}$$

$$S_i = g(A_i, P_i, M_i) \tag{5}$$

Attendance, therefore will be considered as a function of income, the supply of shows, and the price of tickets. Later the total cost of attending the theatre will be reintroduced.

The Data

The basic data, for testing the model cover the period from 1928 to 1963 for the month of February, a period which covers basic shifts in the pattern of theatregoing. In the 1927–1928 season, Broadway in terms of attendance and openings, reached an all time high. With the

advent of hard times, attendance dwindled to half its former level and new productions sank even further.

Attendance for an average week in February was estimated by dividing the total gross receipts for musicals and nonmusicals separately by the average top ticket price. The quotient was then multiplied by 1.6 — the mean ratio of the price of the best seats to the average list price of all seats during the 1950's. The result was a measure of attendance at nonmusicals and at musicals. The two numbers were summed to get the total. It should be noted that the average list price of seats may easily differ from the average paid price if tickets are scalped or discounted, if brokerage fees are charged, or if seats at some price sell slower than others. We presume, however, that no bias is introduced by this method.

The number of shows is the total of nonmusicals plus the total of musicals playing each week during February of each year divided by four. Ticket prices are a weighted average of the prices of the best seats for both nonmusicals and musicals. Since musicals have about 35 per cent more seats available than do nonmusical shows,[18] musical ticket prices were weighted by 1.3475 and nonmusicals by 1. An average was then computed. In actual practice, it makes little difference whether the average was weighted or not.

Price, as was mentioned above, is the mean of the most costly seats at the most costly performances. Necessarily, we are assuming that this indexes average prices.

If published per capita G.N.P. figures were used in testing the model, considerable variation in income would exist because of transitory factors. Since deriving the long-run effects of income and price is our aim, a measure of permanent income was employed. The model for permanent income is a common one. Permanent income in period t is a weighted average of actual income in period i and permanent income in period $i - 1$. Thus, if permanent income is called Y^* and actual income is y, we can write

$$y_i^* = \beta y_i + (1 - \beta)y_{i-1}^*.$$

Our only problem is to estimate β and y_{i-1}^*. Clearly we can write

$$y_{i-1}^* = \beta y_{i-1} + (1 - \beta)y_{i-2}^*$$

and by substitution

$$y_i^* = \beta y_i + (1 - \beta)y_{i-1} + (1 - \beta)y_{i-2}^*.$$

This substitution can be extended indefinitely, but it will always involve a y^* term on the right hand side. As more terms are added, the importance of the value of y^* diminishes. Per capita income in 1919 was chosen as the original y^* to compute permanent income in the years between 1927 and 1962. The model was tested using various β's. The best fit was for β's from .3 to .5. For the results in this paper, the permanent income was computed with a β at .4. A different β would make only a small change in the results.

Testing the Model

Primarily this paper is concerned with the factors affecting attendance. Three ways of estimating the parameters of the demand equation will be considered. First is the naive approach. Attendance is regressed on price, income, and number of shows; a dummy variable for motion pictures can be added. This approach hypothesizes that the supply of shows is determined outside the system, which conjecture is dubious. If false, that is, if the number of shows is a function of attendance, then the naive estimates will be biased.

One method of dealing with this bias is two stage least squares.[19] Briefly, the problem with the naive approach is that the residuals of the demand equation are not independent of the number of shows — a variable that appears in the demand equation. Consequently, the coefficients will be biased. Two stage least squares circumvents this difficulty by using the reduced form equations to predict the number of shows. The resulting predicted values will be an exact function of the exogenous variables. Hence these values are independent of the residuals and, when in the demand equation, will give consistent estimates.

As mentioned above, two variables, population and travel expenses, which are left out of the model, are likely to be correlated with income and hence bias its coefficient. Little faith, therefore, can be had in the magnitude of the income coefficient. We will, therefore, test the consequence on all other coefficients of forcing the income coefficient to be the same as that computed in the cross-sectional part of this paper. To do this it is only necessary to remove the effect of income from our dependent variable and then use the same two stage least squares approach discussed above.

There are several problems involved in using cross-sectional figures pertaining to the relationship between income and attendance in the time-series data.[20] Time-series income data may measure a shorter or longer run than cross-sectional data. Hence, it may be incorrect to use the cross-sectional coefficient. Kuh and Meyer have shown that the introduction of extraneous estimates tends to bias the coefficients upwards. In interpreting our results, this must be considered.

Table 2 presents the results of these tests. The most interesting rows of the table are those listing the elasticities. The price elasticity estimates are very similar, varying from $-.33$ to $-.63$. The naive tests, in which attendance is run on price, income, and number of shows, result in the lowest price elasticities and the highest multiple R^2's. The two stage least squares tests probably reflect more accurately the demand for theatre tickets, but the results differ little from the naive approach. Note that when the income elasticity is forced to one, the price elasticity rises only slightly to $-.63$. It is still rather inelastic. As was mentioned above, slightly higher coefficients can be expected when extraneous estimates are used. Thus, the results seem consistent with each other.

The elasticity for the number of shows measures the effect a change in number of shows would have on attendance. These elasticities are all (except for the semi-logarithmic formulation) approximately one, suggesting that a change in the number of shows leads to a proportional change in attendance. An elasticity of one would indicate that producers face an infinitely elastic demand for their product, that is, within the range of 18 to 30, the addition of another show, if it is of average quality, will increase the total number of theatregoers sufficiently to sustain the new show. The theatre, therefore, appears to have the characteristics of a perfectly competitive industry. While the industry demand curve is inelastic, any firm (producer) can sell as much as he wishes (mount as many productions as he wishes and market their seats) without reducing prices. As long as the marginal cost of a new average quality show is less than the expected revenue, it will open. As producers bid for the scarce supply of good scripts, fine actors, and knowledgeable directors, marginal costs increase. In the end, the supply of talent determines how many shows will open.

The results turn on the specification of the model. Another specification, such as excluding price from the supply function of shows, might make two stage least squares inappropriate. In that case, three stage least squares would be required.[21] A three stage approach

Table 2. Various Formulations of the Demand Model of Theatregoing

	Naive Linear	Two Stage Least Squares Linear	Naive Multiplicative	Two Stage Least Squares Multiplicative	Two Stage with Income forced to Cross Sectional (Multiplicative)	Two Stage Least Squares Semi-Log.
Price Coefficient	-14.057	-15.543	-.453	-.558	-.632	-.059
	(6.390)	(9.468)	(.228)	(.279)	(.496)	(.067)
Income Coefficient	.053	.054	.364	.370		.0004
	(.010)	(.015)	(.064)	(.077)		(.0001)
Number of Shows Coefficient	6.440	6.746	.973	1.070	1.143	.032
	(.433)	(.723)	(.074)	(.102)	(.180)	(.005)
Price Elasticity	-.482	-.532	-.453	-.558	-.632	-.329
Income Elasticity	.348	.356	.364	.370	1.030[a]	.425
Shows Elasticity	.917	.961	.973	1.070	1.143	.745
Total R^2	.878	.742	.862	.800	.554[b]	.626
Durbin-Watson	1.989	1.279	1.844	1.645	.513	1.243

[a]Taken from cross-section.
[b]Computed on the basis of attendance with income removed.

was tried; the results, however, were unimpressive. The price coefficient in the demand function turned out to be positive but insignificantly different from zero.

The model above is predicated on the assumption that the introduction of sound motion pictures affected the supply of factors of production more than it affected attendance. While it undoubtedly had some effect on demand, there are reasons to believe that the major effects (several of which were discussed above) were on supply. In addition, the dummy variable for sound motion pictures is more highly correlated with number of shows than it is with attendance. The simple correlation coefficient between our dummy sound motion picture variable and attendance is .66 and between it and the number of shows playing is .82.

The findings depend also on the assumptions that estimated attendance and the price variable are, at least, unbiased indexes of theatregoing and ticket tariffs. Moreover, the outcome hangs on the truth of the premise that all relevant variables are included or that the excluded ones are uncorrelated with those in the model. Inasmuch as the price of tickets is only part of the cost of attending the theatre, we know that important factors are left out such as the outlay for transportation, travel time to the theatre, the expense of dinner in a restaurant, and the cost of babysitters, all of which should be taken into account but are ignored because of inadequate data. We assumed that this exclusion would have little effect. But if the price variable is correlated with other costs, the measured elasticity would be too high, since it would be reflecting the effect of these other items. The crucial proposition is that the items left out are uncorrelated with the exogenous variables.

We know from the cross section that in 1962 the cost of theatregoing averaged $16.37 per person of which $7.99 was spent on a seat. A ten per cent rise in price of tickets would lead, therefore, to a 4.88 per cent rise in the cash cost of theatregoing and a five per cent fall in frequency of attendance. It follows, that the cash cost-quantity elasticity is about -1.[22]

The time-series data suggest an income-quantity elasticity considerably smaller than was computed in the cross section. It is possible that income, which at least since the early thirties has had a fairly steady upward trend, is correlated with other variables, excluded from the model, such as travel, expenses of visiting Broadway, and restaurant costs. If so, measured income elasticity is too small. Since the

population has moved steadily to the suburbs, travel time and/or cash costs may have risen. Moreover, restaurant prices reflect labour costs which have climbed since the thirties. Therefore, there is good a priori reason to believe that these variables are correlated with income and hence, that the time series income elasticity is underestimated.

Conclusion

The low income elasticity of demand for playgoing seems surprising. A figure considerably above one was expected by the author for such a luxury good as playgoing. The explanation may lie in the fact that theatregoing in New York uses considerable time – about two and a half hours inside the theatre and, for the average commuter to Manhattan, about 140 minutes round trip.[23] Inasmuch as higher income people tend to place a greater value on their time, including that spent in consumption than do lower income people,[24] they will substitute in consumption those goods that use relatively little time for those that use a great deal. Playgoing obviously falls in the latter category. Opportunity costs of theatregoing go up with a rise in income. Hence, advances in earnings lead to a desire to spend more on theatregoing (income effect) and to an appreciation in the opportunity costs of doing so. The measured income elasticity only reflects, therefore, the net effect income has on consumption.

The slow growth in the Broadway audience appears to be a result of a modest net income elasticity, an increase in ticket prices, and possibly the flight to the suburbs which has increased travel time and opportunity costs. Fears that the theatre is pricing itself out of the market seem unfounded, but higher prices may well have reduced playgoing a little. The elimination of the federal excise tax of ten per cent may initially expand attendance only five per cent. Since supply is relatively inelastic, however, the net revenue of theatre owners and producers should improve with the elimination of the tax.

The long-term prospects for Broadway are consequently good. Advancing incomes will lead to a greater demand for the theatre. Partially offsetting this may be higher ticket prices which will dampen seat sales. Nevertheless, with a growing population and a flourishing economy Broadway should prosper.

1. This paper is based on a larger study of the economics of the theatre conducted by the author.
 The author is grateful to the Rockefeller Foundation and Carnegie Institute of Technology for making this study possible.
2. Based on estimates of Broadway attendance made by the author. The procedure for making these estimates is described below.
3. Spending on the performing arts and on spectator sports is taken from the *Statistical Abstract* and *Historical Statistics of the United States*. The series are deflated by the consumer price index.
4. The percentage of individuals from out of town who claimed to be on expense accounts was considerably higher for the one test show that was collected by mail than in the regular survey. Since the data reported on in this paper deal only with theatregoers from New York City or its vicinity, the difference can be ignored. The mail questionnaire brought a response of 31.7 per cent. This should be compared to a response rate of 50 per cent for the identical questionnaire collected in boxes in the theatre two evenings before
5. The figures were prepared for this study by the staff that conducts the research for *Playbill*.
6. Weiss and Geller Research, 'An Exploratory Study of Theatre Audiences Present and Future' (Chicago: March 1956, unpublished manuscript).
7. We have no data on the response rate of the *Playbill* survey but Professor John Enders who conducts the study has assured the author that every effort has been made to assure the randomness of the respondents. The *Playbill* survey is conducted by trained personnel who distribute questionnaires on the basis of location. The Weiss and Geller study is apparently not a random survey.
8. U.S. Bureau of the Census, *Census of Population*, 1960.
9. A semi-log formulation gives almost identical results with slightly lower R^2's.
10. An alternative model would have the supply of shows in one period as a function of price and attendance the previous year. Such a model was tested and found to have substantially the same coefficients for the demand variables except for the shows coefficients. The elasticity of attendance with respect to the number of shows was computed from this coefficient and was considerably above one. This indicates that the addition of another show leads to an *increase* in *average* attendance; a result which is hardly plausible.
11. Opportunity costs of theatregoing should be included in any measure of total expenses. See Jacob Mincer, 'Market Prices, Opportunity Costs, and Income Effects,' in *Measurement in Economics: Studies in Mathematical Economics and Econometrics in Memory of Yehuda Grunfeld* (Stanford University Press, 1963). Unfortunately we have no data pertaining to this variable.
12. This point is discussed in detail in Chapters I and II of the author's forthcoming book on the theatre *The American Theatre: Past, Present, and Future*.
13. Computed from various issues of *Variety*.
14. Performances per theatre were computed by dividing the total number of performances during the season by the number of theatres on Broadway. Total performances were computed by adding up the total for each show as given in *Best Play* volumes and supplemented by *Variety*. The number of theatres was taken from John F. Wharton, *Crisis in the Free World Theatre* (New York: The League of New York Theatres, Inc., 1961). The decline in theatre rental is based on another study of costs by the author.
15. Computed from various issues of *Variety*.

16. Sound motion pictures were first introduced in October 1927 with the *Jazz Singer*. The value of the dummy is 1 in 1928, 1 in 1929, ½ in 1930, $1/3$ in 1931, and so forth. The dummy variable lags the introduction of sound by two years since it must have taken some time for the effect to be felt. Ideally, the number of sound films should be used, but unfortunately it is unavailable on an annual basis. Other dummy variables were tried such as holding the value of the dummy at $1/10$ after year 11 and of having two price variables before and after sound. The former dummy gave values virtually indistinguishable from the ones reported. The latter approach produced poor results.

17. The evidence suggests that this is a reasonable assumption. The ratio of the highest ticket price for a regular performance and the average list price from 1950 to 1963 remained almost constant. There was no noticeable trend.

18. Computed from a sample of all the productions on Broadway in the fall of 1962.

19. See J. Johnston, *Econometric Methods* (New York: McGraw-Hill, 1963), Chap. 9. Since our model is exactly identified, two stage least squares is equivalent to indirect least squares.

20. See L. R. Klein, *An Introduction to Econometrics* (Englewood Cliffs, N.J.: Prentice Hall, 1962), Chap. 2, and E. Kuh and J. R. Meyer, 'How Extraneous are Extraneous Estimates?' *Review of Economics and Statistics*, XXXIX (1957), 380–393.

21. See Arnold Zellner and H. Theil, *Econometrica*, XXXII (Jan. 1962), 54.

22. Costs of theatregoing undoubtedly include the time spent in travel and in the theatre. A simple correlation, logarithms of travel time to the theatre with relative attendance, produced a regression coefficient of − 1.82, suggesting that time in transit does affect frequency of playgoing. This is consistent with the Mincer piece cited in note 11).

23. New York-New Jersey Transportation Agency, *Journey to Work* (New York: New York-New Jersey Transportation Agency, 1963). Average travel time to work is about 70 minutes one way. At times other than rush hour, it will be less for some individuals and more for those depending on public transportation. The average for off hours may not differ greatly from 70 minutes.

24. Mincer, *Op. cit.*

15. Risk, Uncertainty and the Performing Artist[1]

by F. P. SANTOS

I. Introduction

The craving for artistic fulfillment by those in the performing arts may be likened to the spiritual pursuits of the holy man in search of divine realization, for not only is the nurture and discipline of talent characteristically a highly ascetic process, the expected rewards traditionally provide meagre financial compensation. The probabilities determining these expected rewards[2] are subject not only to the scarcity of genius but also to the size of the net inflow into the performing arts and the perspicacity with which entrants judge their own training and abilities. For example, other things equal, a sudden influx of stage-struck dilettantes would diminish the probability of a large income, thereby reducing the income expected from such pursuits.

The predisposition to enter what may be diagnosed as a professional disaster area was observed by early theorists who attributed such behavior to unfounded optimism or ignorance of the odds.[3] More recently, Friedman and Savage[4] provided a theoretical framework for such behavior suggesting that individuals who knowingly engage in uncertain activities, despite actuarial disadvantages, are risk-takers whose marginal utility of income increases as income rises. Therefore, although the expected income, \overline{Y}, resulting from a probability (P) of a low income Y_L and a probability $(1 - P)$ of a very high income Y_H, is lower than the income derived from a riskless alternative Y_0, the value attached to the expected utility of \overline{Y} (that is, Y^*) is greater than the utility of the certain income Y_0 as shown in figure 1. Choice is based on the value of expected utility not the value of income expected and, as such, these individuals voluntarily accept uncertainty, being willing to suffer a loss up to the amount $Y^* - \overline{Y}$.

Assuming performing artists fit within this framework of choice under conditions of uncertainty, evidence of financial sacrifice would

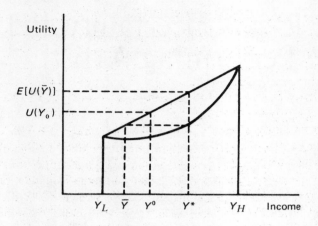

Figure 1.

simply be indicative of the shape of their utility function. An empirical estimation of the losses, if indeed they do exist, and the factors which affect their relative size should serve to define the dilemma more precisely and extract the professional vicissitudes of performing artists from the realm of pure romantic abstraction. Furthermore, by selecting certain occupations within the profession which are representative in terms of required inputs — that is, years of disciplined training and diligent application — greater accuracy should emerge. As careers in both the ballet and opera demonstrate these demanding prerequisites, ballet dancers and opera singers would seem eminently suited for analysis and comparison.

II. Estimation Procedure

Since data providing age-earnings profiles for the two groups to be considered were lacking, the use of a technique specifically designed by Milton Friedman and Simon Kuznets to deal with such situations made analysis of the performing artist's condition possible.[5] Alternative groups were selected for whom age-earnings data were available; these alternative groups had the same average level of formal education as ballet dancers and opera singers but lacked the additional artistic

Table 1. Average Education of
Dancers and Singers

Occupation and Sex	Average Years of Schooling
Dancers — Male	11.7
— Female	12.1
Singers — Male	13.7
— Female	13.9

*Source: U.S. Census of Population
1960, Occupational Characteristics,*
Final Report PC (2) — 7A, Table 9.

training. Findings based on the 1960 Census (see Table 1) provided the rationale for using age-income[6] profiles of those with twelve years of schooling when analyzing ballet dancers and, in the case of opera singers, those with thirteen to fifteen years of schooling. This technique permits, for example, the estimation of the percentage differential between observed average incomes of ballet dancers and those with 12 years of schooling that would compensate for the additional cost incurred by specialized training. The model may be specified as follows:

$$R = \frac{y\left(\dfrac{V + v + c}{V}\,(1 + r)^t\right)}{(y - u) + up} \tag{1}$$

where: R = The compensating percentage differential in observed average incomes between the occupation under consideration and its alternate group.

V = Present value of the returns to the alternate group for all except the last u years of the alternate group's working life.

v = Present value of the returns to the alternate group for the last u years.

c = Present value of the cost incident to acquiring specialized artistic training.

r = Interest rate used in discounting based on the estimated internal rate of return to the appropriate education level.

t = Time lag in income received by those in the occupation under consideration compared with their alternate group. That is, those in the occupation under consideration may

receive each installment of income t years later than their alternate, owing to the time devoted to additional specialized training.

u = Number of years by which working life of the alternate group exceeds that of the performing artist.

y = Number of years of working life, assumed to be 47 years for those with 12 years of schooling (age 18 to 65) and 45 for those with 13—15 years of schooling (age 20 to 65).

p = Ratio of the average income of the alternate group during the last u years to the average income for the rest of the period.

The above equation may also be written:

$$R = \frac{yK}{(y - u) + up} \qquad (2)$$

where

$$K = \frac{V + v + c}{V} (1 + r)^t \qquad (3)$$

The numerator of the fraction (K) is the present value of the income sacrificed by the performing artist $(V + v)$ plus the present value of the costs of specialized artistic training (c). It therefore indicates what the present value of the artist's returns would have to be in order to compensate the financial sacrifice resulting from the choice of a career in the performing arts. Since artistic training tends to take place simultaneously with formal schooling, owing to the importance of developing a technique early, it is not unrealistic to suppose that working life begins at approximately the same time as the alternative group and continues until a reasonable retirement age. Under such circumstances $u = 0$ and therefore $v = 0$. Obviously, the artist does not perform all of these years, but certainly professional life need not cease after retirement from the stage, since teaching and other allied activities form a further aspect of artistic endeavor less dependent on youth and enhanced by experience.

The denominator of the fraction (K) is the present value of alternative income sacrificed by the performer, while the entire fraction provides the figure by which each installment of the artist's income would have to be multiplied in order to make performing financially commensurate with its appropriate alternative.

When each installment of income is received t years later than the alternative group (as, for example, the college graduate who goes on to study law or medicine) the fraction must be multiplied by $(1 + r)^t$ as in equation (3). However, in the case of artists, as was mentioned previously, specialized training can and must take place at the same time as formal schooling since age imposes a physical constraint on the ability to acquire a basic technique, particularly in the case of the ballet dancer. Therefore little or no difference can be expected in the age at which the performer and his alternative group first enter the labor market; t will tend to equal zero and K reduces to

$$K = \frac{V + c}{V} \tag{4}$$

Taking into account all of the above, the original formulation simplifies to:

$$R = \frac{V + c}{V} \tag{5}$$

III. Empirical Estimation of Returns

In order to avoid possible over- or under-estimation of R, age-specific average income, estimated from the 1960 U.S. Census of Population[7], should incorporate certain adjustments. For example, since cross-sectional data are utilized, an adjustment should be made for the growth of the economy over time. Its omission would lead to an under-estimation of the present value of the income stream generated by a given level of formal education, thereby overestimating the compensating differential (R) required to make the investment financially feasible. For this reason, when calculating the present value of the returns (V), each installment of income was multiplied by $(1 + g)^t$, using an empirical approximately of 2 percent for the annual rate of growth (g) of the economy.[8]

By the same token, failure to adjust for the appropriate tax rate and the rate of mortality[9] would lead to underestimation of the R necessitated. Actually, year by year adjustment for mortality resulted in a negligible change in the calculated differential (R) necessary to make investment in training feasible and so was omitted.

Estimates of age-specific average income presume a 100 percent labor force participation rate on the part of each cohort. If it is believed that the return to investment in education can only be realized in the labor market, it may be argued that a complete adjustment should take account of the fraction not in the labor force. Such adjustment would have little impact on the age-income profiles of males before the age of fifty, but for females, labor force participation varies significantly according to age, marital status, and presence of young children.[10] Adjustment (multiplication by the appropriate labor force participation rate) would lower their age-income profiles and raise the calculated R for dancers and singers. However if it is assumed that schooling raises female productivity in home and market activities equally, no adjustment should be made, since the age-income profile would simply be reflecting productivity regardless of production locale. The justification for either assumption is highly debatable; the first tends to polarize the effects of schooling on productivity, whereas the second generalizes the effects to an extreme. Probably the truth lies somewhere in between.[11] In any event the rate of labor force participation was not included in the final estimating procedure.

Obviously incomes reported at a point in time reflect prevailing economic conditions. For example, during a recession, incomes estimates would be biased downward, the bias being more pronounced the younger the age group and the lower the education level. Estimating an average for each group over the cycle would serve to avoid this bias were such data available. However, since extremes of a cyclical nature were not in evidence in 1960, this adjustment would appear to be obviated.

Certain other factors do not readily lend themselves to an adjustment procedure but require verbal consideration since they pertain directly to the income data. For example, the compensating differential in observed average incomes between the occupation under consideration (dancer or singer) and its alternative group (those with 12 or 13–15 years of schooling) implicitly assumes hours worked per day and weeks worked per year are comparable. Time input with respect to rehearsals and performances is union regulated but such regulation reveals nothing as to the incalculable pre- and post-rehearsal time required from each artist. Furthermore, it provides no indication as to the peculiarities of hours spent performing — that is, performances take place at night and on weekends. Under these circumstances, a numerical comparison of hours worked per day would seem extremely arbitrary.

Table 2. Weeks Worked According to Occupation, 1959, and Unemployment Rates for April 1960

	50–52 wks	40–49 wks	Less than 40 wks	Percent Unemployed (April 1960)
		Proportion who worked:		
Males				
All males (14+)	68.8	15.1	16.1	4.9
All males in professional–technical occupations	77.5	12.6	9.9	1.4
Dancers, dance teachers	37.9	26.9	35.2	7.6
Singers, singing teachers	42.6	28.6	28.8	4.6
Females				
All females (14+)	51.1	16.9	32.0	5.1
All females in professional–technical occupations	38.4	22.5	39.1	1.4
Dancers, dance teachers	17.7	23.1	59.2	6.4
Singers, singing teachers	27.2	28.9	43.9	1.2

Source: U.S. Census of Population, 1960: Occupational Characteristics, Tables 3 and 14.

Statistics on weeks worked suggest the intensely seasonal nature of most employment in the performing arts and the relatively high rate of unemployment. Performers are generally contracted by the season and seasons last but a few weeks or months per year. Therefore, the concept of regular employment in the performing arts is at best a tenuous one even for those who supposedly have 'made it'. Table 2 indicates that 42.6 percent of male singers and 37.9 percent of male dancers worked 50 to 52 weeks, whereas 68.8 percent of all males (14 years and over) and 77.5 of all males in professional-technical occupations (occupations for which those with 12 and 13–15 years of schooling would tend to qualify) worked all-year-round. Statistics pertaining to females reveal a similar pattern – 51.1 percent for all females (14 years and over) and 38.4 percent for those in professional-technical occupations, while only 27.2 percent of all female singers and 17.7 percent of all female dancers worked 50 to 52 weeks in 1959.

The proportion of dancers unemployed during April of 1960, shown in the last column of Table 2, was higher than that for both males and females (14 years and over) and much higher than the proportion of males and females unemployed in professional-technical occupations. The lower unemployment rates for singers probably result from the

way in which the occupation category is defined. The category is so broad as to include all types of musicians and music teachers and incorporates positions related to the performing arts only in the most peripheral sense, as, for example, free-lance piano teachers. These positions are generally part-time and may provide more possibilities for alternative short-term employment of unemployed singers, particularly in the case of women.

IV. Empirical Estimation of Costs

Total costs of training are both direct and indirect. Direct costs were restricted to tuition fees and professional equipment and excluded expenses such as board, lodging, and clothing. With respect to indirect costs, the income that might have been earned during the period of specialized training was not taken into account since such training took place simultaneously with formal schooling and therefore did not delay entrance into the labor force. That is, since the model limits comparison to the occupation under consideration and its appropriate alternative group, the only other relevant income is that which pertains to the alternate.[12]

The direct costs of artistic training are of a highly specific nature, tending to differ according to occupational requirements, and, in the case of the ballet, by sex. For example, training for the female dancer must begin at a very early age (about 8 years old), not only because it is necessarily long (6 to 10 years), but because of the previously mentioned constraint inherent to the acquisition of skill. If study is begun too late, it becomes physically impossible to acquire a working technique.

Table 3, based on information from five major ballet studios in New York City, provides an estimate of the direct costs for female dancers during the period of study. It may be argued that estimates derived from studios in only one city cannot be considered in any way representative. However, the extreme centralization and inter-dependency of the training and selection process in the case of ballet defends the rationality of such an approach. Professionally oriented youngsters are sent to study in New York, the home-base of American ballet companies, where new members tend to be selected from the ranks of schools affiliated with these companies. That is, aside from

Table 3. Estimated Annual Direct Expenditures for the Initial Training of Ballet Dancers (Female) — 1959

Age	Lessons per week	Equipment*			Average Tuition $	Total Direct Costs $
		Tights	Leotards	Shoes		
8	2	(1)2.50	(1)4.00	(1)4.95[a]	182	193.45
9	2	(1)2.50	(1)4.00	(2)7.50[b]	200	226.45
				(1)4.95[a]		
10	3	(1)2.95	(1)4.00	(3)7.50[b]	261	295.40
				(1)4.95[a]		
11	5	(2)2.95	(2)5.50	(10)8.50[c]	393	499.90
12	7	(2)2.95	(2)5.50	(20)8.50[c]	484	669.90
13	9	(3)2.95	(3)5.50	(40)8.50[c]	550	915.35
14	12	(3)2.95	(3)5.50	(80)8.50[c]	650	1,355.35
15	12	(3)2.95	(3)5.50	(80)8.50[c]	650	1,355.35
16	12	(3)2.95	(3)5.50	(80)8.50[c]	650	1,355.35
17	12	(3)2.95	(3)5.50	(80)8.50[c]	650	1,355.35

*Figures in parentheses represent the minimum number of units needed during the year.
[a]ballet slippers
[b]more durable point shoes for beginners
[c]point shoes for advanced students and professionals
Source: Average annual tuition derived from 1960 data supplied by five leading schools of ballet in New York City (American Ballet Theatre School, Ballet Arts, Metropolitan Opera Ballet School, Robert Joffrey School, School of American Ballet).
Price of equipment obtained from Capezio Price List, June 1960.

providing high quality training, these schools screen prospective candidates, and thus serve to ration the limited number of jobs available. It is apparent from the information in the table that during the early stages of training, tuition is the major component of direct costs while during the advanced stages, point shoes (an exceptionally short-lived piece of equipment) become an expenditure greater than tuition. Scholarships are not abundant and these direct costs raise the ordinary family expenditures on children substantially, suggesting that female aspirants come from upper-income families.[13]

Since the male dancer need never learn to dance on point and tends to start with greater physical strength and endurance, training may begin at a later age than the female. Equipment expenditures never equal those of the female so that tuition remains the main component

Table 4. Estimated Annual Direct Expenditures for the Initial Training
of Ballet Dancers (Male) — 1959

Age	Lessons per week	Equipment* Shirts	Tights	Shoes	Average Tuition $	Total Direct Costs $
12	2	(1)2.95	(1)6.50	(1)6.00	182	197.45
13	3	(1)2.95	(2)6.50	(2)6.00	261	288.95
14	6	(2)2.95	(2)6.50	(3)6.00	435	465.90
15	8	(3)2.95	(3)6.50	(4)6.00	510	562.80
16	9	(3)2.95	(3)6.50	(4)6.00	550	602.35
17	9	(3)2.95	(3)6.50	(4)6.00	550	602.35

*Figures in parentheses represent the minimum number of units needed during the year.

Source: Average annual tuition derived from 1960 data supplied by five leading schools of ballet (American Ballet Theatre School, Ballet Arts, Metropolitan Opera Ballet School, Robert Joffrey School, School of American Ballet) in New York City.

Price of equipment obtained from Capezio Price List, June 1960.

of direct costs throughout (see Table 4). Scholarships are more accessible reflecting a prevailing tendency for qualified males to be in short supply — a phenomenon which may arise, in large part, from the stigma attached to a profession reputed to cater to homosexuals and other social rejects.

In the case of singers, serious study can only begin after the voice has matured and therefore at a much later age than dancers. Table 5 indicates that both male and female singers may begin studying voice at 16 or 17 years of age, many singing teachers requiring two lessons per week at $6 to $20 per half hour.[14] Assuming that the aspirant studies 44 weeks out of each year for approximately 10 years at an average cost per lesson of $13, annual tuition (as of 1960) would be $1100.

The average education level of singers suggests that during the third and fourth years of training, tuition would be slightly higher owing to enrollment in a college or conservatory. However, institutional financing during this period in the form of scholarship aid would also tend to be available. The particular institutions selected to provide tuition information for these two years have no justification other than reputation since, unlike ballet dancers, there is no pronounced interconnection between training ground and market-place.

Training and equipment costs incurred after the initial training

Table 5. Estimated Annual Direct Expenditures for
the Initial Training of Singers (Male and Female) —
1959

Age	Estimated minimum expenditure for music	Estimated average annual tuition	Total direct costs
16	$50	$1,100	$1,150
17	50	1,100	1,150
18	100	1,257	1,357
19	100	1,257	1,357
20	100	1,100	1,200
21	100	1,100	1,200
22	100	1,100	1,200
23	100	1,100	1,200
24	100	1,100	1,200
25	100	1,100	1,200

Source: Tuition estimates for all except the third and fourth
year of training derived from information provided by George
Shirley's testimony in *Economic Conditions in the Performing
Arts*, Hearings before the Select Subcommittee on Education
of the House Committee on Education and Labor, 87th
Congress, 1st and 2nd session, Nov. 1961–Febr. 1962.
 Estimates for the third and fourth year of training
supplied by catalogues of Eastman School of Music, Mannes
College of Music, Manhattan College of Music, Oberlin
College, Julliard School of Music, — 1960.

period were not allowed for. Since employment for a ballet dancer
generally occurs within the confines of a ballet company and most
companies are affiliated with a school of ballet, daily classes are made
available at no cost. Under these circumstances, practice clothes and
make-up would be the main expense not taken into account. For the
singer, investment after initial training could be considerably more
burdensome with the possible exception of members of the Metro-
politan Opera, who may receive additional funds specifically to cover
coaching, language, and acting lessons necessary to the perfection of
their roles. Otherwise, in the case of the singer, such additional
expenses could easily average more than $1000 per annum.

 Costs and returns to training were discounted using private rates of
return to white males in the north of the United States (1960) estimated
by Giora Hanoch — that is, 16 and 7 percent for those with 12 and
13–15 years of schooling respectively.[15] Since rates of return to their

investment in human capital tend to be roughly 2 percentage points lower, 14 and 5 percent were used in the case of females.[16]

V. Observed and Empirical Estimates of Income Differentials

Having discussed various qualifications and considerations pertaining to the data, it remains to consider the estimated R's derived from our model (equation 5). These estimates, presented in Table 6, suggest that mean income (net of taxes) for male dancers should be 6 percent greater than that of male high school graduates. Actually, in 1960, the observed mean net income of male dancers and dance teachers ($4384) was 7 percent less than that of high school graduates ($4733).

Because the present value of their costs relative to returns was higher in the case of female dancers the estimated R was also higher. Therefore, although the observed percentage differential in incomes was positive, i.e., the average income of female dancers and dance teachers ($2397) was 10 percent greater than that observed for high school graduates ($2189), it was still less than the estimated 20 percent required to make the investment financially enticing.

The compensating differential in observed average incomes estimated for male and female singers was 8 and 15 percent, respectively. These estimated differentials (R's) stand in pathetic juxtaposition to the differentials observed. Average net income for male singers and singing teachers ($5167) fell 15 percent short of the observed average for males with approximately 14 years of schooling ($6222). For female singers, the average net income ($2208) was 16 percent below that observed for their alternative group ($2624).

In both instances the present value of costs relative to returns was higher for females than for males. The resulting required differentials in average observed income were three times higher for female dancers and almost double for female singers in comparison with their male counterparts.

Observed differentials were positive in the case of female dancers, although not large enough to compensate for the investment. Observed average income for female singers was not only less than that observed for females with 14 years of schooling, it was less than the average observed for female dancers. The relatively large size of this category as shown in Table 7 may explain this finding. Furthermore, if the category

Table 6. Observed and Calculated Percentage Differentials in Average Income (1959)

	Mean Incomes (1959)		Percentage Differential in Observed Average Income (1959)		Calculated Percentage Differential Necessary to Make the Investment in Training Feasible (R)	
	Male	Female	Male	Female	Male	Female
Dancers and Dancing Teachers[a]	$4384	$2397				
Singers and Singing Teachers[a]	5167	2208				
Persons with 12 years schooling[b]	4733	2189				
Persons with 13–15 yrs. schooling[b]	6222	2624				
Dancers vs. Persons with 12 yrs. schooling			−7%	10%	6%	20%
Singers vs. Persons with 13–15 years schooling			−15%	−16%	8%	15%

[a]Source: Estimated from data provided by U.S. Census of Population: 1960, Final Report, PC(2)-7A, Table 25.
[b]Source: Estimated from data provided by U.S. Census of Population: 1960, Final Report, PC(2)-5B, Tables 6, 7.

Table 7. Estimates from 1/1000 Sample (U.S. Census of Population: 1960)

Sex and Years of Schooling or Occupation	Sample Size	Mean Income	Standard Deviation	Coefficient of Variation
Male (12 years)	9966	$5331	$3510	.65
Female (12 years)	7437	2621	1841	.70
Male (13–15 years)	4043	6222	4121	.66
Female (13–15 years)	2749	2827	1810	.64
Male dancer	5	2160	1550	.72
Female dancer	22	2618	2972	1.14
Male singer	81	5932	9035	1.52
Female singer	117	2514	6168	2.45

is a sort of catchall, incorporating any job vaguely related to music, low-paying, part-time employment, the sort often held by women with a weak attachment to the labor force, could be responsible for lowering the average observed income of the female singer below that of the female dancer.

Since the market tends to discriminate according to sex, providing more favorable employment opportunities for males of a given level of education, it is not surprising that forgone income was the main cost consideration as far as male singers and dancers were concerned. Financial sacrifice in terms of the income differential observed was less pronounced in the case of male dancers, not only because their alternative income pertains to a lower education level than male singers, but also owing to their short supply (see Table 7), a phenomenon which possibly reflects the social stigma enveloping their occupation.

Table 7 provides information on the comparative risk of the various groups under consideration based on data from the 1/1000 Sample (U.S. Census of Population: 1960). With the exception of male dancers, for whom estimates were inconclusive owing to their small sample size, it is apparent that occupations in the performing arts are characterized by greater variation in income. In order to allow for differences in sample size, an F test was performed using the variance in income of dancers (females) and singers (both males and females) and their educational counterparts. In each case the null hypothesis was rejected at the .05 level. That is, the variances in income of dancers and singers proved significantly larger than the variances of those with twelve years of schooling or one-to-three years of college.

VI. Conclusion

The uneven nature of the cost data does not allow the results to be considered in any way definitive. However they do plead the precariousness of professional life in the performing arts and the financial sacrifice inherent. For both dancers and singers, the observed percentage differentials were never as large as the estimated differentials required to compensate the respective groups for their investment. The only instance in which the estimated and observed differentials came close to equalizing was in the case of male singers and dancers owing to forgone income. That this was not so for females possibly reflects the relatively low level of wages and professional opportunities generally available to them. Finally, aside from the negative returns to artistic training implicit in the results, a very high variance in income was found in comparison with the alternative groups used (those with 12 and 13—15 years of schooling), especially in the case of singers.

Such privation remains within theoretical bounds if we consider that the larger variance in income characteristic of the performing arts serves as an attraction to prospective entrants. Moreover, psychic income, derived from the pleasure of performing, permits the romance and pathos of artistic endeavor to remain within the scope of economic rationality. Thus, even though expected income urges the sagacity of Noel Coward's avuncular advice 'Don't Put Your Daughter on the Stage, Mrs. Worthington' and suggests that such counsel also be accorded sons, risk preference and psychic income apparently prevail over financial considerations when considering the pursuit of a career in the performing arts.

1. The author wishes to thank Gary S. Becker, William Landes, Cynthia B. Lloyd and Jacob Mincer for useful comments made on earlier drafts.
2. The simplest formulation for the average or expected gain from an activity may be expressed as follows: $Y = PY_L + (1 - P)Y_H$, where Y_L and Y_H stand for low and high incomes respectively, P represents the probability of a low income, and $1 - P$ the probability of a high income, the sum of the probabilities equalling unity. Obviously, more than two incomes may be considered, since a whole distribution of incomes with their respective probabilities may be relevant to an activity.
3. See Alfred Marshall, *Principles of Economics* (8th edition; New York, 1920), pp. 398—400, 554—555, 613; Adam Smith, *The Wealth of Nations* (Modern Library, reprint of Cannan Edition, 1937), Book I, Chapter 10.

4. See Milton Friedman and L. J. Savage, 'The Utility Analysis of Choice Involving Risk' in The American Economic Association, *Readings in Price Theory* (Homewood, Illinois, 1952), pp. 57–96.

5. See Milton Friedman and Simon Kuznets, *Income From Independent Professional Practice*, (New York, 1945).

6. It may be argued that property income should be excluded. However, at the aggregate level, Census incomes can be used to measure earnings since underreporting of earnings has been found to roughly offset the inclusion of property and other unearned income. See Gary Becker, *Human Capital* (New York, 1964), pp. 163–164.

7. Average income according to age, education level, and sex was calculated by taking the sum of the midpoints of each closed income interval and the Pareto estimate of the open end interval ($15000+), weighted by the proportions of persons in each income bracket. The estimation procedure for the Pareto estimate of an open end interval may be found in A. L. Bowley, *Elements of Statistics* (London, 1937), pp. 344–347.

8. Edward Denison estimated that national income per capita grew at a rate of 1.7 percent annually from 1929 to 1957. See Edward Denison, *Sources of Economic Growth in the United States* (Washington, D.C., 1962).

9. Tax rates according to level of income were derived from the *Statistics of Income: Individual Income Tax Returns*, U.S. Treasury Department, Internal Revenue Service, 1960. The mortality rate, i.e., number of deaths per 1000 population (United States 1959–1961), may be found in *Fact Book* (Institute of Life Insurance, 1969), pp. 106–107.

10. For a detailed analysis of labor force participation rates by sex, age category, marital status, and presence of young children see William G. Bowen and T. Aldrich Finegan, *The Economics of Labor Force Participation* (Princeton, 1969).

11. For a further discussion of this point see Jacob Mincer, 'On-the-Job Training: Costs, Returns and Implications' *Journal of Political Economy* (Supplement: October 1962), pp. 66–67.

12. That there are earnings forgone for the alternate groups is also not a consideration here.

13. For a theoretical and empirical analysis of the income elasticity with respect to expenditures per child see Gary Becker, 'An Economic Analysis of Fertility' in *Demographic and Economic Change in Developing Countries* (Princeton, 1960), pp. 211-212.

14. See *Economic Conditions in the Performing Arts*. Hearings before the Select Subcommittee on Education of the House Committee on Education and Labor, 87th Congress, 1st and 2nd session, November 1961 – February 1962 (George Shirley's testimony).

15. See Giora Hanoch, 'An Economic Analysis of Earnings and Schooling' *The Journal of Human Resources* (Summer, 1967), p. 3.

16. Jacob Mincer found that rates of return to investment in human capital by females was roughly two percentage points lower than comparable investments made by males. See Jacob Mincer 'On-the-Job Training Costs, Returns and Implications' *Journal of Political Economy* (Supplement October 1962), p. 68.

Bibliography

Baumol, William, J., and Bowen, William G. *Performing Arts: The Economic Dilemma.* New York: Twentieth Century Fund, 1966.

Becker, Gary S. 'An Economic Analysis of Fertility.' *Demographic and Economic Change in Developing Countries.* Princeton University Press, 1960.

——. *Human Capital.* New York: National Bureau of Economic Research, 1964.

——. 'Underinvestment in Education?' *American Economic Review*, L, no. 2 (May 1960).

Bowen, William G., and Finegan, T. Aldrich, *The Economics of Labor Force Participation.* Princeton University Press, 1969.

Bowley, A. L., *Elements of Statistics.* 6th Edition, London: P. B. King & Sons, Ltd. 1937.

Denison, Edward. *Sources of Economic Growth in the United States.* Washington, D.C.: Committee for Economic Development, 1962.

Economic Conditions in the Performing Arts. Hearings before the House Committee on Education and Labor, 87th Congress, 1st and 2nd sessions, November, 1961–February 1962.

Fact Book. Institute of Life Insurance, 1969.

Friedman, Milton and Kuznets, Simon. *Income from Independent Professional Practice.* New York: National Bureau of Economic Research, 1945.

Friedman, Milton and Savage, L. J., 'The Utility Analysis of Choice Involving Risk' in the American Economic Association, *Readings in Price Theory.* Homewood, Illinois: Richard D. Irwin, Inc., 1952.

Hanoch, Giora. 'An Economic Analysis of Earnings and Schooling'. *The Journal of Human Resources*, II, no. 3 (Summer 1967).

Marshall, Alfred. *Principles of Economics.* 8th Edition, New York: The Macmillan Company, 1920.

Mincer, Jacob. 'On-the-Job Training Costs, Returns and Implications' *Journal of Political Economy* (supple.) (October, 1962).

Raskin, A. H. 'Labor as Performer and Practitioner in the Arts'. Unpublished paper written for the Rockefeller Panel, 1964.

Rockefeller Panel Report. *The Performing Arts: Problems and Prospects.* New York: MacGraw-Hill, 1965.

Schickel, Richard. 'Dance in America'. Unpublished paper written for the Rockefeller Panel, 1964.

——. 'Opera in the United States'. Unpublished paper written for the Rockefeller Panel, 1964.

Schultz, Theodore W. *The Economic Value of Education.* New York: Columbia University Press, 1963.

——. 'Investment in Human Capital'. *American Economic Review* (March, 1961).

Smith, Adam. *The Wealth of Nations.* Cannan Edition, New York: Modern Library, 1937.

Statistics of Income: Individual Income Tax Returns. U.S. Treasury Department, Internal Revenue Service, 1960.

U.S. Bureau of the Census. *U.S. Census of Population: 1960.* Final Report PC (2) − 5B and PC (2) − 7A. Washington, D.C.: U.S. Government Printing Office, 1962.

Weisbrod, Burton. 'Education and Investment in Human Capital' *The Journal of Political Economy*, 70 (supple.) (October, 1962).

Witkin, Richard. 'Economics of the Dance'. Unpublished paper written for the Rockefeller Panel, 1964.

16. The Supply of the Performing Arts

by R. WEISS

reprinted from Museum News May *1974 pp. 932—7*

Although state support for the performing arts has risen at the very rapid rate of 15% per year compounded over the past 20 years in Britain, recent discussion has exposed many grounds of discontent. The London orchestras have loudly complained that support is inadequate to provide performance at the level of the best orchestras internationally. Others have argued that public support of the performance of new (British) compositions is inadequate. Still others have argued that public support inadequately allocates performance to the provinces and outside the large urban centres, and to the cultivation of new listeners among the young and the working classes. These protests all point to the need for criteria for determining the social benefit of alternative directions and amounts of expenditure. The Arts Council has been challenged to develop more objective criteria, partly to make explicit the goals it is pursuing and partly to enable it to tell how well they are being approached.

The state, through its agency of the Arts Council, providing roughly half the income of most of the major performing organizations, has assumed the principal role of determining the kind, quality, amount and location of performance in the country. The discussions of criteria for measuring the social benefit of expenditures look to ways to improve the organization of decision-making about resource allocation. The Arts Council, acting at arm's length both from the state and from the performing groups it supports, allocates its funds as a new kind of consumer, buying services, not necessarily the same services as the private consumer. Neither leaves the performing group free from the influence of the other. The consumer speaks through his purchase of seats; the Arts Council through a complicated negotiation and review of budgets, performance results and objectives with the group being supported, making its allocations in a complex compromise among pressures from staff and directors acting in committee.

A number of economists, with interests both in the arts and in the study of public expenditures, have been studying the organization of the arts, viewing the problem from the side of demand and the role of the state to determine the optimal combination of activities for a given budget allocation. Relatively little analysis has been applied to the other side of resource allocation — supply. William Baumol and William Bowen, in their important study,[1] formulated two propositions about the supply of performance. First, that the factor inputs are rather rigidly specified, i.e. the number of performers, the length of performance etc, so that cost cutting does not have much scope. Second, that the performing arts, being highly labour intensive, are subject to a tendency of costs to rise more than many other goods on which consumers spend. Over long periods, therefore, the performing arts are unlikely to be able to maintain their scale of output without increasing levels of state subsidy. The study pointed to the need for an Arts Council (in America's case, the National Endowment for the Arts and Humanities) to fill the 'dynamic gap' between the rate at which costs rise and the rate at which patrons are willing to bear the increased ticket prices. The alternative would be to allow orchestras to go the way of shoemakers, dressmakers, bakers and cigar makers.

Music, like drama, much of education, health and governmental services, in Baumol and Bowen's argument, is not subject to much rationalization: to play a symphony faster or with fewer instruments, or to concentrate on standardized and simple pieces, does not offer much prospect of desirable cost savings, notwithstanding the degree to which some of these ideas are already incorporated in the organization of orchestras. In fact, chamber orchestras, pops programmes that are acceptable with little rehearsal, and the all-too-frequent repetition of a narrow repertory are certainly as much a reflection of the low costs of supplying this sort of music as of the musical tastes of the audience.

The inexorable trend of a progressing economy suggests a crisis will come in the performing arts; but when such a crisis might come is not indicated by the dynamic gap itself; such a gap has existed for more than a century, longer than the modern orchestra itself. We certainly cannot conclude merely from this that 'concerts do not and cannot pay',[2] or that large and increasing governmental subsidies are desirable and needed at any time for a particular art. But certainly one of the fundamental facts of orchestral life is the tendency for costs to rise relative to some of the other things for which consumers spend money, as Baumol and Bowen have pointed out.

Table 1. Growth in Expenditure during the Postwar Period, USA
(Annual Average Percentage Increase, Compound Rate)

	Expenditure per Performance	Wholesale Price Index
Basic 11 Orchestras,* 1947—64	3.2	1.3
23 Orchestras,† 1947—64	3.1	1.3
Basic 11 Orchestras, 1961—4	4.9	0.1
23 Orchestras, 1961—4	3.9	0.1

*Weighted average of the growth rates of Chicago, Cincinnati, Cleveland, Indianapolis, Kansas City, Minneapolis, National (Washington), Philadelphia, Pittsburgh, St. Louis and San Francisco.
†Weighted average of the growth rates of Atlanta, Baltimore, Boston, Buffalo, Chicago, Cincinnati, Cleveland, Dallas, Detroit, Houston, Indianapolis, Kansas City, Los Angeles, Minneapolis, National (Washington), New Orleans, New York, Philadelphia, Pittsburgh, Rochester, St. Louis, San Antonio, and San Francisco orchestras.
Source: Baumol and Bowen, *The Performing Arts: the Economic Dilemma* (New York 1966) p. 199.

In the nine years since 1962—3, the budgets of the 11 largest American orchestras rose at the compound rate (unweighted) of 14.5%, the number of concerts at the compound rate of 3.5% and the cost per concert at the compound rate of 11%. The 23 orchestras had similar experience: their budgets rose at the compound rate of 13%, the number of concerts at the rate of 4%, and the costs per concert at the rate of 8.5%. In Britain and America, both over the longer period since 1929 and in the periods Baumol and Bowen studied and the decade after their study was completed, the number of concerts rose between 3 and 4% per year, compounded, in spite of the escalation of costs. In the face of this evidence we may conclude that demand has risen and is an important factor in explaining the rise of output and of cost. Of course, in both countries, the increase in demand has been fostered by large amounts of public and private subsidy.

Thus doomsday has been held back by the rise of demand; perhaps at some future date, when quadraphonic sound will be matched to three-dimensional video-taped home reproduction systems or when a large segment of the listening audience, sated with late 19th-century sonorities, turns to oriental sounds, there may be a collapse in public demand for live concerts. Tastes may change, and with that there will be a need for reorganization of resources devoted to live concerts. Much of the public discussion of orchestral performance defines the problem

Table 2. Orchestral Concerts in London,
1929—64

Year Ending	1929 Dec 31	1938 Dec 31	1963—64 March 31
Winter Season			
BBC	25	22	12
LPO	—	34	90
LSO	10	7	87
Other	2	1	—
NPO	—	—	24
RPO	—	—	16
Proms	49	49	52
Provincial	3	—	17
Total concerts	89	117	309

Sources: The Times; Arts Council Committee on
the London Orchestras.

as the maintenance of a given number of orchestras or a given number
of positions for performers (usually the present number).[3] Although
redundant musicians would be cheaper to maintain than redundant
supersonic aircraft workers, before founding too many more orchestras
we might keep in mind Adam Smith's dictum: the end of production is
consumption.

Although orchestral inputs would seem to be technically specified
by the composer and much can be made of the absurdity of efficiency
experts who recommend playing a concert faster, it is not hard to see
that economizing decisions can be made on a wide range of costs.
Orchestras vary from 80 to 110 members and the size of any one
orchestra has varied both up and down according to the ambition of its
supporters and the movement of the business cycle. Henry Wood's
Prom concerts were performed with one rehearsal on the day of the
concert; the quality of performance can be varied and the repertory can
be chosen to permit savings in rehearsals. The cost of a concert can be
greatly reduced if its programme can be repeated, spreading the fixed
cost of rehearsal over several performances in the same way that the
cost of a book varies with the size of the printing order over which the
fixed costs of setting type and making the presses ready must be spread.

In the larger American orchestras, concert seasons are organized to
provide two or three performances of each programme; thus in Chicago
one programme is prepared each week, performed on Thursday and

Saturday nights and alternately on Friday or Sunday afternoons or Monday night in a nearby city. In London the four competing orchestras usually perform a programme only once; most of the exceptions are made to allow the Festival Hall to be used twice on Sunday, leaving only the morning free for rehearsal. Instead of repeating the afternoon concert and saving a rehearsal, one of the concerts shares some or all of the programme with a concert at an outlying hall earlier in the week.[4] The effect of the allocation of concert dates by the Festival Hall management among the four orchestras is to guarantee a season of a wide selection from the standard repertory and a system that has little scope for efficient reorganization, depending as it would on the agreement of the orchestras, organized into a cartel (London Orchestral Concert Board), the Arts Council, the Greater London Council and the Musicians' Union.

Although the data are not perfectly comparable, they indicate a striking contrast between the London and American orchestras in the use of rehearsal and concert time. When we look to data for engagements (performances promoted by others), the ratios are much closer to those of American orchestras. The engaged performances for opera, ballet, tours and school concerts have some repetition of programmes.

A London orchestra saves about £600 for each rehearsal eliminated, or about 40% of the present subsidy per concert. Suppose that by repeating programmes the only saving were in rehearsal time (ignoring possible savings in artists' and conductors' fees, and in the printing of

Table 3. Ratios of Rehearsal to
Engagement Performances, London
Orchestras

	LPO	LSO	NPO	RPO
1972—3	0.7	0.92	0.94	0.84
1971—2	1.03	1.55	0.56	0.92
1970—1	0.88	1.6	1.7	0.88

Sources: LOCB *Annual Reports*; ratios taken of engagement rehearsals to engagements, net of BBC TV, recording and film engagements (the engagements include performances at Glyndebourne [LPO only], in ballet and at festivals, tours and schools).

Table 4. Ratio of Rehearsals to Concerts, London and American Orchestras, self-promoted Concerts

	LPO	LSO	NPO	RPO	Boston	Chicago	Philadel-phia
1972–3	2.56	2.96	2.7	1.94	0.83	0.91	0.93
1971–2	2.04	2.8	3.2	2.3	0.74	0.77	0.97
1970–1	2.4	3.1	3.1	2.3	0.72	1.3	0.91

Source: LOCB *Annual Reports* and ASOL *Annual Comparative Reports.*

programmes and advertising); suppose further the present season of 171 concerts were organized to require 57 programmes, each given three performances. Increase the number of rehearsals for each programme by 0.5, i.e. to 3.0; the total number of rehearsals would fall to 171 from the former level of 428, a saving of 257 rehearsals in the concert season. At roughly £600 per rehearsal, the saving in direct expense would be £154,000 per year, or 75% of the present level of concert subsidies, with benefits in the quality of performances that would increase from the first to the last performance. Touring and the repetition of concerts in nearby cities bring the same benefit, limited by the high cost of transport.

To carry the argument further (stopping short of each orchestra, though not necessarily each conductor, playing only one programme): if each programme were to be given four performances, the 43 programmes, each given three rehearsals, would save 299 rehearsals, or approximately £180,000 annually, or 90% of the present direct subsidy for London concerts. The 257–300 fewer rehearsals would represent between 53 and 62% of the present work-load of one of the orchestras.

Such a radical reorganization cannot be seriously entertained without careful study. One would need to know much more about the concert-going audience before assuming (as this argument has) that the reduction in number of programmes would not also reduce the number of tickets sold either to those who at present go, let us say, more than once a week, or to those whose musical tastes are specialized to a narrow range of composers. A reduction in the number of programmes would reduce the frequency of performance of the repertory by as much as two-thirds. Economists seldom find better examples of the difference between marginal and average cost and the effect of economies of scale. Curiously, it is the monopolistic provincial and

American orchestras that have realized these economies, while the oligopolistic and cartelized London orchestras, organized as producers' cooperatives, have failed to find an efficient organization of their performances. In private industry there would have been take-over bids and mergers; a notable example in orchestras is the merger of the New York Symphony and the New York Philharmonic Society in 1928.

Table 5. Sessions per 1000 Attendance, Selected Orchestras

	London		Boston		Chicago		Philadelphia	
Year ending	1967	1972	1963	1972	1964	1972	1963	1972
Total sessions	667	599	218	360	299	345	296	360
Total attendance, 000s	315	376	286	612	329	477	421	797
Sessions per 1000 attendance	2.12	1.59	0.76	0.59	0.91	0.72	0.70	0.45
No. weeks contract	52	52	?50	52	40*	52	37	52
*1964–5								

Sources: LOCB *Annual Reports*; ASOL *Comparative Reports*

Although both American and the London orchestras have become more efficient (sessions per 1000 attendance) in the past decade, it is only the London orchestras, whose concerts are their minor activity, for which reorganization could bring about a dramatic reduction in deficit. Their dependence on engagement and recording sessions for the major part of their incomes has kept them in the traditional position of selling their services, collectively, as freelance musicians, at session rates. The central staffs and office overheads needed for organizing their collective activity are quite small. All the work undertaken by the orchestras is therefore priced at the marginal cost of providing it. The provincial orchestras in Britain and America have all been organized by voluntary associations of patrons in areas where local demand was not sufficient to support sedentary orchestras for the length of season needed to hold the musicians in the community. With costs contracted over a whole season, these orchestras could more easily disregard the marginal cost pricing of their services.

The major American orchestras are all on a similar footing in relation to their economic base; their earned incomes are provided chiefly by ticket sales to their patrons at home; their summer work, though often provided by nominally independent festival organizations, is subsidized

from the same sources as the remainder of the year, and earned income provides only about 50% of expenditures. But the differences among the orchestras are significant. For roughly the same size of orchestra and the same number of sessions (the Chicago figure is exceptional in 1972–3), and the same salary scale, the total budget of Philadelphia was $1,200,000 less than Chicago's and $1,500,000 less than Boston's. Earned income accounted for 76% of Philadelphia's total expenditures against 48 and 69% for Chicago and Boston. The total cost per concert varied from $25,000 in Philadelphia to $32–33,000 in Chicago and Boston. Administrative expense, perhaps not defined consistently to allow meaningful comparison, was more than $500,000 less in Philadelphia than in Chicago.

Table 6. Comparison of orchestral costs, Boston, Chicago and Philadelphia 1972–3

	Boston	*Chicago*	*Philadelphia*
Size of orchestra	102	108	106
Number of concerts	197	177	186
Number of sessions	360	338	360
Average weekly salary, $	391	376	390
Total attendance, 000s	611	512	867
Subscription sales as % of capacity	80	83	72
Earned income as % of total expenditure	69	48	76
Orchestra's total budget, $ 000s	2630	5691	4735
Concert production cost, $ 000s	2170	1498	1921
General administration, $ 000s	669	787	244
Expense per concert, $	33,000	32,000	25,700
Expense per seat occupied, $	4.63	4.36	2.82
Average price of subscription seats $	5.86	7.38	4.82

Source: ASOL *Comparative Report*

The differences in costs and revenues between Philadelphia and Chicago are principally in overhead ($324,000), additional number of concerts (28), additional seating capacity (360) and additional recording net income ($572,000). If Chicago were favoured by these same elements, and assuming attendance at 90% of capacity, Chicago's earned income would rise and expenses fall by a total of $1,790,000 per year and the ratio between them would rise to a level around 85%. Of course efficiency cannot be made by wishing, and circumstances do

not often cooperate. Local pride is flattered by expensive tours to Europe, and a corporate president in Chicago may take great pride to know that a few thousand Europeans and a score of newspaper critics find their orchestra as outstanding when heard in live performance as in recordings.

The data available do not allow more careful analysis, aggregating the summer, winter and touring expenses together. Apparently every part of the season's activity loses money, the ticket sales covering only the musicians' salaries even in the winter season.

The initial premise of Baumol and Bowen that technology has passed over the performing arts was not strictly accurate; the long-playing record and tape recordings, radio and television have brought a revolution in the cost of reaching audiences. British concerts are broadcast to radio audiences of 100,000 and television audiences between 1,000,000 and 6,000,000. A long-playing record costing one pound, played, let us say, ten times, brings music to the listener's home at a cost of 10p per performance. The same performance can be provided at a cost of 3p and 0.3p per listener to radio and television respectively, assuming audiences of the size estimated above and costs that include the full promoted concert costs less ticket revenues from the attending audiences. There may be advantages and disadvantages from listening to recorded and broadcast music; broadcast music loses some of the fidelity, balances and excitement of the concert hall, depending partly on the quality of the receiving equipment. But there are some gains in comfort and savings in the time and expense of travel to and from the concert. A recorded performance is usually more accurate but sometimes less inspired than live performances. But technology has greatly reduced the cost of hearing music and it allows reaching an audience that cannot come to the concert hall by reason of being tied to the house by small children, illness, age, poverty and distance, and it permits a variety of choice over repertory, performers and the time of performance not available to concert-goers, regardless of their means and location. A cheapening of cost in the order of magnitude of 90% matches the most important consumer products. Baumol and Bowen, in concentrating on live performance, were not encouraged by this prospect.[5]

Under the impact of such a cheapening of cost, other things being equal, we might expect a concentration of output into the hands of the most efficient firms, a decline in the number of orchestras, perhaps, and a decline in live performance in favour of recorded and broadcast

performances. The average quality of performance might rise considerably, and the orchestras that survived would combine concert activity with broadcast and recording. The recording industry would, as it has, migrate to countries with the lowest wage costs, and the high wage countries would suffer from the competition of expensive live concerts with cheap recordings; the resistance of demand for live performance to increased prices might be greatest in the high-wage countries.

The cheapened cost of recorded music against the escalating cost of live concerts would surely have had devastating consequences in an ordinary market; that the number of concerts has risen in the past 15 years argues for a large shift in demand in favour of concerts. But the orchestras have been able to take little advantage of the opportunities of sharing rehearsal costs among live, recorded and broadcast performances. In Britain the BBC organized its own orchestra in the late 1920s when no alternative existed in London. But instead of using its patronage to strengthen the provincial orchestras, it created parallel and independent establishments in Manchester and Glasgow.[6]

The London orchestras derive between 20 and 33% of their employment from making recordings. With session costs almost four times as high as those of London orchestras, few American orchestras derive a net revenue from recording; a few orchestras seem to subsidize their recordings.

Touring and the repetition of concerts in nearby cities have traditionally provided the means for 'extending production runs'; the Hallé Orchestra regularly took its programme to Liverpool; the Scottish National Orchestra repeats its concerts in Glasgow and Edinburgh; the Chicago SO plays in Milwaukee, Wisconsin. High transport costs, the high value of musicians' leisure time and the element of local pride all stand in the way of extending the market, but there may be an unrealized potential in reorganizing seasons in Boston, New York, Philadelphia and Washington for regular exchanges of programme; possibly Chicago, Cleveland, Detroit and Milwaukee could similarly federate.

Where summers were hot and patrons left the city, concerts were organized in the open air; British and American orchestras still have summer seasons in suburbs or resort areas. With poor acoustics, the interference of aeroplanes, trains and insects, these settings provide a poor environment for refined performances of a major orchestra. Perhaps air conditioning of the concert hall can provide a superior alternative.

Although on the Continent most symphonic music is provided by opera orchestras, there are few cases in Britain or the USA of sharing an orchestra for both functions. The LPO plays for the summer Glyndebourne season and the San Francisco Symphony plays a regular opera season. Although few operas call for as large an orchestra as late 19th-century symphonies, there are potential savings in the sharing of orchestras, apparently not at present being realized when 20–40 members are paid not to play.

Another means of economizing might call for splitting the large orchestra of 100–110 instruments into two smaller ensembles, each of a size appropriate to much contemporary music and to the repertory composed before about 1850. There could be economies from concert series in outlying areas with smaller halls. The Peacock committee heard strong evidence against dividing orchestras, where the experience of one orchestra was a decline in the quality of the ensemble both of the divided orchestra and of the reunited orchestra. Yet, on the face of it, the variety afforded by the chamber orchestra repertory, the stimulus to the musician from being able to hear and play with others to whom he cannot relate in the full orchestra, might be very valuable to the members. Recently Pierre Boulez recommended that 'the orchestra of the future' be formed from various small groupings 'split up into quartets, chamber groups and contemporary ensembles, so that . . . they could hear themselves play for a change'.[7] The smaller groupings that enable the orchestra member to grow in his musicianship also might afford reaching new audiences in new locations with a better potential for covering the cost of performing than either the full orchestra in the new location or in an additional concert in their usual hall.

The agency of the state that allocates public subsidies to the performing arts needs to be 'cost effective', to find and apply criteria for making choices of kind, quality and quantity. As the preceding discussion points out, it must also use its subsidies to organize the performance of the arts at the lowest cost. In the market, where there is competition among firms offering similar goods, there may be a strong tendency for owners to find the best combination of activities and mode of production under the stern discipline of making profit at the ruling market price. But performing organizations are usually monopolists in their local areas and need operate efficiently only to the extent that subsidies give incentives for doing so. The Arts Council, like a banker, at arm's length from his client, but indispensable to him, is

careful not to dictate to its client. It creates incentives with blunt tools and only in extremity can force consolidation, liquidation or reorganization when it is prepared to threaten closure. A powerful lobby of interests faces such an agency, whose function necessarily is transformed into decision making by a committee of representatives of the interests of clients. The agency of the public, allocating funds vital to the continuation of each performing activity, becomes the sole repository of initiatives, yet is hamstrung from moving except with a 'discrete incrementalism'.

The alternatives discussed above are not intended as a prescription to any orchestra. It was intended to point to some of the dimensions of cost savings that a good use of social resources would try to exploit. To that extent it adds another set of criteria that the agency for subsidizing orchestras will try to implement.[8]

1. *The Performing Arts: the Economic Dilemma* (New York, 1966). The following abbreviations will be used in this article: LOCB, London Orchestral Concert Board, Ltd; ASOL, American Symphony Orchestra League, Vienna, Virginia; *Peacock Report*, Arts Council of Great Britain; *A Report on Orchestral Resources in Great Britain, 1970*.
2. Arts Council of Great Britain, Committee on the London Orchestras: *Report* (London, 1956), p. 6: 'In our view these subsidies must be accepted as the price a great city must pay to provide a proper range of music for its citizens and visitors. This is a public service'.
3. In a strong dissent to the *Peacock Report*, Hardie Ratcliffe argued: 'I believe that, in the interests of the many colleges of music, and of the hundreds of students they train to become professional performers, employment for musicians should be increased as soon as possible if full advantage is to be gained from the expenditure of much time, effort and money. For this reason, I think it unfortunate that the Committee . . . felt unable to recommend that the number of symphony orchestras should be increased'.
4. The lesson of the distinguished Courtauld-Sargent concerts organized each season between 1929 and 1939 was forgotten. Among the principles of the series, there was to be no deputizing, each concert was to be rehearsed three times and repeated at least once (in the 1932–3 season twice).
5. Baumol and Bowen see technological change mainly as a threat to the (live) performing arts. 'Progress in general technology has had a considerable impact on the arts through new methods of presentation of performances to the public. The development of motion pictures, phonograph records, radio and television has caused a precipitous drop in the cost of providing an hour of entertainment to each member of the audience. But these innovations have not helped the live performing arts directly; in fact, the competition of the mass media for both audience and artistic personnel has sometimes had serious consequences for performing organizations' (p. 390).

6. For data on performers and orchestras, see *BBC Handbook 1974* (London, 1973), pp. 260—62, and the *Peacock Report,* pp. 47—54.

7. *Peacock Report,* quoting the Scottish Arts Council: 'Frequent division of an orchestra is as bad for the whole as it is for the parts', (p. 25), to which they add the statement of Thurston Dart: 'Any of us who have worked for decades with chamber orchestras know that it is *not* possible to carve a chamber orchestra out of a small symphony orchestra (of say 65 players) or a large symphony orchestra (of say 105 players). The styles of playing are different, as are the assignments of responsibility'. But Pierre Boulez argues that musicians need the variety of styles and changes in ensemble in order to fulfil their potential; see the paraphrase of his remarks to the New York Chapter of the American Musicological Society (*Musical Newsletter,* iv/1, Winter 1974, p. 21).

8. This article is a revised version of a paper read to the British Association last summer.